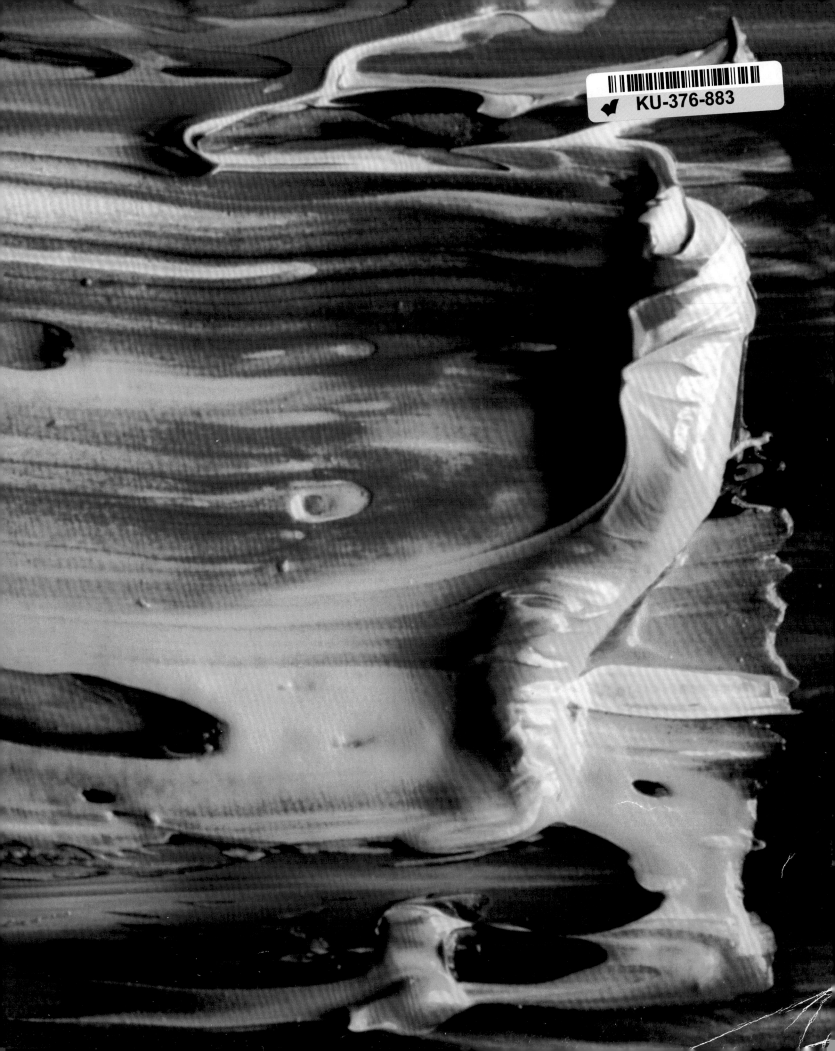

CONTENTS

FROM OLD WISDOM
TO NEW BRILLIANCE

black dog
publishing

london uk

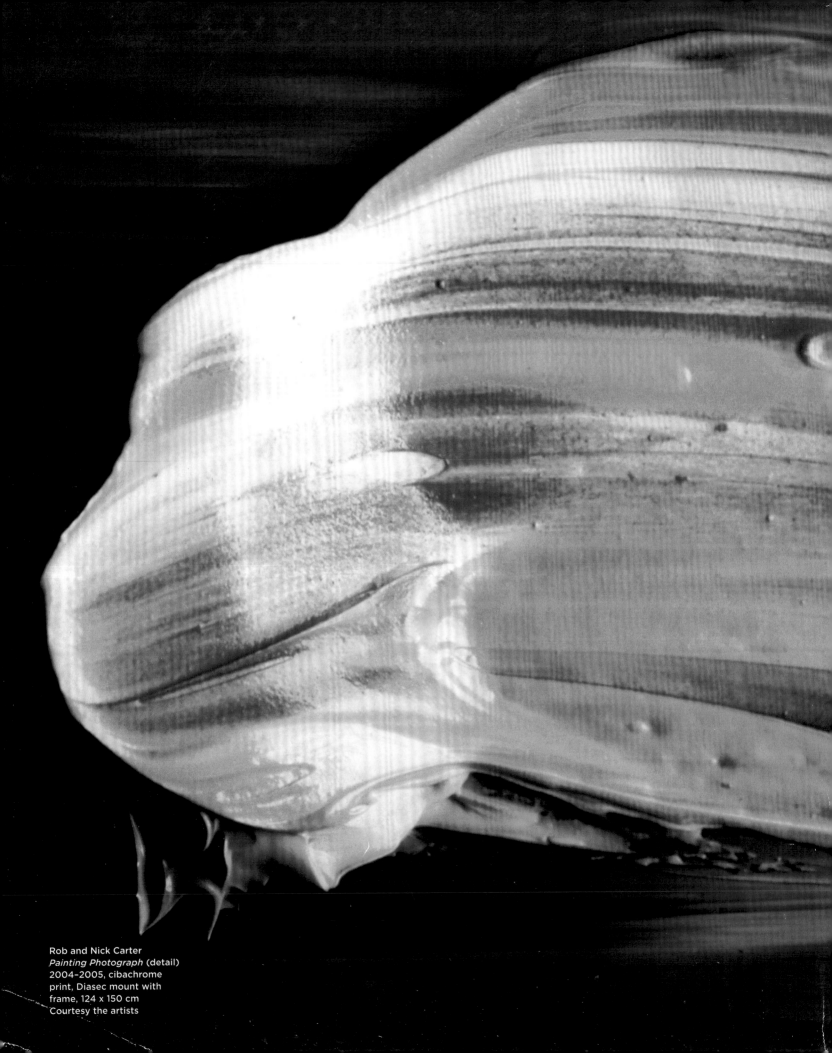

Rob and Nick Carter
Painting Photograph (detail)
2004–2005, cibachrome
print, Diasec mount with
frame, 124 x 150 cm
Courtesy the artists

COLOUR IN THE MAKING —INTRODUCTION

When we think of the art of colour what we are often thinking of is in fact the science of colour. Such queries as how is colour made, how do different colours come from the same pigments, and how do we see colour are all scientific questions, as well as being fundamental to the history of art and design.

Colour theory wasn't developed in a way that we consider 'scientific' in today's standards until Newton, and Newton's theories outlined in *Opticks* didn't actually make things clearer for artists. What we talk about as the art of colour before Newton is actually a kind of alchemy, a combination of early science, craft and technology, all employed in the pursuit of art. Until the Industrial Revolution, c. 1800, the production of paint and pigment was made in the studios of artists, and to recipes handed down over the generations. With the development of synthetic pigments this all changed. Pigments, paints and dyes were manufactured on a much larger scale and became readily available to artists and manufacturers.

ME Chevreul
Colour circle
1864

One thing that remains the same today is that all paints and inks are made in the same way—pigments suspended in a medium. What that medium is varies the form of the paint, from watercolours to complex polymer binders for hi-tech applications like scratch proof car paint or the latest chip-proof fluorescent nail varnish colours. The binder affects the colour of the paint as much as the pigment it carries. Paint making is an art, whether by artisans or the highest powers in industry.

What we have tried to do with this book is divide it into sections that demonstrate the stages of development that producing and making colours have taken over time. We delve into the history of ancient pigments and when and how they were discovered. Mark Clarke discusses the legacy of the mediaeval painter in his essay "Recovering the Mediaeval Palette". Looking at the ancient materials and methods used to make paint, Clarke takes a closer look at the decline of materials over time and how the appearance of artworks has changed.

Following this some of the many colour theories are introduced that helped to give us a greater understanding of colour from a scientific

Amanda Christie
*3part Harmony:
Composition in RGB #1*
2006, 16 mm colour
film with mono optical
sound, 6:00
Courtesy the artist

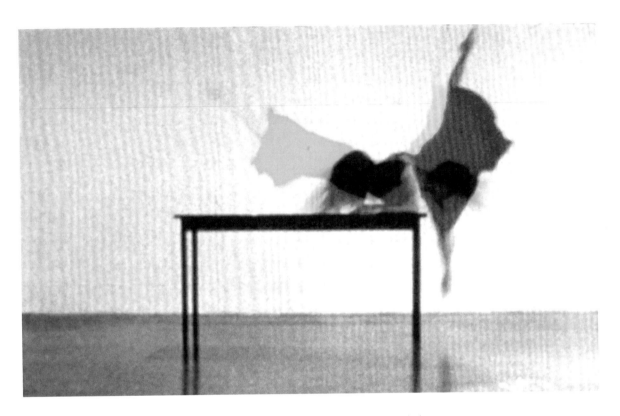

viewpoint. We then take a focus upon the nineteenth century and the development therewith of various new synthetic pigments. Philip Ball's essay "Rainbow Wars: the nineteenth century liberation of colour" discusses how the painters of the nineteenth century utilised the colours available to them and in turn how fine art grew to become what it is today, taking into account chemistry and industrial colour innovation.

Various different applications of colour are then discussed, in particular film, photography, fine art and fabrication, concluding the book in the modern day with Carinna Parraman's essay "Colour Mixing in the Twenty-First Century", which takes digital technology and new pigments, dyes and inks as its focus, in relation to the work of a number of forward-thinking artistic practitioners. Her essay, and the book, ends by looking to the future and what we might expect in the development of colour technology in the years to come.

It is hard to make definitive breaks in a chronology that stretches from prehistoric time to today—many pigments used in cave painting are still used, and to great effect. What we have tried to achieve with this book is a way to look at and re-examine colour, whether considering a pigment used in Mediaeval times, and now being reused to create contemporary icon paintings, or a soft yellow colour, used for its anti-corrosive properties on Second World War tanks. These colours are all featured in this book because they are rightfully astounding.

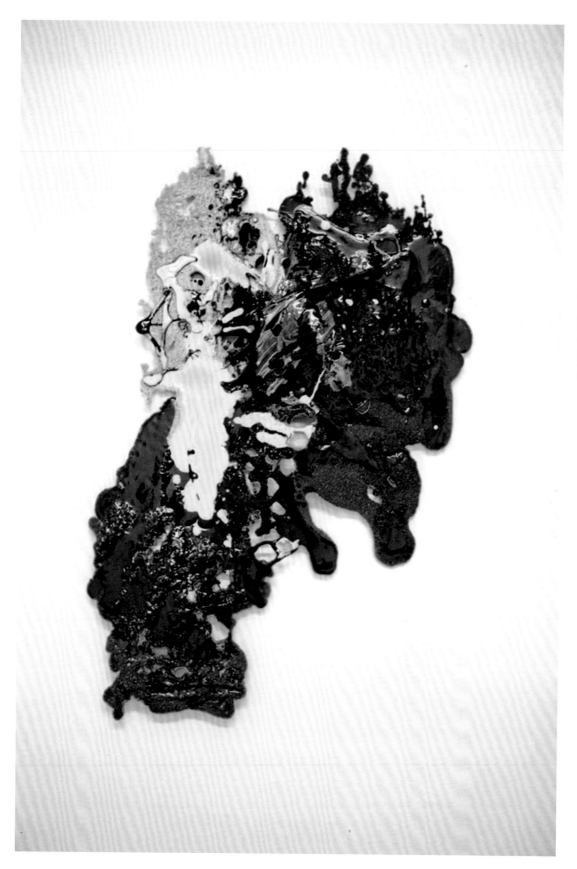

LEFT
Kai Franz
Nonlinear Shapes I
2012, CAD-Drawing,
Custom CNC-Code,
Custom CAM-Software,
Plopper, Polyurethane,
Sand, Pigments,
30.48 x 58.42 x 6 cm
Courtesy the artist

ABOVE
Issue three of the
controversial *Colors
Magazine* produced by the
United Colors of Bennetton
Courtesy *Colors Magazine*

EARLY COLOUR-MAKING —FROM CAVE PAINTING TO THE RENAISSANCE

Human beings have been marking walls, stones, the ground likely since before we can accurately date and certainly since before we have any record. In geographical locations where chalk is present, this crumbly rock has been used to make markings, drawings and groundworks and charcoal has equally been employed to create marks, arguably the earliest drawing materials and pigments for the colours white and black. When we think of the earliest use of pigments we tend to think of cave paintings, such as Lascaux, where traces of iron oxide in various states of heating and cooling have created an array of colours from yellows through reddish oranges into deep browns.

Colour in pre-industrial times can largely be categorised in terms of geography as well as chronology. Early indigenous cultures all over the world have particular colour associations, many of which are intricately bound to our associations with that culture. Imagine the Ancient Egyptians without the first developed synthetic blue pigment, created from crushed blue glass, or the early Aztecs without sumptuous red cloth derived from the cochineal beetle found on the leaves of cacti, or the 100,000 year-old ochre slates at Blombos in South Africa, the first known use of markings as human language, without which we would have no idea that human kind was so complex so long ago. The use of lead white is synonymous with the Ancient Greeks; and vermillion with the Romans. Colour also travelled. Reds found in ancient Chinese temples didn't make it to the West until the twelfth century.

Mineral pigments gained popularity throughout the Middle Ages with their newfound applications in art. Ultramarine and azurite were particularly popular, with artists such as Michelangelo and Rembrandt utilising these earth pigments initially for drawing and the most basic form of painting, using egg tempera—a mixture of pigment, water and egg.

These methods gradually became obsolete with the development of paints into the Renaissance period, with a new-found understanding of pigments and their applications. Painters and alchemists alike became familiar with how to manipulate materials to their advantage, with artists such as da Vinci and Raphael becoming akin to this. Whilst the pigments were largely the same (there were some new colours), artists began to use the materials differently, applying them to canvases and understanding the science behind the art, creating different hues and saturations and furthering their many uses.

The map, overleaf, indicates where the early naturally-occurring pigments of carbon black, ochre, lead white, azurite, malachite, orpiment, realgar, verdigris, vermillion, ultramarine, indigo and woad—those which have been employed in the early production of paint—were originally discovered. Each of these are then detailed over the following pages,

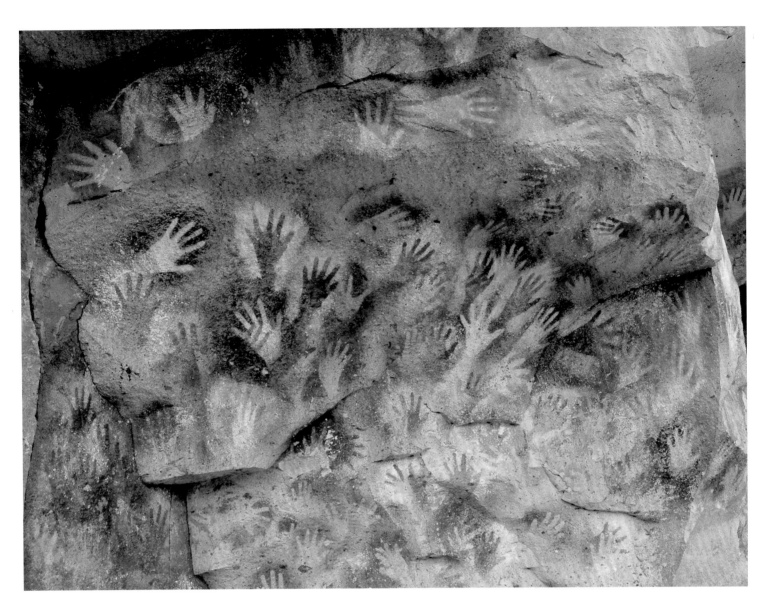

discussing their creation, how they are made, their evolution and giving examples of their use from fine art to architecture and more.

Mark Clarke concludes the chapter in his discussion on the "aims to recover the lost materials of the mediaeval painter and illuminator", looking at the early recipes and methods of making paints in order to uncover the history of paint making today.

NATURALLY OCCURRING PIGMENTS

WORLD MAP

- CARBON BLACK
- OCHRE
- LEAD WHITE
- AZURITE
- MALACHITE
- ORPIMENT
- REALGAR
- VERDIGRIS
- VERMILLION
- ULTRAMARINE
- INDIGO
- WOAD

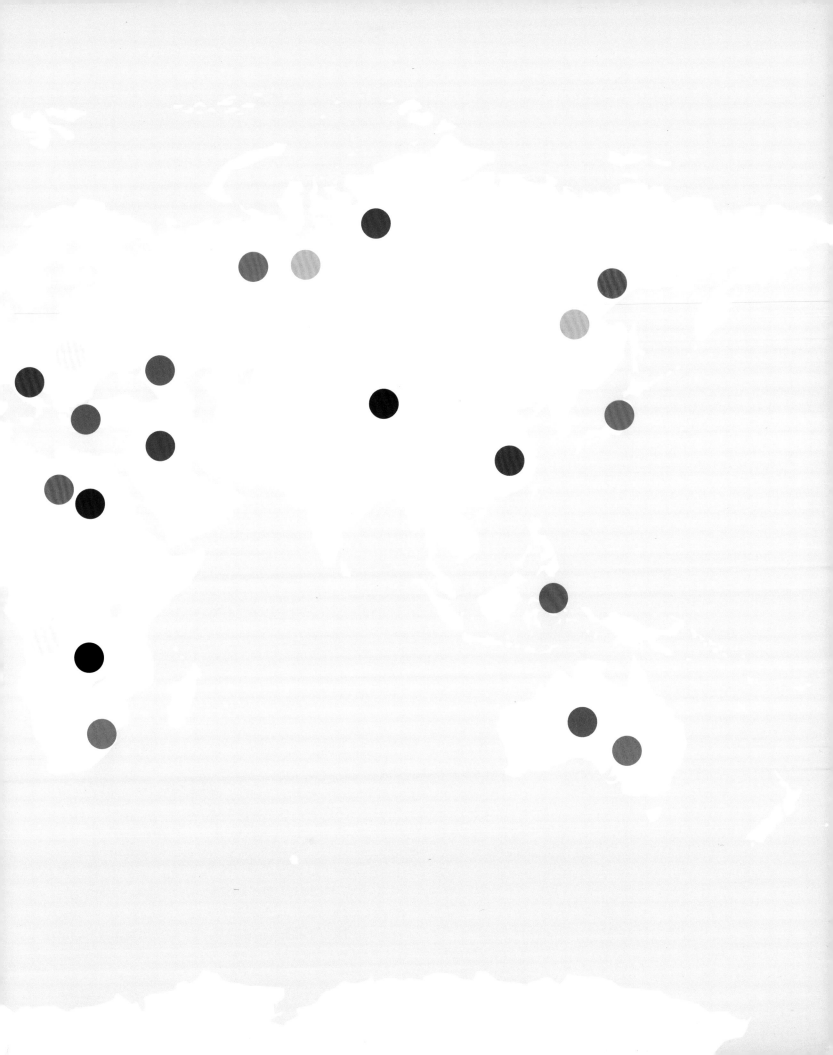

CARBON BLACK

Carbon is arguably the earliest pigment created by human beings. Versions of carbon pigments are found all over the world, making their way into every tradition of mark-making—from cave paintings to the fine hidden layers in frescoes, Chinese inks and contemporary drawings.

Carbon is the material that remains once organic matter, including vegetation and plant life, and even animal fats, is completely burnt. This is most effectively procured by applying a very high heat to the organic material, and reducing the amount of air it is heated in, preferably in a controlled environment such as a kiln. Easy to make and use, carbon is also non-toxic and thus an excellent material for artists to experiment with. Today, carbon black is still used as a very effective colourant, either unaccompanied—in the finer form of willow charcoal, compressed charcoal or charcoal powders—or in oils, watercolours and inks.

Carbon black is often found under the aliases 'Vine Black' or 'Lamp Black', which refer to the way it was historically obtained—Vine Black was created by charring vines, and Lamp Black taken from the soot deposits in oil lamps. Now that these colours are artificially created, the names are commonly used to indicate the quality of the colour produced— Lamp Black more intensely dark black than the softer Vine version.

Oil lamp soot is also the main ingredient of traditional ink, which is thought to have been common in China and Egypt as early as 3,000 BC. Usually formed in bars of Lamp Black and animal glue, the ink is traditionally wetted with a damp brush until it liquefies. Early Japanese *sumi-e* drawings, such as the beautiful *Landscape of the Four Seasons*, attributed to Tenshō Shubūn, display such use of the material to graceful effect in delicate washes and subtle brushstrokes.

Carbon was traditionally used in Western classical art as an underpainting material. Lightweight and effortlessly applied, it was the perfect matter to impress upon canvas a framework onto which more in-depth painted images could be established. Although some charcoal drawings, considered studies or underpainting trials remain, the vast majority were of course painted over. Using infrared scanning technology, however, conservators have been able to reveal the hidden structures underneath on account of their inherent material properties. The very matte black produced by carbon is extremely effective at absorbing light. Thus, when a painting is scanned, the concealed charcoal absorbs the infrared and the underpainting below becomes apparent.

RIGHT
Tenshō Shubūn
Landscape of the Four Seasons
Fifteenth century, ink on paper, 150 x 355.4 cm

OPPOSITE
A broken piece of fully burnt charcoal. The material can be ground to create a pigment for inks, oils or watercolours. Photograph Magnoid

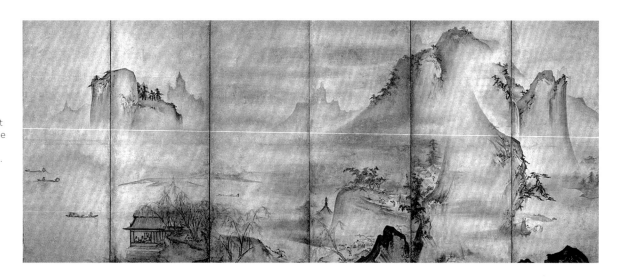

OCHRE

Though derived from the Greek for 'pale yellow', the term 'ochre' technically encompasses a clayish colour range from the golden-yellow and yellow-brown of ochre as we know it, to the deeper natural reds and intense darker browns of 'red ochre' and 'brown ochre', even progressing into some monochrome shades of black and white.

The soft clay deposits from which ochre is obtained occur in globally diverse locations including France, Italy, Canada, Japan, Australia and Swaziland, reflecting the diverse gradient of earthy shades attainable. Natural ochre is a blend of quartz sand, clay and the mineral iron oxide, the variety and amount of which determines the ochre's final colour. Quantities of the iron oxide haematite, for example, will produce a redder shade, while the yellower, more recognisable and commonly found ochre consists of larger amounts of goethite.

Pigment is obtained from ochre in a simplistic process of sublimation. The original clay substance is ground and submerged in water. Its quartz components subsequently sink, but lingering clay oxides remain on the surface of the liquid and, after evaporation, form a powdery residue. So simple and effective is this process and the resulting pigment, that ochre lent itself to our earliest experimentation with expression, and consequently the substance has been used to depict our experiences since the very first occurrences of artistic endeavour.

Ochre's significance is global. Native Americans became known to white settlers as 'Red Indians' on account of the dark ochre with which they superstitiously decorated their bodies; in Ancient Egypt red ochre was used liberally on celebratory occasions and was symbolic of life and victory; whilst Australian Aboriginals considered ochre almost sacrosanct using it not only in ritualistic decoration, but also as a visual means of passing on ethnic customs so that native traditions could survive.

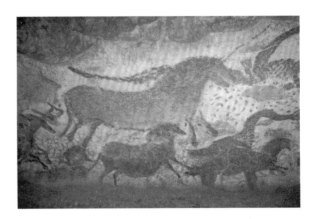

Rudimentary ochre illustrations of prehistoric life line caves all over the world. The extensively studied drawings of Lascaux, in the Dordogne, France, remain from the middle Paleolithic period, dating them to approximately 40,000 BC. Recent excavations at the Blombos Cave in South Africa, however, have unearthed evidence which suggests that ochre was prepared as a paint even approximately 30,000 years before that.

Ochre has never fallen out of favour with artists. In fact, the finest ochre pigments were sought after for their natural effect and versatility. Pigment taken from Sinope (an area on the Black Sea, now Sinop, Turkey) was preferred in the classical era to the extent that the terms 'sinopia' and 'sinoper' became synonymous with deep ochre tones.

LEAD WHITE

Lead white only began to fall out of use during the nineteenth century, with the basics of its recipe remaining virtually unchanged to this day. The 'Dutch' process (sometimes known as the 'stack' process) of producing lead white involves laying rolled sheets of lead over vinegar in special containers which are then sealed in a room filled with manure for several weeks. The acetic acid present in the vinegar reacts to the warmth and carbon dioxide of vapours released by the animal dung, resulting in the appearance of a flaky white substance—lead carbonate—on the surface of the metal.

Lead white is a warm, shiny colour; in its oil paint form it dries the quickest of all whites and provides unsurpassable flexibility on the canvas. Caravaggio's *chiaroscuro* figures, Vermeer's luminous interior scenes, and Sisley's vibrant landscapes, are all paintings that aspired to replicate the glow of natural light by using great quantities of lead white. However, careless or unknowing applications of lead carbonate, particularly on surfaces exposed to air and other pollutants, have aged badly. The gases released by Victorian lamps, and acids such as those left by fingerprints, have oxidised the paint, turning black the originally pink and white faces of frescoes and illuminated manuscripts.

Darkening over time is not lead white's worst feature: it is also a very effective poison. Those unfortunate enough to be involved in its production in the past commonly suffered painful deaths as a result of lead dust inhalation. Its historic inclusion in cosmetics has lead to the untimely demise of many young women seeking an immaculate, unblemished complexion. Our past obsession with attaining whiter skin has claimed innumerable lives, causing tremendous damage on the skin itself, as well as the nerves, renal system and all-round mental well being of its victims.

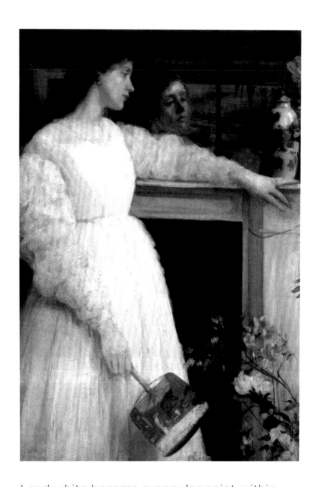

Lead white became a popular paint within the household during the flourishing of Neoclassicism at the end of the eighteenth century. Perhaps the best-known example of such use is the United States' presidential residency, the White House, which acquired its name after the lead white paint that coated its sandstone structure.

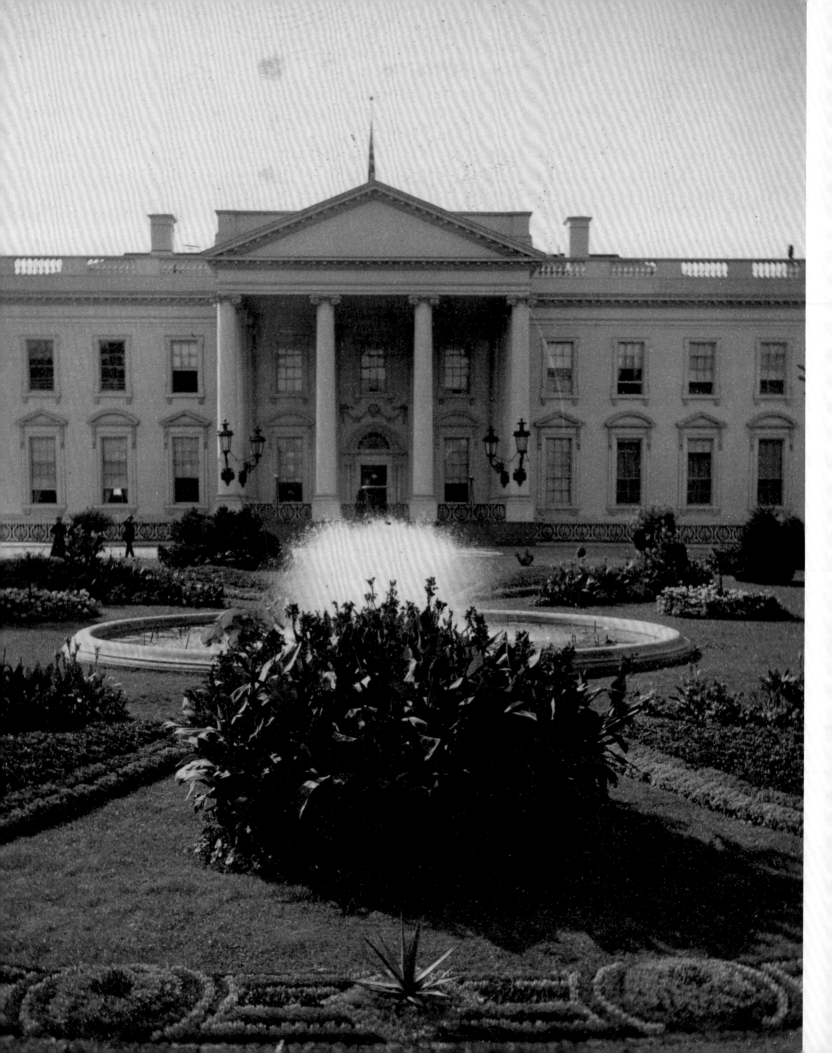

AZURITE

Azurite, also known as 'bice blue' or 'blue verditer', is a naturally occurring mineral that has been used as a pigment in various forms since Egyptian times. Found in as diverse locations as Japan, China and the Americas, its representation in early arts is global. In Western art it reached its prime in the Middle Ages, when it was frequently used to allude to celestial, God-like majesty in the blue of highly ornate church ceilings and frescoes.

Azurite is one form of the mineral copper sulphate. In its earliest use as a pigment and paint the natural material, seen in the upper parts of copper ore often with bright green malachite (copper sulphate's other natural form), was simply ground, washed and sieved, leaving a fine blue powder. The amount of grinding done to the natural material affects the colour of the blue produced; large fragments produce a deeper, darker blue, whereas when finely ground the blue produced is softer—something more akin to a sky blue. This effect is noticeable in the naturally occurring blooms of blue in rocks. Smaller crystals are paler, a soft, almost baby blue.

As with many pigments, the binder alters the colours produced. Egg tempera makes the blues greyish and oil turns them green. For making frescoes the pigment is mixed with water and layered over compacted, still wet plaster. The exterior frescoes at the Voronet Monastery, built in 1488 by Prince Stephen the Great in only three months and three weeks, present a great example of some of the advantages of using azurite as a pigment. Despite being over 500 years old and open to the elements in northeast Romania, the fresco is still a remarkably bright blue. Research conducted in the 1960s has shown that this is due to both the processes used in the production of the fresco and the pigment itself; copper as a material is anti-fungicidal. The blue pigment was also laid over a black, charcoal base. This is likely to have protected the material from the alkalinity present in the lime mortar, as well as cleverly enhancing the blue's optical qualities.

RIGHT
The exterior frescoes of the Voronet Monastery remain a bright blue, despite having being exposed to the elements for over 550 years.
Photograph Adam Jones

OPPOSITE
Washington DC—Natural History Museum—Azurite with Malachite
Photograph thisisbossi

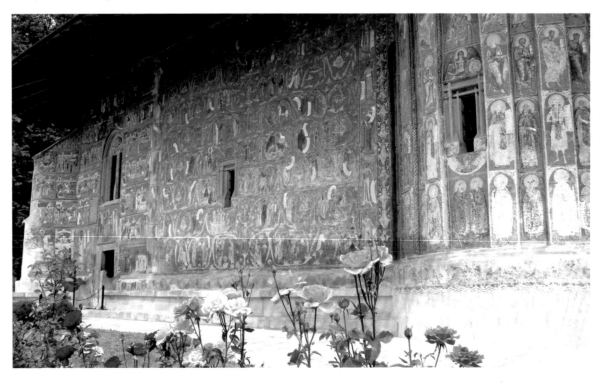

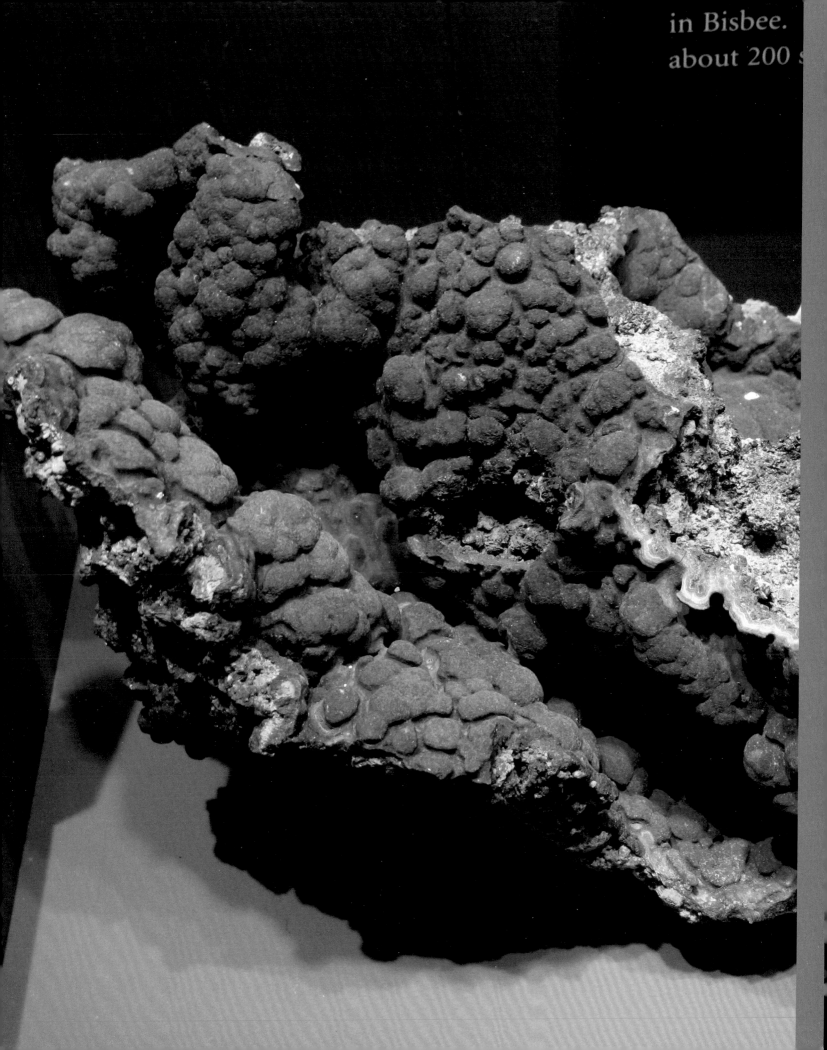

MALACHITE

Malachite, alongside azurite, is one of two naturally occurring basic copper carbonates found in copper deposits all over the world, some of the most significant being China, Russia and the USA. The copper ores in these locations react to carbonate components of neighbouring materials, such as limestone, to produce colourful crystals, the shade and intensity of which depends on the extent of their oxidisation; originally blue azurite, copper carbonate crystals flourish into potent green malachite on further oxidisation.

In its natural form, malachite is exceptionally beautiful. Once polished, a marbling of light and dark green tones is revealed, producing a rippled effect across its surface. As a consequence, it was frequently used in decorations of Ancient Egyptian burial tombs, embedded in bejewelled headdresses, and flaunted in extravagant displays of excess—grandiose green stone columns embellished with gold gilding still line the 'Malachite Room' of the Winter Palace in St Petersburg.

Malachite is not only revered in solid form. When ground it produces one of the oldest known green pigments. Examples of its use include Egyptian tomb paintings, which date from as far back as the sixth century BC, as well as historic Buddhist wall paintings in China, Tibet and Japan. Malachite also has a frequent presence in illuminated manuscripts of Europe, Persia and India as well as in both ancient and contemporary sacred icon paintings. Indeed, the malachite greens of mediaeval Italian frescoes maintain most of their original brilliance.

The use of malachite pigment declined with the introduction of oil paint in Europe in the sixteenth century, perhaps as a consequence of the poor, transparent mix created when the powder is applied to oil. As tempera, however,

malachite use continued until the eighteenth century. Its legacy survived even further, though, as it lent its name to one of thousands of new colours synthesised during the chemical revolution of the nineteenth century; the dye known as malachite green (which has no relation to the mineral) was created in 1877 and has since then attributed silk and paper the same bright colour of this semiprecious stone.

ORPIMENT

Made up of intricate, intermingling orange, yellow and golden coloured crystals, the mineral orpiment takes its name from the Latin *auripigmentum* (gold pigment). Its physical properties, ostensibly similar to gold, have stirred excitement amongst history's alchemists and artists alike.

Once crushed and processed, orpiment produces a warm, radiant yellow pigment. As such a shade was difficult to attain elsewhere, the pigment was used considerably in ancient art pieces from as long ago as the sixteenth century BC and was particularly popular with the Ancient Egyptians.

Naturally occurring in parts of Asia and Europe, orpiment was frequently used in significant contexts; so regal was the hue considered, it often adorned the robes of Chinese Emperors (yellow being a Chinese symbol of power) and has been found commonly on twelfth to sixteenth century religious icon pieces in places such as Norway, Russia and Bulgaria.

During the eighteenth century, processes of manufacturing orpiment were established and an artificial pigment was created

(sometimes dubbed "King's Yellow", either on account of its vibrancy, or as a result of an unofficial name of true orpiment, the "Two Kings", shared with the mineral realgar). Both manufactured and pure orpiment pigments were used throughout the nineteenth century, with notable examples including many of the works of JMW Turner.

Though conducive to creating an exuberant colour, orpiment is not an agreeable material to work with; it is largely incompatible with other pigments, tarnishing on interaction (especially with those that are lead or copper based), it is quick to corrode, and extremely light sensitive. A sulphide of arsenic, orpiment is highly poisonous and handling the mineral and pigment, in both natural and artificial forms, should be done infrequently to avoid its toxic effect and repulsive, noxious fumes.

Despite the exuberant colour it produces, orpiment's less amenable features detracted from its appeal and once alternative yellows were increasingly available by the end of the nineteenth century, it had largely been replaced.

RIGHT
Golden orpiment
with realgar
Photograph cobalt123

OPPOSITE
The Imperial Portrait of
the Chinese Emperor
Daoguang
c. eighteenth century
Courtesy Highshines

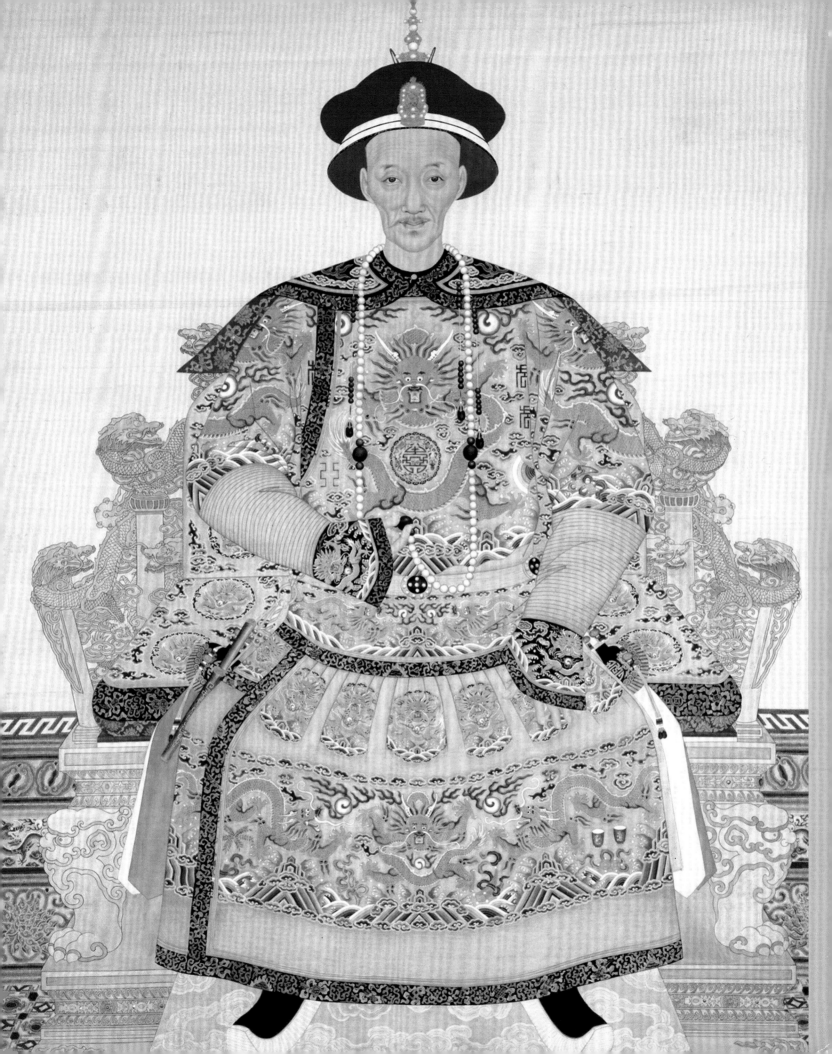

REALGAR

RIGHT
Getchell Mine Realgar2
Photograph jsj1771

OPPOSITE
Titian
Amor sacro y amor profano
(detail)
1514, oil on canvas,
118 x 279 cm

Realgar, derived from the Arabic for 'powder of the mine' (*rahj al ghar*) is a deep orange pigment created from a fiery mineral of the same name. Composed of translucent, ruby red crystals, realgar is both beautiful and dangerous in appearance—reflective of both the orange-red aurora pigment it produces and the pigment's extreme toxicity.

Realgar thrives in sites of hot natural water and is found commonly in springs and volcanic rock passages in Asia, North America and Europe, amongst other places. It usually develops in clusters amongst other minerals, including the similarly sinister orpiment. Found in the same deposits as orpiment (though usually in far smaller quantities), realgar shares many of its chemical characteristics. The 'Two Kings', as they are often known, were likely to have been traded together historically, implied by the various names realgar pigment has accumulated throughout the centuries, including 'red orpiment' and 'burnt orpiment'.

Besides their mutual toxicity, another trait common to both realgar and orpiment is the volatile nature of the pigments attained from them. As a substance to paint with, realgar is unstable, corrodes promptly and is uncooperative when combined with other pigments. As a mineral too, realgar is markedly changeable; on excessive exposure to light its surface degrades into pararealgar, an ill looking, pale yellow, powdery matter.

Used to a much lesser degree than orpiment, there are far fewer surviving examples of realgar's use in art throughout the ages, though distinguished examples include works by Titian. By the end of the eighteenth century realgar had fallen out of favour completely, with no examples of it postdating that time.

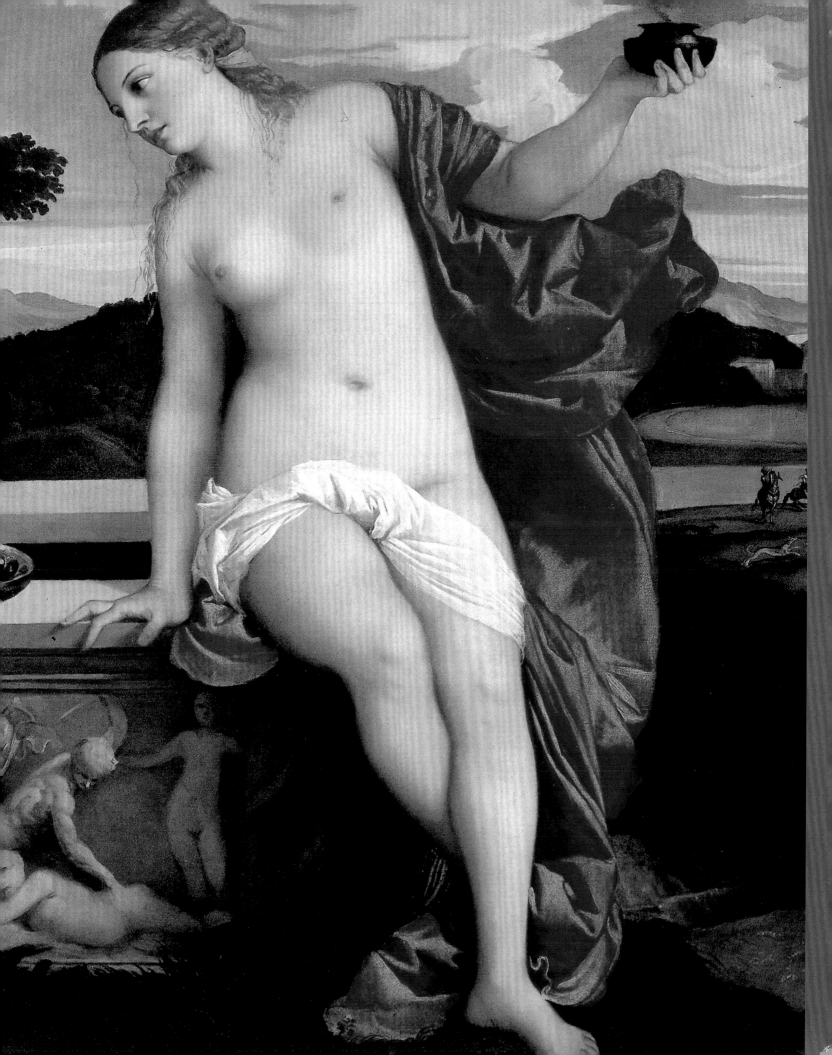

VERDIGRIS

The pigment verdigris is derived from copper acetate, the same patina which coats aged coins and copper roofs. Methods of artificially attaining verdigris are age old, though the ancient process remains virtually unchanged. Sheets of copper, suspended over a source of acetic acid, traditionally fermenting grape skins or casks of vinegar, soon gather delicate crystals along their surfaces. These first signs of copper acetate are then nurtured in a lengthy process of accelerating the copper's degeneration by intermittently pouring wine over the ripening green crystals. Once ground and mixed with water or oil-based substances, the pigment is ready to use.

The European name 'verdigris' originates from the Old French *verte grez*, (green of Greece), though its use was certainly not limited to one country, as testified by the German term for the pigment, *Grünspan*, (Spanish green). A version of verdigris named zangar, made with a recipe that used yoghurt instead of wine, was extensively used in Persian miniatures. For this purpose it was often mixed with saffron, which added brilliance to the green that was long lasting and very stable. Artworks featuring this pigment didn't suffer the otherwise corrosive effect of the organic acids present in unmixed verdigris—elsewhere it is known to have burned holes through parchment.

In addition to its caustic quality, verdigris has poor staying ability, and was notorious amongst artists throughout the ages for its ability to dull and blacken over time. In oil paint, and with the conscientious use of appropriate varnishes, verdigris becomes increasingly stable and, arguably, more powerful.

The intensity of its colour and the lack of better options—there were plant-derived pigments that illuminators and dyers could use to make green, but even these were often mixtures of blue and yellow—made verdigris one of the most used greens in Mediaeval, Renaissance and Baroque oil painting. Perhaps the most celebrated example of the use of verdigris in oil is the deep green dress worn by the young bride in Jan van Eyck's *The Arnolfini Marriage*, 1434. *The Arnolfini Marriage* is an example of the artist's mastery over the pigment, an ability to use it to such beautiful effect that it was often referred to as 'van Eyck green'. Little did van Eyck know that his skilful, diligent method of applying varnish to each layer of verdigris would maintain the colour so well that to this day the image remains as intensely vibrant as the moment he painted it.

RIGHT
Bronze Buddha Eyes
Courtesy Thor

OPPOSITE
Verdigris
Courtesy Longhairbroad

VERMILLION

Since antiquity vermillion has been highly prized for its royal hue. The naturally occurring mineral from which this pigment is obtained is cinnabar, a deep red ore of mercury, found in volcanic areas such as California in the United States, Guizhou Province in China, and the world's most prolific mercury mining location, Almadén in Spain.

Vermillion was one of the first pigments to be synthetically replicated. While cinnabar in its raw form was widely used in ancient art (particularly by the Romans), by the eighth century China was using mercury to produce the pigment artificially. More intense than earthy red ochres, the pigment was coveted for decorative pieces and soon became synonymous with the engraved lacquer-ware it coloured, which aptly acquired the name 'Chinese Red Lacquer'.

By the twelfth century methods of synthesising vermillion had made their way from the Orient to the West. In fact, so refined became the procedure throughout the centuries following that artificial vermillion was soon considered finer quality than that derived from pure cinnabar. Adapted somewhat, the process of subliming a mixture of mercury and sulphur is still used to this day.

In addition to its enhanced quality, synthetic vermillion is somewhat less hazardous to handle than pure, toxic cinnabar. Nonetheless, the substance remains highly dangerous on account of its mercury content and physical properties, with the tiny particles of powdered pigment being easily inhaled.

Among the numerous artists interested in vermillion and its uses was one of Britain's most notoriously colourful modern painters, JMW Turner. Naming many of his masterpieces after the pigment, Turner adored this rich red and repeatedly used it to create warmth in his paintings.

RIGHT
Cinnabar and dolomite

OPPOSITE
The gates of the Fushimi Irari Grand Shrine stretch up the mountain-side in a snake of vermillion
Photograph Kim Unertl

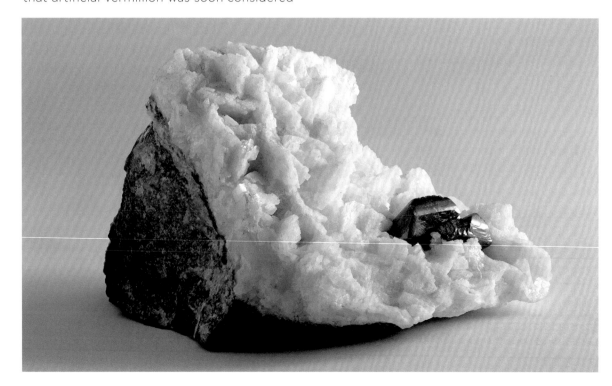

ULTRAMARINE

Ultramarine, a vivid, deep blue pigment, is derived from *lapis lazuli*, the complex composition of hauyne, sodalite, nosean and the mineral lazurite. Like the pigment it lends itself to, *lapis lazuli* is richly blue in colour, with specks of iron pyrite (fools gold) flecked throughout that give the stone an effect often compared to stars in the night sky.

Obtaining pigment from the mineral is an intricate and prolonged process during which the *lapis lazuli* is ground to a powder and combined with resin, wax, gum and linseed oil to form malleable dough, which is subsequently kneaded for the lengthy period of up to three days. The substance is then submerged in a bowl of lye solution and worked until the liquid is saturated with blue flakes, which sink, are separated, dry and result, finally, in a fine blue powder. This elaborate procedure can be repeated several times, each one producing a lower grade pigment, which is reflected in the price of the products and the demand for initial pressings.

This ancient, natural process produces inconsistently shaped crystals, structures which create a multidimensional, multi-reflective, and subsequently vibrant surface: an effect for which the pigment has been desired for thousands of years.

While ultramarine was used historically throughout the Middle East and Asia, the pigment did not reach Europe until the thirteenth century, when appropriate trade routes were finally constructed. Arriving from alien shores (its name literally means 'from beyond the sea'), ultramarine's exotic allure, in addition to its exuberant effect, rendered it incredibly desirable.

The pigment was also, however, remarkably expensive. In fact, the considerable process of mining and importing the stone, the lengthy, skilled method of withdrawing pigment from it, and the startlingly small amount of pigment attainable from large quantities of it, all contributed to ultramarine's worth at one

stage exceeding that of gold. Subsequently, ultramarine became the elite pigment of the era; with its rich appearance and high value, it soon became a precious entity. A colour of such superiority, and rarity, it was considered the only one worthy of adorning sacred subjects, and maintains an association with the Virgin Mother to this day.

By the sixteenth century, artists had started to be more experimental with ultramarine, no longer reserving it for the sanctified. Perhaps most notable to do so was Titian, who famously used the pigment in abounds for his 1523 portrayal of Bacchus and Ariadne.

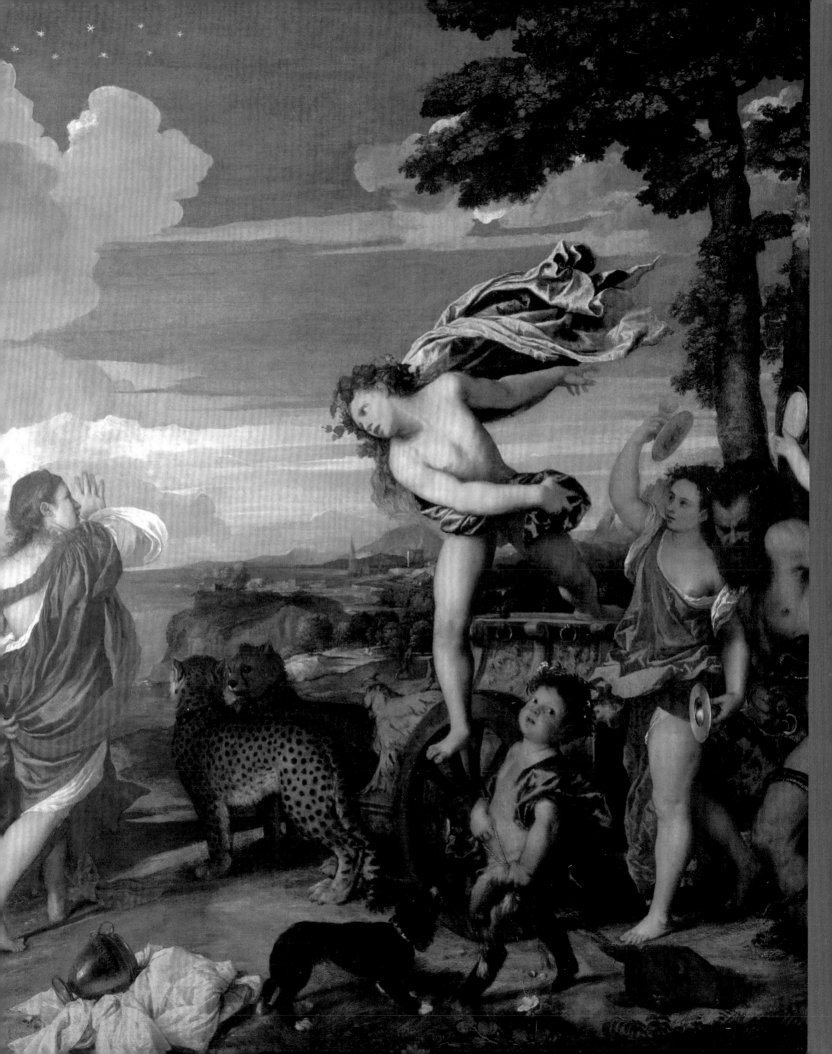

INDIGO

Indigo, a deep, inky blue—the colour of ripe blueberries and dark denim—is one of the most historically important colourants. Indigo dye is taken from a plant of the same name (or *Indigofera tinctoria*), a shrub of which various sub-species grow in diverse locations across the globe.

Pigment is obtained from the raw material in a lengthy process; after being dried out the leaves are rolled and crushed against volcanic rock. Powder derived from this process is then fermented in the juice of a cactus leaf for up to six months. When first removed from the juice the pigment is green and as malleable as clay. When left in the sun, however, it turns a deep blue—indigo. In the past, urine would also have been used in the fermenting process, its ammonia acting as a reducing agent and contributing to a stale stench by-product. Dying with indigo likely originates in India, as the colour's name implies (the word 'indigo' is probably a derivative of the Greek *indikon*, or 'from India'). Production of the dyestuff in the region dates from as far back as fourth century BC, when the use of vegetable dyes was already commonplace. Evidence suggests that indigo was also commonly used in Ancient Egypt and Mayan Mexico, but it was India that maintained a close relationship with the pigment.

By the mid 1600s indigo was being traded into Europe on a vast scale, providing direct competition for another natural blue dye: woad. Though many dyers found that combining both plant extracts provided the most successful, intense colour, indigo had overseen the demise of woad use by the end of the century.

Indigo's Indian history is not all success, however. Under the control of British colonial enterprise The East India Company, indigo production and export in India became corrupt and exploitative; Indian farmers faced pressure to abandon food cultivation in favour of indigo which was then often forcibly and unfairly purchased. The first demonstration of peaceful

disobedience led by Mahatma Gandhi, in 1917, was in support of indigo farmers.

Though the colour indigo is still abundant, it is rarely achieved with the natural plant process practiced for centuries, as successful artificial replacements were found in the development of synthetic colour production in the 1800s.

WOAD

Woad was the most important and lucrative blue dyestuff in Europe until indigo eventually arrived from Asia. Most commonly thought of as the blue paint smeared over the bodies of ancient Celtic warriors preparing for battle, this was perhaps, as Julius Caesar mused, a technique employed by the native Britons in order to appear fierce and threatening. The plant's antiseptic properties also render it the perfect accessory in a fight.

Derived from the plant of the same name (or *Isatis tinctoria*) from which one tonne of woad leaves is required to make a kilo of dye. This was perhaps the main cause of the high value of the Mediaeval woad industry and, eventually, its inability to contest with cheaper, and better quality indigo.

The procedure that turns cloth deep blue starts with the leaves, which are harvested and ground in a mill to a paste, then shaped into balls and put aside to dry until rock-hard. Broken up and left to ferment, the cakes are then ready for the dyer, who, in woad's heyday, would use urine to ferment them again, releasing an enormous amount of ammonia until they became fit for the dye vat. Cloths immersed in the strangely yellow liquid, turn green on their removal from the vat and contact with air, eventually evolving to a deep blue colour.

Native to the Caucasus region and Central Asia, the woad plant had already made its way all over Europe by the Neolithic period. Its story is intrinsically linked to many human histories: it is the blue of Egyptian mummies' cloth wrappings and European illuminated manuscripts; it is embroidered in the eleventh century *Bayeux Tapestry* (which narrates the Norman conquest of Britain) and woven into the late fifteenth century series of tapestries *The Hunt of the Unicorn*; it was worn by Scandinavian nobility in life and in their graves; and the famous green worn by Robin Hood and his merry men was achieved by mixing woad with the yellow dye plant weld. Towns such as Erfurt in Germany and Toulouse in France flourished thanks to the woad market, evidence being everywhere from cathedral porticoes and mansions to the names of local regions and universities.

By the 1930s, the main use of woad in Britain was as a component in the dyeing of police uniforms, though a synthetic blue replaced the natural substance in this process soon after. Reflective of a wider trend, the vast majority of blue dye is now achieved through synthetic means. However, with a current rejuvenated interest in natural colours and techniques, the production of woad is being revived as a sustainable source of blue not only for textiles, but a variety of materials including oils, inks and paints.

RIGHT
Isatis tinctoria
Photograph Matt Lavin

OPPOSITE
The Unicorn Dips His Horn into the Stream to Rid it of Poison (detail)
c. 1500, wool, silk, silver and gilt wefts, 394 x 379 cm

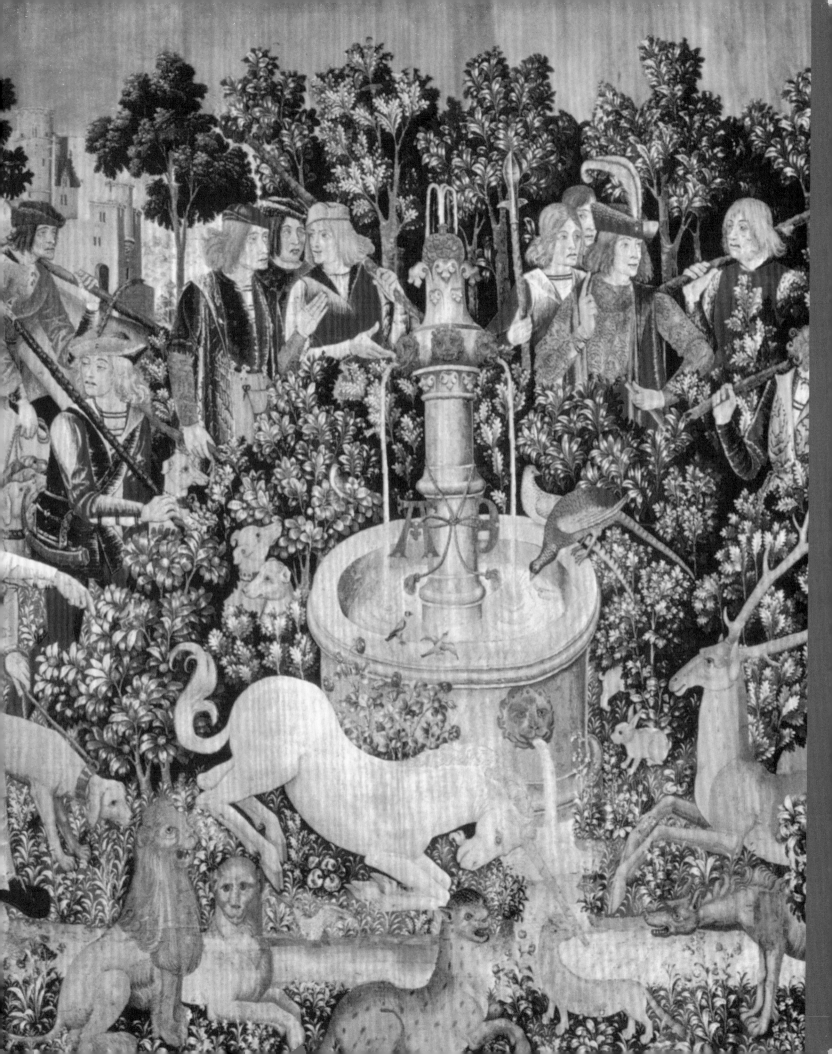

RECOVERING THE MEDIAEVAL PALETTE

MARK CLARKE

Dragons' blood, stones from the gates of heaven, Attic mud and the urine of a red-headed boy: all the physical materials which made up mediaeval paint. All the aesthetics, philosophy, psychology, and history of colour starts from looking at and enjoying physical objects. But with mediaeval art this is challenging, as much of the colour that would have dazzled a contemporary observer is now lost and, even when it survives, the colour observed today is not always the same colour as was originally chosen and applied.

In this chapter we shall see how the physical nature of these mediaeval colouring materials, and their behaviour during the intervening centuries since they were first applied, can frequently mislead us as to their creator's original intention; in particular how ancient paint has become lost, faded or discoloured through age. Then by considering the evidence for how mediaeval paint was made and used—the materials, mixtures, layers and mixtures—we shall begin to grasp how the surviving coloured artefacts must have looked when they were still pristine. This chapter thus aims to recover the lost materials of the mediaeval painter and illuminator.

THE LOSS OF MEDIAEVAL COLOUR

Paints, pigments and dyes can change their appearance.[1] They can change their colour, they can change their intensity and saturation, and they can disappear almost completely. Considering mediaeval colour, the vast majority of it has disappeared: clothes, wall-hangings, wall-paintings, enamels, jewellery, street signs, and scenery for pageants.

Often a significant
proportion of an artwork
is not original but is a later
replacement of lost material.
Areas only surviving as
modern retouching have
been blacked out.

Anon.
Annunciation
Fifteenth century, Flanders.
Shading by Hélène
Verougstraete.

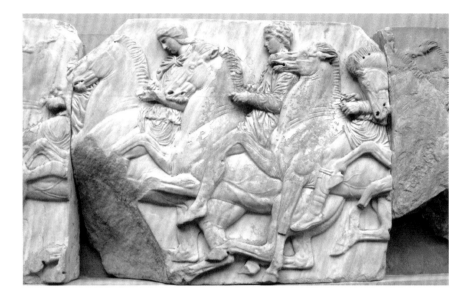

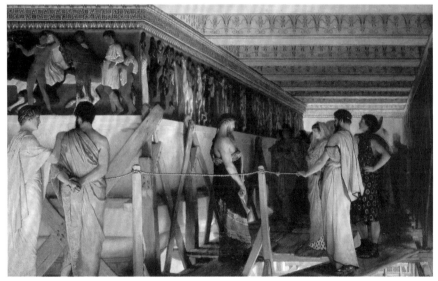

For most periods even 'fine art' paintings have not survived well, but
have required periodic restorations, including sometimes fairly radical
reconstruction of losses.

The majority of architectural colour is gone completely, murals and
polychrome sculptures having been over painted or scraped off.
Mediaeval canvas paintings (of which there would have been tens
of thousands) are lost but for a mutilated and faded handful.

Manuscript paintings, being preserved from the light and atmosphere
inside closed books have generally fared better, and it is from
miniature paintings, and the world they depict, that we get the most

vivid impression of the colourfulness of mediaeval decoration. But in some cases even robust mineral-based pigments have suffered; for example, as a consequence of pollution (e.g. from a sulphurous coal fire) certain red and white pigments can turn black (see *Æthelstan offering the volume to St Cuthbert* on p.51). For the delicate organic pigments (those made from plants and insects) the situation can be far worse, often with colours having faded to an unrecognisable extent.

Ignorance of these alterations results in serious errors. Interpretations of the iconography and symbolism of colour, or deductions concerning the appreciation and comprehension of colour by mediaeval artists and their contemporary audiences, or attempts to understand the stylistic use of colour by individuals, ateliers or movements, cannot be correct if the colours that the interpretations are based on are not those that were originally intended. Clearly all theorising must be preceded by the evaluation of the original appearance, and that is best carried out by an evaluation of the likely original material composition. One of the great pleasures of the study of 'Technical Art History'—the study of works of art as physical objects—is coming to understand the magnificent and often jewel-like colours that were used since Antiquity, and coming to appreciate just how dramatic the pristine works would have been.

COLOURS VERSUS COLOURANTS

Analytical thinking about colour (whether by an art historian or a chemist) must begin with an appreciation of the difference between a colour and a colourant, that is, between a colour and the colouring material that produces that colour. To talk of 'pigments' or 'dyes' (the principal colourant families used in artworks) is to talk of physical materials, and to talk of 'colours' is to talk of a property of those materials.

Colourants and colours do not by any means have a one-to-one correspondence: any given colour can be made in a variety of ways. For example, any one colourant may produce more than one colour, depending on its preparation method.

More importantly for our purposes here, a specific colour can be made by more than one pigment or one combination of pigments. For example, the plant yellow 'weld' (*Reseda luteola*) and the artificial pigment lead-tin yellow have identical colours.

MIXTURES AND IMITATIONS

Any one colour may also be made from many different mixtures of pigments. From c. 300 AD onwards treatises survive recording hundreds of recipes for imitating expensive colours such as ultramarine. These substitutes can be completely convincing to the eye. For example, it has often been asserted that the appallingly expensive Tyrian purple

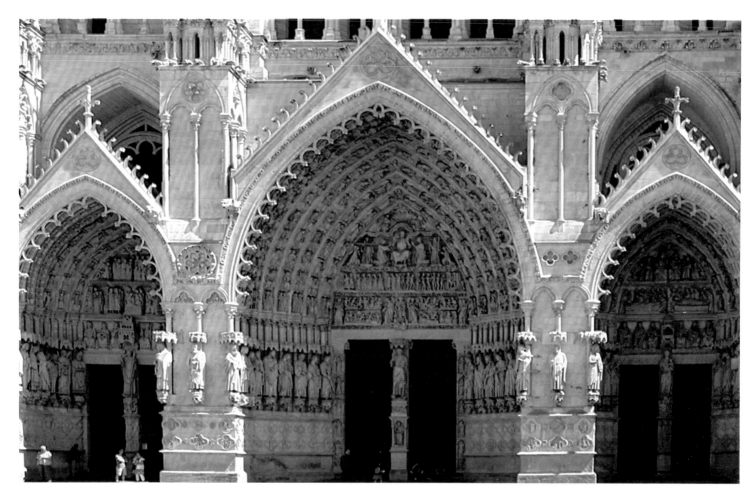

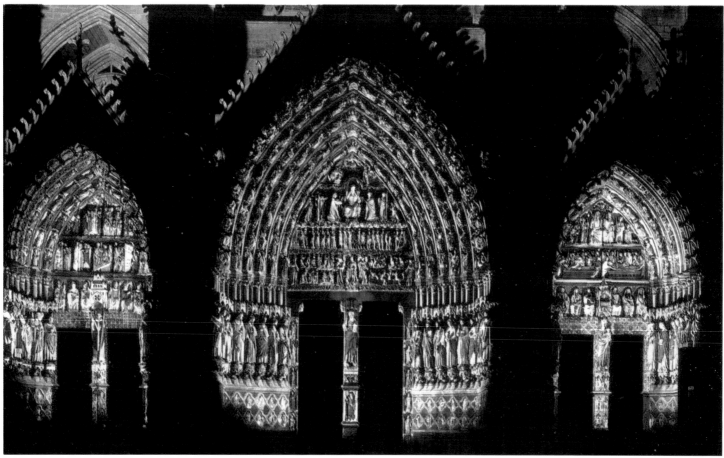

(derived from shellfish) was used to dye parchment pages, but analysis indicates this is extremely rare compared to purples made from other ingredients and from mixtures. Similarly, mediaeval recipes explain how red brazilwood could be added to blue azurite to imitate the more purple hue of the more costly pigment ultramarine. Other recipes describe manufacture of a tin-based compound called 'mosaic gold', which contains no gold but can look remarkably like it.

There were various mediaeval attitudes to substitution and imitation. One attitude was that to use valuable materials was desirable in itself. The use of gold, precious stones, and ultramarine to highlight iconographically important elements in a picture is well-known. Another example is the choice of mosaic gold or real gold, or ivory black (an expensive pigment) or bone black (indistinguishable and inexpensive). Alternatively, skill could be considered as more important than the use of expensive materials. A preference for skill and final appearance over cash-value is one reason for the popularity of imitations and substitutes.[2] The twelfth century technical author Theophilus seems to have favoured this attitude when he warned not to disparage any thing "just because your native soil has spontaneously and unexpectedly produced it for you" and asked why one would "despise these as cheap local products and travel over land and sea to procure foreign ones that are no better and are perhaps of less value". These attitudes created reasons to choose one material over another, given otherwise similar colours and working properties. These attitudes would have been present in different proportions in different individuals.[3] Consequently, sometimes an artist might have chosen to use a genuine expensive material, whereas an imitation may have been considered appropriate for a different object or by a different artist. That sometimes there were genuine expensive materials used, and sometimes not, is in itself interesting. The use of intrinsically expensive materials is an important indicator of the attitude of the artist and the patron to a book. And yet to the naked eye it is not always clear. Indeed, the difference cannot be detected using colour-measuring instruments, so good are the imitations. To determine these mixtures and imitations, other techniques of chemical analysis are required, often requiring micro-sampling to be performed. But this sampling and analysis returns a good yield of information in return for an amount of damage that cannot be detected by the naked eye. Firstly, it can detect traces of a now-discoloured or now-faded pigment, such that the original appearance may be deduced. Secondly, when chemical analysis can discern between expensive and inexpensive materials this is helpful in indicating which attitude or attitudes applied to which objects or to which periods, regions, artists or patrons.

SOPHISTICATION OF THE PALETTE

Of course there are other reasons to use pigment mixtures, not just to imitate precious materials. Not all colours can be obtained from a

OPPOSITE
Similarly almost no mediaeval architectural polychromy has survived; a mediaeval church or cathedral, for example, would have been almost entirely painted inside, with important external elements also being coloured.

TOP
Amiens Cathedral, West Front, thirteenth century, France, present appearance (detail)
Copyright Mark Clarke

BOTTOM
Polychromy reconstructed by light projection
Copyright Mark Clarke

single pure natural material. Until very recently there was, for example, a great shortage of green pigments. For symbolic or diagrammatic work this was not problematic, since a face or a landscape could be adequately modelled with one or two crude colours, but for more sophisticated work, or to be more realistically representational, the shortage of subtle colours was a problem. The problem was overcome in two ways.

The first method used to increase the range of available colours was mixing pigments. It is frequently stated that mediaeval artists, having made such efforts to obtain pure colouring materials, did not want to adulterate them, and that in consequence they did not mix pigments. This is simply not true. Mediaeval artists' recipe books contain thousands of prescriptions for mixtures, and chemical analyses have shown a great variety of mixed pigments, notably those mixed to produce greens. Another solution was layering, where a thin or transparent layer of one colour was used on top to modify another. These combinations allow for more sophisticated or more representational art, and indeed, around the 'Eyckian turning point', c. 1420, we find more and more mixtures and transparent over-layers. Such layering is found not only in panel painting or in oil painting but also in manuscripts.

The second method of increasing the gamut of available colours was to harness the colours of plants. There are many recipes based on plant extracts, either to make lake pigments, or simply to colour white pigments with the juices: "Take yellow flowers, and grind, and express the juice, and temper white lead with this juice, and dry. And temper it again, and dry, and repeat thus a third time." These flower extracts are often specified to be for use *in carta*, i.e. on paper or parchment. However, even in a relatively well-protected environment as a closed book, organic pigments based on plant material are very prone to change colour and fade. For example, the image on pp. 52–53 shows a page from *The Bury Bible*, a de luxe manuscript. The rubric is composed of primary colours, but compared with the other colours the yellow is dull, weak, and translucent. Here, surely we can infer that this buff or yellow-brown colour must originally have been intended to be a strong colour as well, most probably a bright yellow imitating gold. A digital reconstruction of the page based on this assumption produces a more dramatic effect with a more plausible contrast of colours. When analysis demonstrates the use of local products, plants or minerals, this itself becomes a useful tool for establishing provenance.

Knowing this provides a powerful tool for the study of art. It has been shown repeatedly by physical and chemical analysis that specific colours were made in different ways by different artists or ateliers, and in different regions and periods. Identifying colourants can thus help clarify provenance and authorship. A knowledge of materials derived

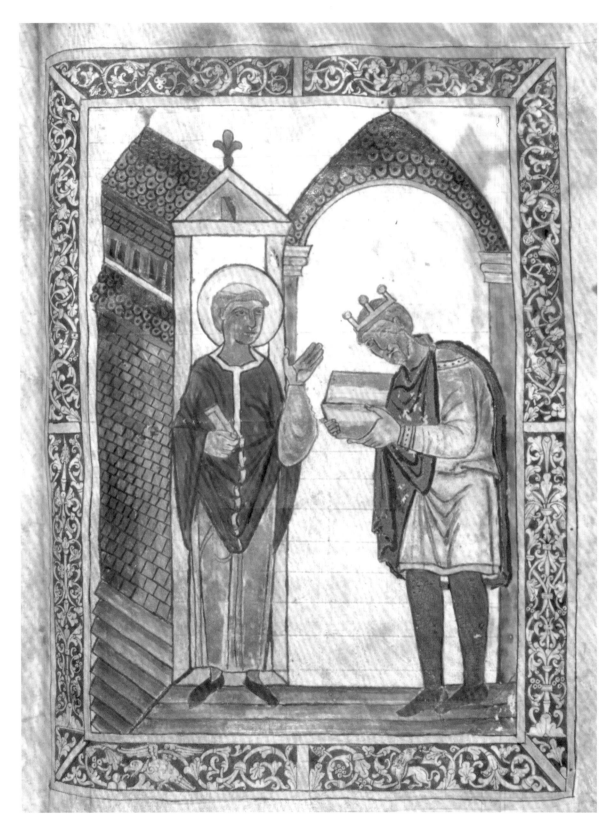

Blackening of white and red pigments.

Æthelstan offering the volume to St Cuthbert
Ninth century, England, Corpus Christi College, Cambridge
Copyright The Master and Fellows of Corpus Christi College, Cambridge

OPPOSITE
Digital reconstruction
of *The Bury Bible*,
showing original colours

Paints and inks made from
plant colourants do not
always survive well, but
fade. In this twelfth century
manuscript what is today a
muddy pale brown (above)
would originally have been a
golden yellow, as bright and
saturated as the red, green
and blue (opposite).

from chemical analysis is therefore not only interesting to a scientist
or a conservator/restorer, but also to a historian, and can inform our
understanding far more profoundly than a simple examination of colour
ever can.

Another important consequence of all the above is that any attempt to
identify pigments or dyes by eye is doomed to failure, partly because
of the absence of a one-to-one correspondence, and partly because
colours may degrade beyond recognition with age.

TOOLS FOR EVALUATING LOSSES AND RECONSTRUCTING ORIGINAL APPEARANCE

Visual examination can reveal areas of fading or discolouration, but very
frequently it is not obvious from iconography or visual harmony alone
that a colour change has in fact taken place, and indeed in some cases
it is not obvious that an area was coloured at all. Technical art history
offers three interdependent methods to evaluate how art originally
looked: technical examination of surviving artefacts, contemporary
written sources, and historically informed reconstructions.

As early as the nineteenth century, close examination of Classical
sculptures uncovered tiny paint fragments. Although meeting with
considerable resistance from aesthetes, it became increasingly

apparent that all that 'pure', 'classically' white statuary had originally been polychrome: in a way that to the *soi-disant* 'classically trained' eye was shockingly garish. Similar investigations of mediaeval sculpture (notably the elaborate doors of cathedrals) revealed similar paint traces, permitting similar reconstructions. Today chemistry and physics have provided us with powerful analytical tools allowing us to determine what materials are present in an artwork, even though those materials may now be almost completely discoloured or lost. Identifying these damaged traces, which are often unrecognisable as the familiarly coloured paints that they began as, we can piece together the probable original undegraded appearance.

One of the most important sources of information we have about the manufacture of early artists' materials at different periods is contemporary written 'recipe books', of which hundreds survive. Coherent extended treatises such as those attributed to Theophilus and Cennini, are very much the minority, and the vast majority are anonymous collections of short recipes. Mediaeval artists' recipe texts consist mainly of instructions for the manufacture of materials: pigments, inks and painting media. Some also describe the preparation of supports, such as panel assembly and priming, or parchment manufacture. Recipes particularly concentrate on preparation of paints and inks starting from the raw materials, including the selection and testing of materials, refining, grinding, and mixing of pure materials,

and the manufacture of synthetic materials and compounds such as ink, verdigris and white lead.

The earliest technical recipes that survive are Mesopotamian Assyrian cuneiform texts, c. 1700 BC, that describe dyes, ceramic glazes, coloured glass and imitation gems. These are followed by a long gap until two Egyptian *papyri*, written in Greek, from c. 300 AD, the *Stockholm Papyrus* and the *Leiden Papyrus X*, which mainly deal with the imitation of precious and sumptuary materials, that is the 'improvement' and imitation of gold, silver, Tyrian purple dye, and gems. This long gap was punctuated by references to artists' materials by Classical authors such as Pliny but these are not true recipes, nor (with the exception of Vitruvius) were their authors practising craftsmen. Then, from c. 800 AD to the present, the repertoire of craft recipes is unbroken.

While chemical analysis can be very helpful, in some cases material characterisation is not possible with currently available techniques, and in these cases the technical texts can provide clues. For example, the faded yellow in *The Bury Bible* cannot at present be analysed chemically, but from contemporary recipes we can hypothesise that it was originally made from the plants weld, saffron or safflower.

It is unclear how much durability of pigments was understood by mediaeval craftsmen. One widely circulated set of recipes (*De coloribus et mixtionibus*, "On colours and their mixtures") warns that certain pigments are chemically incompatible and will discolour each other if mixed, and other recipes specify that some pigments (notably organic ones) were suitable for manuscripts but not suitable for other supports (such as panels and walls) where they would be vulnerable to light, touch, and unclean air. It is not clear how soon after painting colour loss occurred, nor to what extent it was noticed or repaired. Certainly financial documents do record mediaeval restorations of wall and panel paintings, and even manuscripts.

PUTTING IT ALL TOGETHER: MEDIAEVAL COLOURANTS

Assembling evidence from both sources (technical analysis of objects and contemporary recipe books) it is possible to come up with a fairly comprehensive and plausible overview of the mediaeval painter and illuminator's palette. This evidence may be tested and explored by means of historically informed reconstructions.

Artificial pigments have been made for thousands of years, using minerals, metals, plants, shellfish and insects as raw materials. The development of new pigments did not always come from within the painterly community. Painting was only one use of these coloured materials. Pigments were also used for colouring ceramics, for cosmetics,

Reconstruction of saffron illuminator's paint. Reconstruction and photographs Nabil Ali

(as lead white and even arsenic were used until the eighteenth century) and even for cooking (lead white was used to sweeten Roman wine). Refinement and new development was needed for these other uses, and the painters benefited. Some of the new synthetic pigments were by-products of other industries or crafts, for example Egyptian blue (a by-product of glass craft) and lead antimonate yellow (of ceramic craft). Our knowledge of the dates of introduction of most pigments is very approximate, but the tendency is that new materials supplement old ones, and old ones continue to be used. Exceptions are the Egyptian manufactured pigments, Egyptian blue, which apparently disappeared forever, shortly after the collapse of the Roman Empire, the classical shellfish dye Tyrian purple, which apparently disappeared after the fall of Byzantium in 1453, and lead antimonate yellow which disappeared and reappeared later as Naples yellow.

Palaeolithic man was already modifying natural materials to make pigments at least 10,000 years ago, heating ochres to produce a different colour. The Egyptians introduced some new materials, notably the crushed mineral colours natural red cinnabar, the two related pigments natural orpiment (yellow) and natural realgar (red), and the two copper carbonates malachite (green) and azurite (blue). They also innovated the use of two corrosion products, lead white and verdigris, deliberately manufactured by suspending strips of metal over vinegar in sealed pots.

The Egyptian palette also contained the first truly new synthetic pigments (rather than copies, modifications or refinements of naturally occurring materials): blue frit (copper-containing ground glass from c. 2500 BC), lead antimonate yellow (from c. 1600 BC), white gypsum, and later (in the Ptolemaic period) madder lake pigments.

The Classical palette added dragonsblood (a red plant resin), minium (red lead), terre verte, yellow plant lakes, kermes insect pigments and dyes, some form of madder red lake, and Tyrian purple. It is in the late Classical and early Mediaeval times that synthetic versions of natural products began to be made: orpiment, minium, and cinnabar/vermillion. Often the starting point was the natural product, but the resulting pigment had colours that were more pure and intense than the natural products. This manufacture of man-made inorganic pigments continued through the Mediaeval period, and to the present

Reconstruction of oil glaze
(brazilwood)
Copyright Leslie Carlyle
and Mark Clarke

Organic lake pigments
(pigments made from
coloured plant extracts)
become translucent in the
oil medium. Transparent
coloured glazes could thus
be layered on, which allowed
a far greater subtlety of
modelling for flesh and
drapery than is possible
with opaque paints alone.

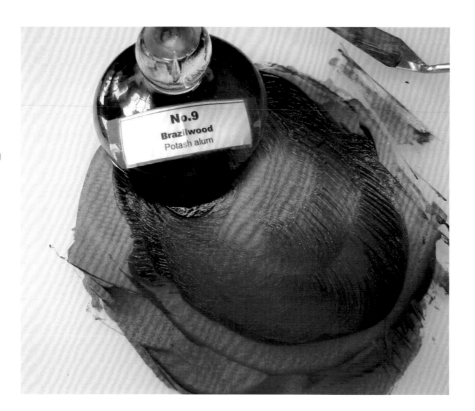

day. It is especially these that Cennino refers to as *"fatto d'archimia"*
(made by 'alchemy', i.e. by synthetic chemistry).

While known to the Egyptians and Romans as a stone, ultramarine was
not apparently used by them as a pigment, but it was the mediaeval
blue pigment *par excellence*, first identified in northern European paint
c. 1000 AD. It was more expensive than gold, since it required complex
purification, and because the main or even the only source exploited
in the Middle Ages was in Afghanistan. Further Mediaeval innovations
included bone white, the widely-used import brazil (red dye from an
Indian wood), and the blue ultramarine. It is also in the mediaeval
period that we see the expansion in the use of lake pigments.

The most important mediaeval lakes were the plant-dye lakes madder
red, weld yellow and brazilwood red, and lakes made from the
red dyes obtained from insects: kermes, carmine, and lac. Another
mediaeval innovation for illuminators was the 'clothlet' colour: pieces
of rag dipped in the coloured juice of various plants. When they were
required for use, a piece was put into a shell, and a little painting
medium was poured over it; then it was stirred about until the colour
was discharged. Dyes and stains were also used early on for painting,
as were clothlets. Coloured plant material could be placed directly
into the medium, and allowed to stain it.

Indigo (from woad or from imported indigo) may have been used, perhaps ground as a pigment or as a lake. The red resin dragonsblood was also known and apparently used. Recently it has been confirmed that—very rarely—the classical 'Tyrian' or 'Imperial' purple dye (extracted from various species of shellfish) was used in manuscript painting.

CONCLUSIONS

Mediaeval innovations in pigments formed an important legacy, continuing in use until nineteenth century synthetic chemistry displaced them (see "Rainbow Wars" by Philip Ball, p. 126), although in fact many still continued in use in some form until today.

It seems, from inspection and chemical analysis of the surviving traces of colour, and from contemporary recipes, that there was a far more extensive use of vivid colours in mediaeval art and architecture than is now visibly apparent. Some instances of discolouration are evident, but in other cases (for example with pigments and dyes produced from organic materials such as plants, insects, and shellfish), changes and losses are severe but not at all self-evident. Clearly we can all benefit from an awareness of these possible colour alterations.

1. A pigment is the part of the paint that gives it its colour. Strictly speaking a pigment is a finely divided particle, which is insoluble in the paint medium, as opposed to a dye or stain, which is soluble in the medium, but for convenience when talking about paint we may call them both pigments.

2. We might consider a third attitude: the symbolic, magical, and spiritual value. In jewelled objects one stone would certainly be chosen over another for its symbolic value, according to the lapidary texts. I have, however, found no evidence that such values were ever attributed to pigments.

3. One might contrast for example Suger with Bernard of Clairvaux.

PREPARING NATURAL PIGMENTS

MASTER PIGMENTS

Master Pigments is a web-based business that prepares and sells high-quality, traditional artists' pigments, expertly prepared from natural minerals in authentic processes of purification and refinement.

Inspired by the work of the old masters, the company was founded following experiments to recapture an enticing surface effect lost by modern synthetic paints. Particles of organic pigments, attained by crushing and grinding minerals, are idiosyncratic in size and shape, creating a multifaceted, multi-layered surface through which light travels and reflects in a number of directions as a lively, vibrant surface. In contrast, inorganic pigments, made up of physically similar particles— the result of the uniform chemical reaction that created them— create a flat, solid layer with comparatively little transparency.

Master Pigments' founder and pigment creator, Attila Gazo, began his venture into preparing pigments with a crude trial of repeatedly washing crushed malachite in clean water, until, after air-drying, he had seven distinctly different pure green shades, from grassy to mint. Using illustrious historical literature and his own interpretations, as well as expending a great amount of time crushing, washing, sieving, grinding and drying powders, Gazo soon progressed to extracting azurite and *lapis lazuli*, eventually perfecting his premier colour, Fra Angelica blue, and finally acquiring a repertoire of successful distilling techniques substantial enough to start the business.

Since its inception, Master Pigments has seen an increase in the number of artists returning to homemade paint. In addition to the exuberant end results and a deeper familiarity with the material and its colour properties than self-making paint allows the artist, it also gives them the opportunity to engage in an authentic, centuries old painterly custom.

Clean pigment emerges
in the azurite purification
process.

Courtesy Attila Gazo,
Master Pigments

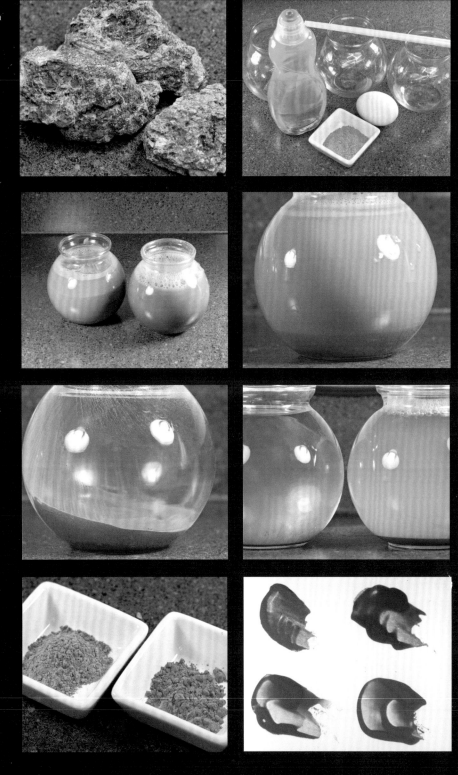

An array of natural azurite pigments are extracted with an egg yolk and household detergent.

Courtesy Attila Gazo, Master Pigments

CLEANING AZURITE

Varieties of pristine blue, obtained in the purification of azurite, are amongst Master Pigments' favoured products. The following method is used to cleanse azurite, a mineral sometimes tainted with natural impurities which give it a muddy hue when ground, to gather a range of clean blue pigments.

Firstly, powdered azurite is combined with water in a glass jar, to which an egg yolk, dissolved in water, is also added. A dirty foam materialises on the surface, and the solution is left to sit for a few minutes, until distinct layers appear.

The mixture is then poured out into a second jar; smaller particles, still floating in the water, are poured out with it, but a blue residue remains in Jar One, to which fresh water is added, stirred and left again to settle. Meanwhile, the mixture in Jar Two settles, and again distinct layers materialise. The solution is then tipped into a third, final jar, again taking with it the finest particles, and again to this water is added.

Each of the three jars then go through a process of cleansing with fresh water; once the pigment has descended to the bottom of the jar, the newly dirty water is poured away (care being taken now not to discard the floating pigment particles), it is topped up with fresh water and left once more to settle. This is repeated until the water remains clean throughout the process.

Next, simple household, non-foaming detergent is used to degrease the pigment, cleansing it of the fatty egg yolk. Once the last of the clean water is poured away, leaving pigment deposits at the base of each jar, a drop of detergent is added and, after mixing with more fresh water, its cleansing effect is immediately evident; particles swirl freely and the water is more saturated with dirt.

Each jar is put through another repetitive process of topping up, mixing, settling and pouring until again the water pours away clear of dirty particles, after which it is finally left to air dry, and three pure variations of azurite pigment result.

SEIZURE

ROGER HIORNS

Roger Hiorns
Seizure
2008
An Artangel/Jerwood
Commission
Harper Road, London
Photography Marcus
Leith, London
Courtesy Corvi-Mora,
London

Artist Roger Hiorns engaged with colour to spectacular effect in his Turner Prize nominated piece *Seizure*, 2008. The artwork, commissioned by Artangel and the Jerwood Charitable Trust, was an ambitious installation and radical experiment in art and chemistry, in which a derelict south London council flat was transformed into an awe-inspiring crystalline cavern.

The prolonged alchemical process—it took approximately a year to realise—began with pouring 75,000 litres of copper sulphate solution into the reinforced flat through an opening in the ceiling, until every internal surface was covered with the substance. It was then left for several weeks; time enough for the chemical formula to solidify into flourishing copper sulphate crystals.

Once excess liquid was drained away, the luminous result was revealed: the flat had been mineralised—seized—by the material, its interior encrusted with exuberant, translucent blue crystals which jutted out from ever floor, wall and ceiling surface. Glinting little shards even engulfed the bathroom fittings, though a recognisable bath shape remained, outlined with sharp blue flakes.

Copper sulphate is a blue compound with a similar chemical makeup to azurite, the intricately crystallised blue mineral from which the artists' pigment of the same name is obtained. Like its organic counterpart, the copper sulphate of Hiorns' piece displays a range of tone, the intensity of colour incrementally increasing with crystal size—the smallest buds, underfoot, are a fair sky blue, while the largest shards blossom into glassy cerulean blue.

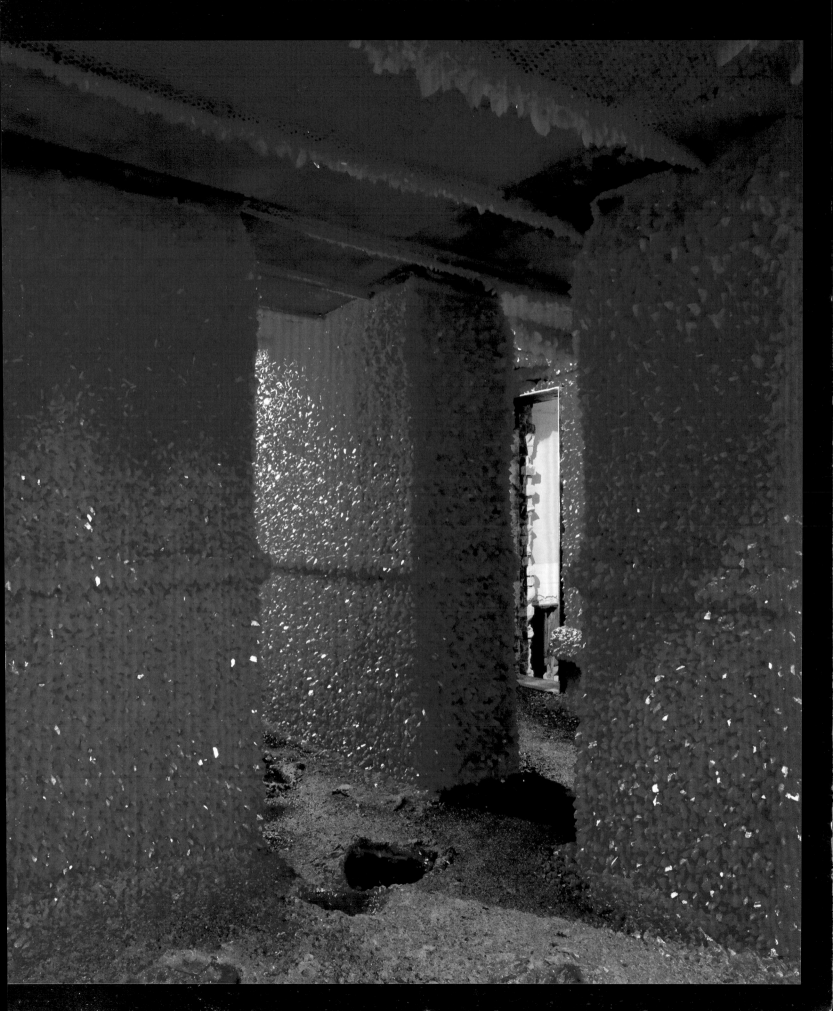

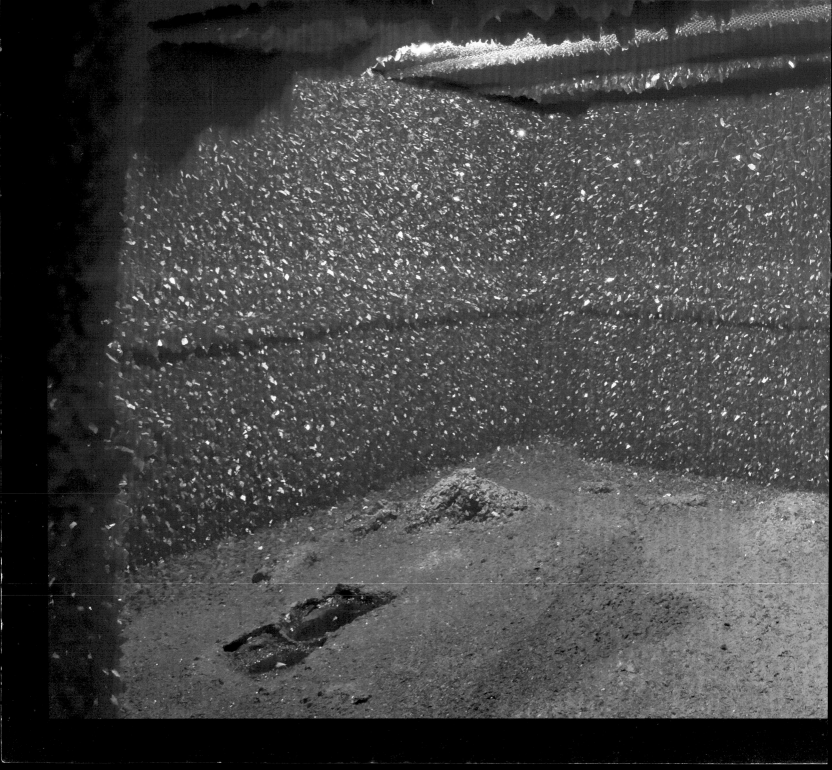

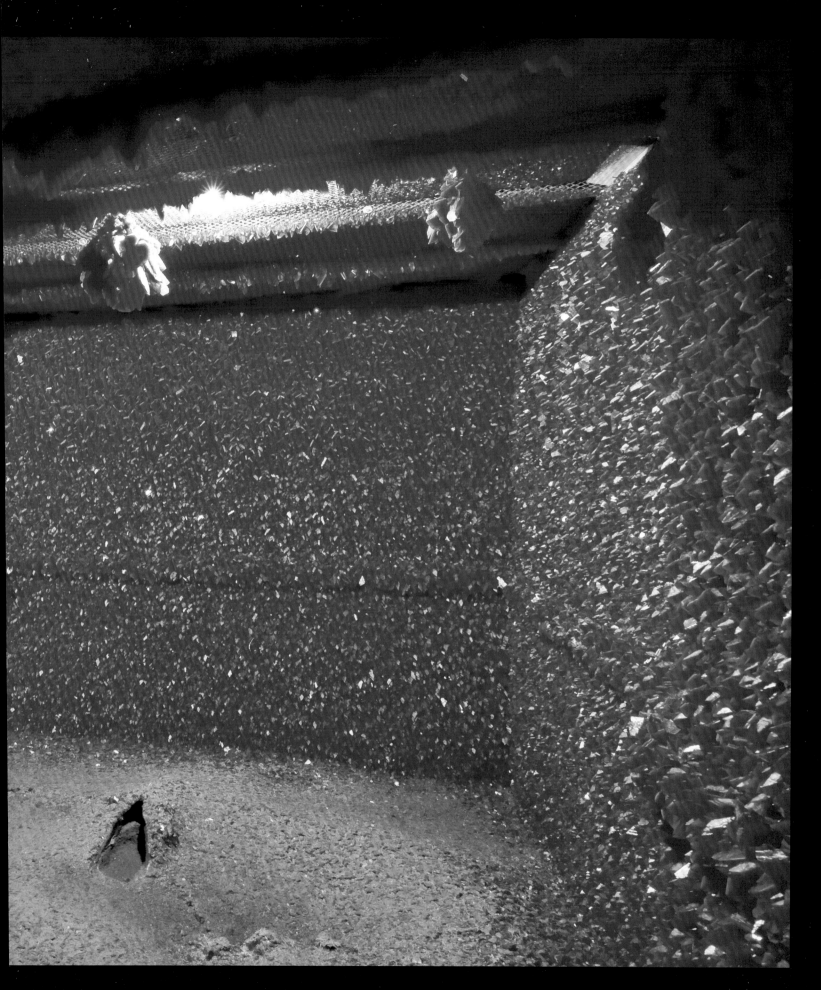

POST-NEWTONIAN COLOUR —COLOUR PERCEPTION

COLOUR THEORIES

The experience of colour makers, from the early alchemists to contemporary craftsmen and colour chemists, is vastly at odds with the colour experience of those who study colour as a property of light. A rudimentary science lesson will tell you that pigments do not behave as light does. Mixing primary colours of paints tends to produce a darkish grey, depending on the shade of primary used, whereas the combination of red, green and blue light (the light primaries) will produce a white light. The sludgy browns and greys produced by any novice painter when first attempting to mix colours are testament to the skillful art that colour mixing requires. Over the centuries since Aristotle's first hypotheses about colour, and notably since Newton's seminal *Opticks*, the development of colour theory has aided and furthered the craft and science of making colour, and those who develop and manufacture pigments and create printers could not do so to the degree of accuracy required for contemporary image reproduction were it not for the numerous in-depth and detailed theories of colour, particularly developed since Newton (some of which are discussed over the following pages). Any discussion of the materials of colour would be lacking without the important understanding of how the materials of colour have been understood, theorised and organised.

One of the problems with creating a book about colour is that colour itself is hard to describe; it is complicated when put to words because doing so reveals the writer's own cultural biases and preconceptions and it is then further confused by the different customs and languages that might be employed to understand it. Colour is also used across so many fields of art, design and science that each field of practitioner has their own language with which to discuss its properties, and many have developed whole models with which to understand how colour functions. Painters have the colour wheel, graphic designers have automated Pantone® conversion matching systems and the latest Photoshop colour gradients, and physicists have in-depth models of the spectrum as represented in Wave Theory. A painter's understanding might be nuanced, learnt by feel and eye; a colour scientist's might be more systematic and structured. Both will talk about colour differently, and grade colours in potentially opposing ways, depending on

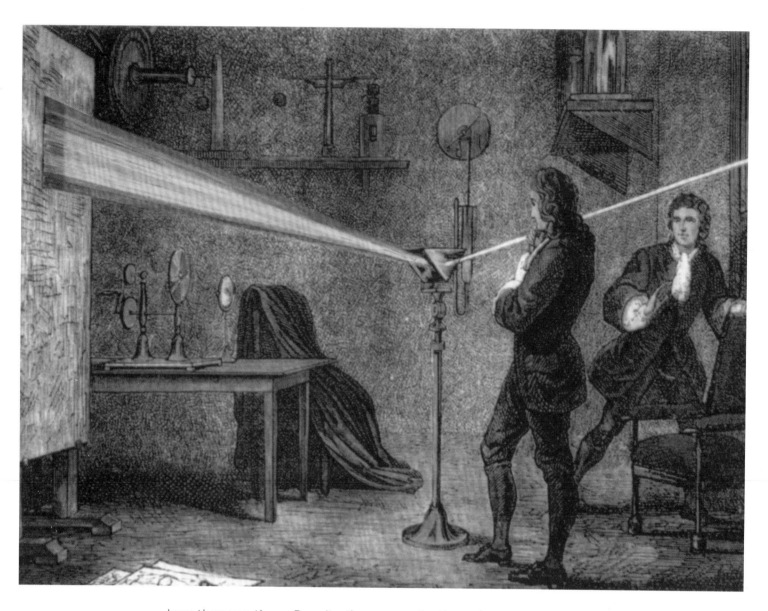

how they use them. Despite these complications there are some unifying principles, based in physics and explained through the properties of light. To understand these it is important to understand that all colour is the result of our own perception of it, and that we perceive colour in the form of electromagnetic waves.

WAVE THEORY

Wave Theory is the scientific theory that everything in the universe is made up of vibrations or waves. The phenomenon we call 'light' is determined by a bracket of those vibrations or wavelengths which are below the level that the human eye can detect. Our visual perceptual range is only between 0.00038 and 0.00075 millimetres of wavelengths, but within that range we can distinguish about ten million variations of colours. The full spectrum of visible light is read as 'white', but when some of the wavelengths are missing—absorbed by the object they are reflected from—they are seen as 'coloured'. Colour as perceived by humans is, in

PREVIOUS PAGE
Louis Hayet
Colour circle

ABOVE
Isaac Newton's
prism experiment
Unknown artist
1874, coloured engraving

Isaac Newton
Colour circle from
Opticks
1704

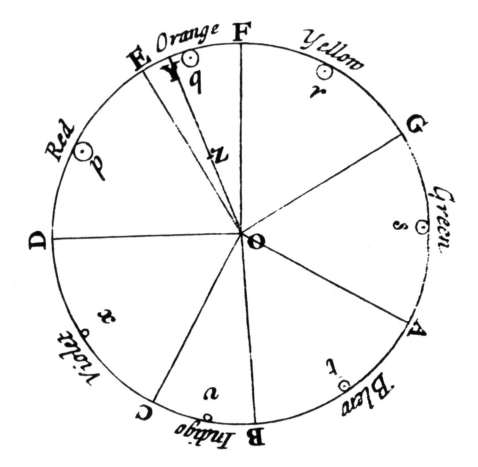

actuality, the result of the physical reception of altered wavelengths on the retina. With the colour known as 'red', for example, what we are seeing is in fact a result of a small section of the electromagnetic spectrum where other wavelengths are absent. A red object, perhaps a clump of cinnabar, absorbs all light except that with a wavelength of around 0.0007 millimetres, which is reflected and received by our retinas. However, we also only know that it is red because we have culturally learned this fact. Our brains inform us of the colour and immediately attach cultural meaning to it. It is therefore difficult to make a distinction between the physical process of perception and our cognitive understanding of colour—the way in which we define and represent a colour in relation to another is socially, culturally and linguistically constructed. Even with the most sophisticated colour models and theory, your understanding of colour is yours alone. In short, colour perception is not an objective phenomenon, no matter how sophisticated our models have become.

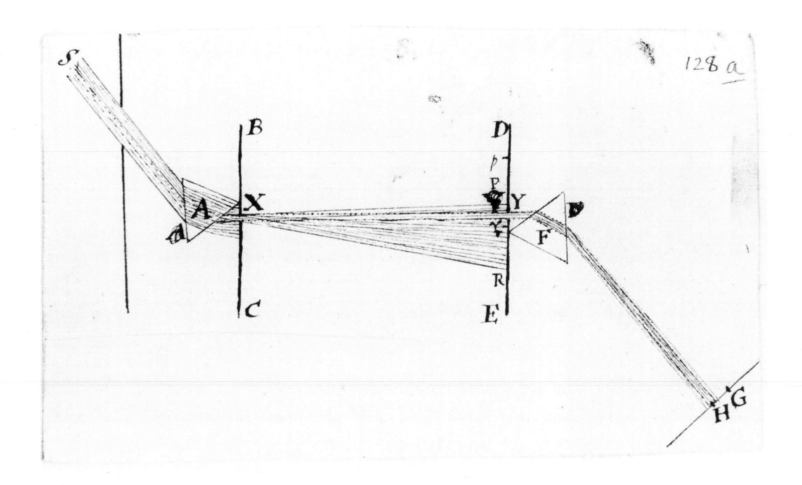

NEWTON'S OPTICKS

How we see colour at all was a problem that remained unsolved until the proposal of Wave Theory in the late nineteenth century, the development of which was built on Newton's observations. The Ancient Greeks, most notably Aristotle, understood colour to be the result of the sun's passage through or reflection from an object. Aristotle noticed that light faded or was less intense after an interaction with an object, and therefore deduced that colour as a phenomenon was the property of an object. It was not until Isaac Newton published his study of light, *Opticks*, in 1704, that this notion was finally overturned. Newton's discovery that light rays could be bent using a prism to produce a spectrum—the seven colours of which he identified as violet, indigo, blue, green, yellow, orange and red—visually demonstrated that colour was a property of light, not of an object, and that our perception of it was the result of an object disturbing that light. The main and instrumental break that Newton's theory made

Diagram of a ray of light divided into the primary colours by a prism and then white light by another prism.
Isaac Newton
1662

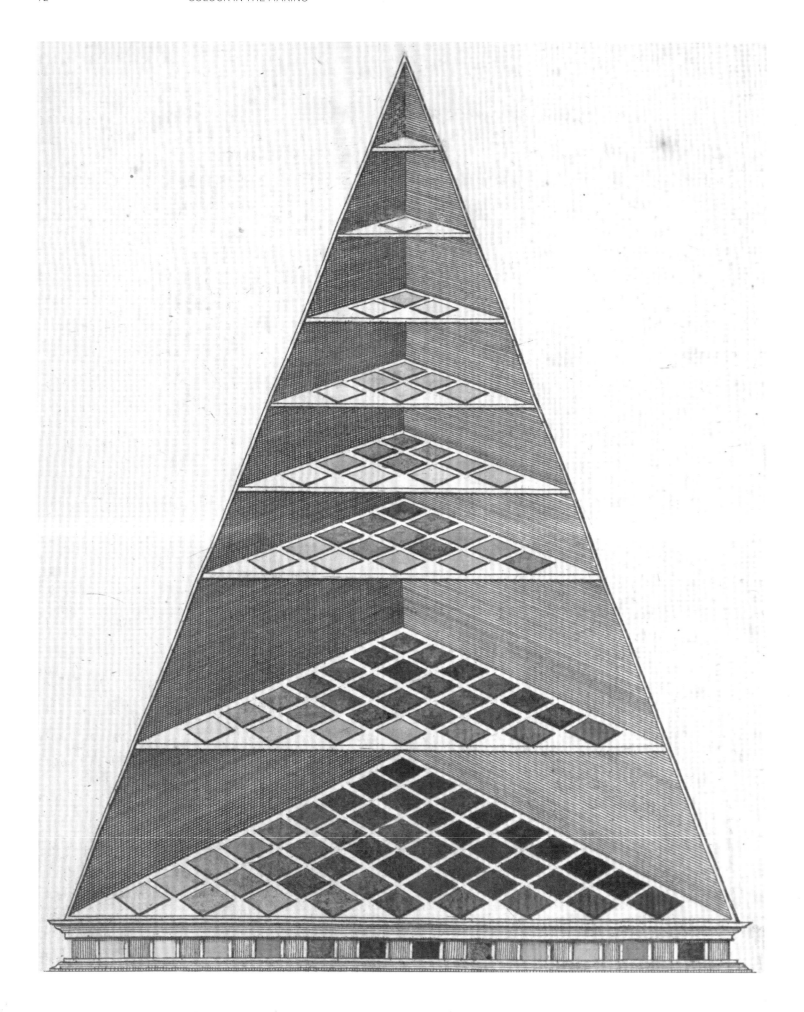

with what went before, however, was the discovery that light could be divided. Sunlight was therefore no longer considered a singular, pure form. It was comprised of multiple forms of light.

While a child's drawing of a rainbow might divide it neatly into an arc with seven distinct colours, if one actually tried to stare at a rainbow in order to distinguish where one colour stops and the next one begins it would be a difficult exercise. Here, even in Newton's revolutionary theory, fundamental to our understanding of light and the development of Wave Theory, Newton introduced his own cultural preconceptions—it is thought that his attempt to identify seven colours was an allusion to musical harmony, which isn't completely incongruous, given that sound was already understood to be the result of vibrations. Any current light technician will tell you that the light primaries are more commonly divided into three colours, the RGB (red, green, blue) primaries. However, the development of this model of thought was slow, with each theorist building on the work of previous thinkers. It is this insistence on seven primary (indivisible) colours that made Newton's theories incompatible with pictorial theories of colour—those learned by colour mixing. However, Newton was clear to distinguish between the mixtures of coloured pigments and his concern, which was "the quantities of light reflected from them".

Christiaan Huygens, a contemporary of Newton's from Holland, was the scientist that pressured Newton into admitting that sunlight—or white light—could in fact be created from as little as three primary colours. His own theory proposed that white light could even be composed from as little as two primaries, for instance, blue and yellow.

JOHANN HEINRICH LAMBERT

Johann Heinrich Lambert, a mathematician and physicist from Austria, developed the first three-dimensional colour chart, in the form of a pyramid. Fascinated with colour, Lambert took to investigating the primary colours and their relationship with light, following on from those discoveries made by Newton and Huygens in the eighteenth century. Lambert proposed that the primary colours had varying degrees of saturation, according to their absorption of light, and would therefore need to be indicated somehow in a colour chart. Levels of brightness increase to the top of the pyramid, which is only represented by the colour white.

JOHANN WOLFGANG VON GOETHE

Johann Wolfgang von Goethe, the German writer and theorist, developed a different kind of theory in 1810, nearly 100 years after Newton, which he called "Theory of Colours". Goethe's work was a direct response to Newton's theories, which had, in the 100 years that had passed, become fundamental to scientific understanding. For Goethe, Newton's

OPPOSITE
Johann Heinrich Lambert
Farbenpyramide
1772

observations of the physical properties of light did not answer questions regarding human interaction with and perception of colour. Newton had created a focus on colour as a physical phenomena, when Goethe felt that interpreting colour in terms of the physical properties of light alone is to make only one observation of cause and effect among many. *Die Farbenlehre* (*Theory of Colours*) is a series of experiments and observations about colour as perceived by the human eye. Its tone and method are logical and its results are detailed, but because of their perceptual and subjective nature, the narrative form veers into subtle descriptions of physiological perception. Wittengenstein—another theorist fascinated with the perception of colour—noted that it "really isn't a theory at all".[1]

As a series of noted colour experiences, Goethe's theories became popular with painters, because they allowed for the Impressionists' experimentation with the visual effects caused by colour relationships. A relayed story of his perception of a red poppy in its opposing blue-green colour field causes him to write that it was "flame-like" and that the poppy seemed to "emit a momentary light".[2] Goethe's Triangle offered a simplified explanation of colour mixing. Using the primary colours (red, blue and yellow) for each vertices of the triangle, he coloured the secondary triangles the colour created by mixing the two primary colours to its side and the tertiary triangles the colour created by mixing the primary and secondary colours to their sides.

PHILIP OTTO RUNGE

Philip Otto Runge developed the first three-dimensional colour model *Die Farben-Kugel* (*The Colour Sphere*) between 1777–1810. Presenting the colour system as a sphere, Runge used the purest form of each colour at its equator, with gradations in accordance with the colours across its surface. It was the first colour model of its kind, introducing light and dark into what was previously only a three-colour system.

ALBERT MUNSELL

Albert Munsell's extensive study of colour was published in his book A *Color Notation* in 1905. A simplistically accurate colour system using hue, value and chroma as its starting point from which to describe the different colour variations. Munsell used an irregularly shaped three-dimensional model to demonstrate his ideas, citing the sphere models that preceded his own as inaccurate due to differences in saturation points between the colours. He also used five primary colours as his basis, instead of the standard three: red, yellow, blue, green and purple.

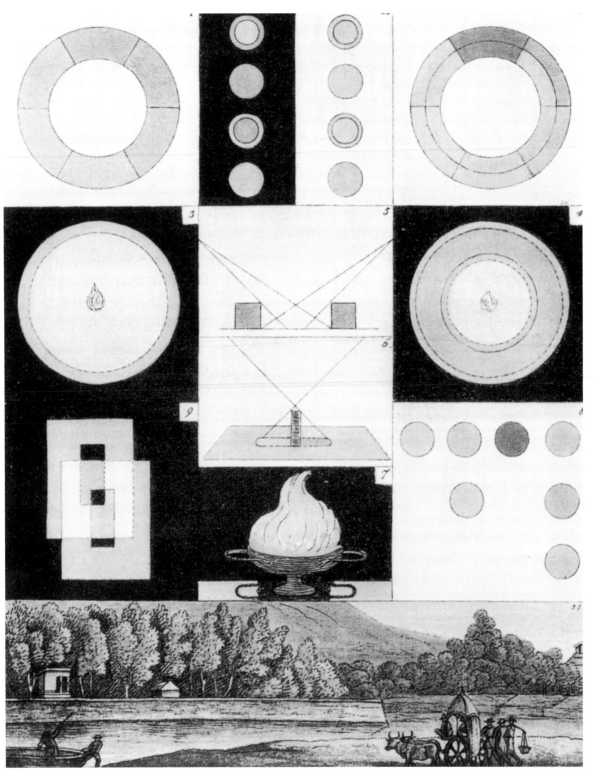

J W Goethe
Frontispiece to
Die Farbenlehre
(Theory of Colours)
1810

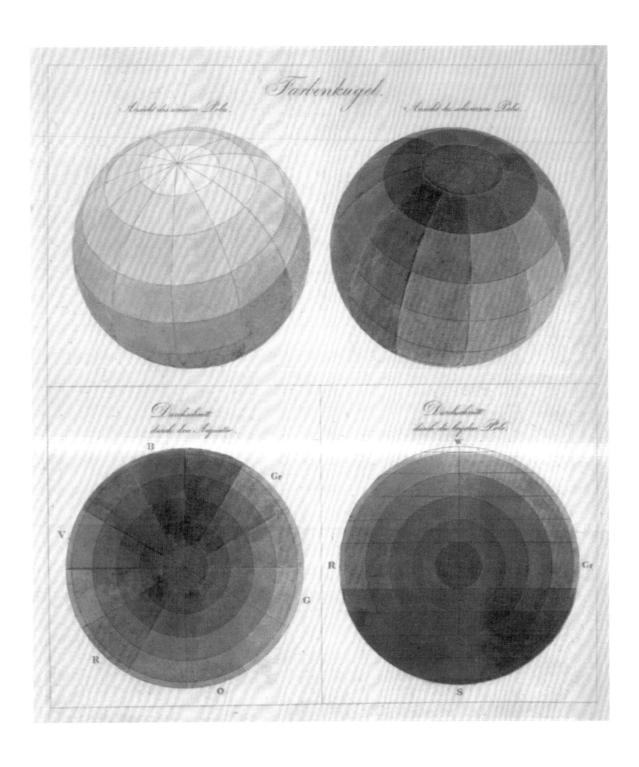

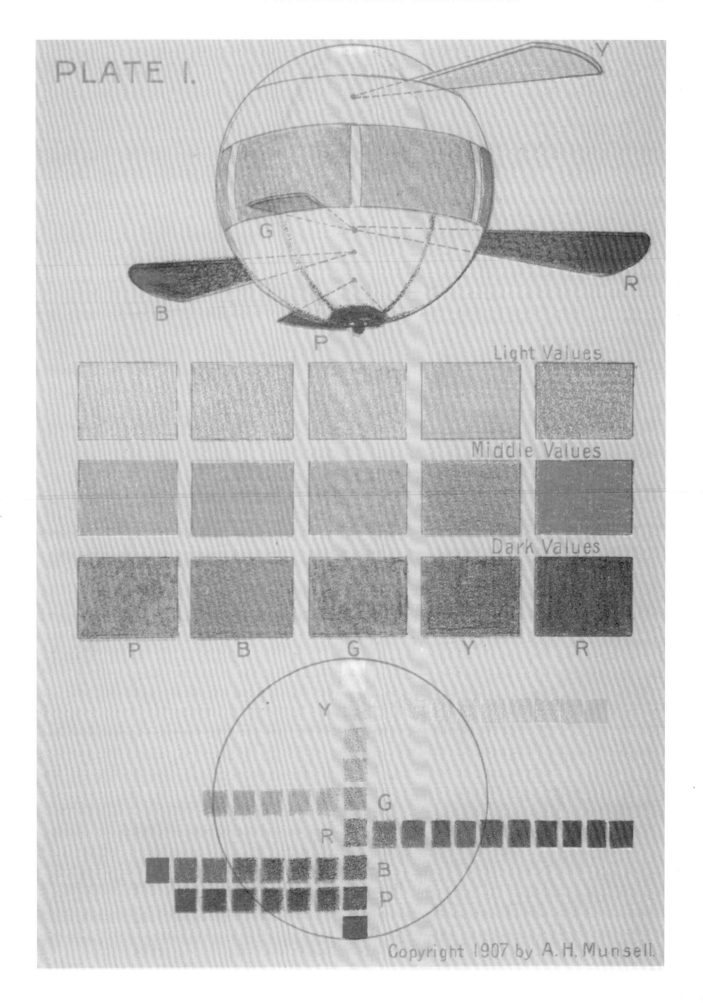

PLATE I.

Light Values

Middle Values

Dark Values

P B G Y R

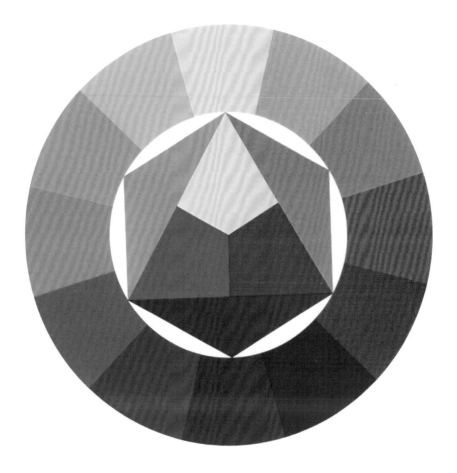

Johannes Itten
Farbkreis
1961

ITTEN AND ALBERS

The Bauhaus was a German school of art and design in the city of Weimar between 1919 and 1933, from which the Modernist movement of the same name was borne. The Bauhaus' interest in colour theory extended throughout a number of its practitioners work, including Johannes Itten and his student Josef Albers. They developed a theory on colour, based upon a colour's relationship to its surroundings, in that it is always relative, being seen and perceived in accordance with its surroundings. They also proposed that colour is perceived depending on experience. Whereas Goethe's theories put these relationships into words, Itten and Albers developed colour theories that were also more methodically put to practice, thus integrating the experience of human perception into a calculable and measured theory.

HUE SATURATION MODEL

A modern-day colour model, the Hue Saturation model was developed in the 1970s for use in computer graphics. There are two different

models that take the same diagram—that of a cylinder—the HSL and HSV models—standing for Hue, Saturation and either Light or Value. The central vertical axis of the cylinder corresponds with hue, the distance from the axis corresponds with saturation and the distance along the axis corresponds with lightness or value. The hue refers to the colour, the saturation refers to how white the colour is, and the value or lightness refers to how dark the colour is.

COLOUR MIXING

The mixing of pigments to produce colours has evolved from a nuanced process perfected by Mediaeval artists' assistants to the crisp and accurate processes of halftoning and colour balancing in effect today in most print processes. In order to understand how these processes function, we must first look at how two pigments, or pigments in a carrier forming an ink or paint, mix together to produce another colour.

A primary colour is simply a colour that cannot be produced by mixing two colours together. In simple terms these are red, yellow and blue. However, as it can be seen from the limited palette of colours available to the artist pre-Industrial Revolution, which red, yellow and blue are mixed together can create hugely varied outcomes. Using natural mineral pigments, or even early synthesised pigments like artificial azurite—copper sulphate—that were derived from differing minerals produces a slightly different tone. Each different binder also affected the colour, meaning that producing an accurate theory for colour mixing was an approximate art, with the result produced most effectively by eye, derived from years of experience.

In colour mixing for painting, the fundamental rule is that there are three colours that cannot be made by mixing other colours together. These three—red, blue, and yellow—are known as the primary colours. However, by mixing these three colours in different amounts, a whole new range of colours can be created.

DIGITAL TECHNOLOGIES

Digital colour mixing, on the other hand, works on an additive or subtractive basis with regards to how light is used in conjunction with specific colours to create further variations. The Additive Colour Model, otherwise known as the RGB model, works with three primary colours: red, green and blue (RGB), and is used for digital, on-screen colour. Red, green and blue light is radiated using different levels of brightness to create different colour variations. Within this system the use of white is considered to be the combination of colour, whilst black is the absence of colour.

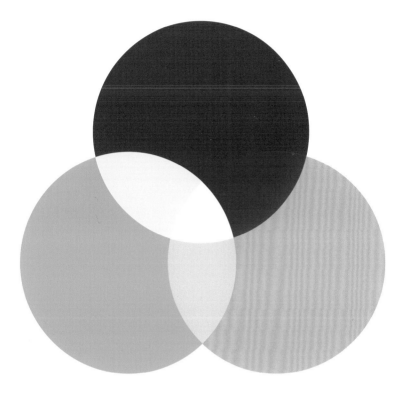

ABOVE
RGB model.

OPPOSITE
Illustration of CMYK
colour composition.

The Subtractive Colour Model on the other hand, or CMYK, uses cyan, magenta and yellow as its primary colours, and is used for printed colour. Unlike the Additive Model, white is understood to be the absence of colour, whilst black is the combination of colour (the 'K' in CMYK refers to this). The Subtractive Model works by reflecting light, and it is this process of reflection that determines the different colours available. The different wavelengths of light reflect different strengths of colour according to human perception.

Today, our understanding of colour and our ability to apply it in a multitude of ways, has been made easier with the use of standardised colour matching systems such as the Pantone® Matching System. We are now able to reproduce thousands of colours that correspond across industries and are recognised internationally. Frustratingly, however, no matter how sophisticated the techniques become that determine how we perceive colour, if the materials with which we mix colour cannot match them, they remain ineffective in practice. Carinna Parraman's essay in the fifth chapter details the way in which colour models have made printing accurate and detailed colour reproductions possible.

1. Wittgenstein, Ludwig, *Remarks on Colour*, GEM Anscombe ed., Linda McAlister and Margarete Schfattle trans., Oxford: Blackwell, 1977, p. 11.

2. Goethe, Johann Wolfgang von, *Theory of Colours*, Charles Locke Eastlake trans., Cambridge MA: MIT, 1970, pp. 23–24.

C=100, Y=0, M=100, K=0

C=0, Y=0, M=100, K=0

C=0, Y=100, M=100, K=0

C=100, Y=0, M=0, K=0

C=0, Y=100, M=0, K=0

C=100, Y=0, M=0, K=100

C=0, Y=0, M=0, K=100

C=0, Y=100, M=0, K=100

COLOUR CIRCLE/ COLOUR SPECTRUM

OLAFUR ELIASSON

Olafur Eliasson is a Danish-Icelandic artist whose practice is largely concerned with light, colour and perception. Best-known for his Tate Turbine Hall installation *The weather project* in 2003, Eliasson employs the mediums of large-scale installation and sculpture, along with the use of materials such as light and water, to explore his ideas.

The colour circle series creates three new colour circles, each carefully constructed from three separate parts, each an in-depth examination into tone and hue, moving from the primary and secondary colours in *The constant colour circle*, their complementary colours in *The double constant colour circle* and the equidistant hues of these in *The triple constant colour circle*. The result is three colour circles ranging in colour from the vivid hues of the first to the muted almost black colouring of the third. Each following stage of the series is a further, subtle exploration into how colour appears on paper and the subtle nuances achieved through changes in hue.

Carrying on his investigation into colour theory and perception, *The colour spectrum series*, produced in conjunction with Boris Oicherman from the University of Leeds, is a study into the idea of colour perception. Originally exhibited at the Ikon Gallery in Birmingham, UK in 2006, *The colour spectrum series* presents the full colour spectrum as seen by the human eye in 48 colour photogravures.

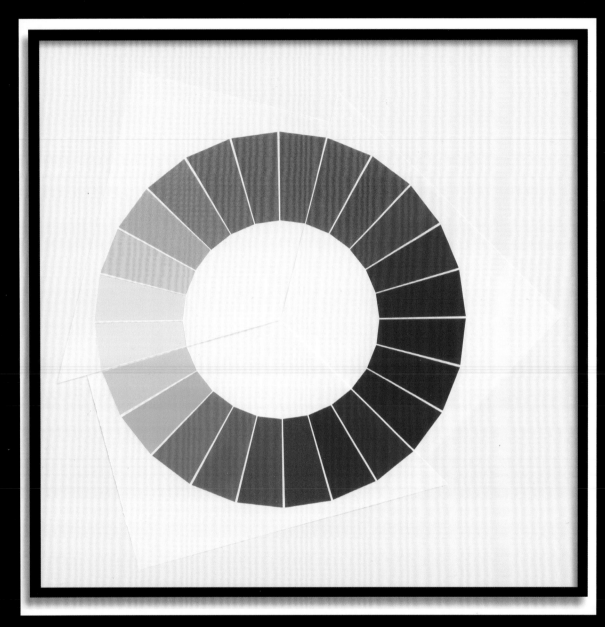

LEFT
The constant colour circle
2008
Courtesy the artist

ABOVE TOP
*The double constant
colour circle*
2008
Courtesy the artist

ABOVE BOTTOM
*The triple constant
colour circle*
2008
Courtesy the artist

OVERLEAF
The colour spectrum series
2005
Courtesy the artist

RGB COLORSPACE ATLAS

TAUBA AUERBACH

American artist Tauba Auerbach explores the full colour spectrum via her interest in publishing and book making in *RGB Colorspace Atlas*, 2011. Three vibrantly coloured books (20.3 x 20.3 x 20.3 cm) present the RGB cube sliced in three different directions. Made using digital offset prints on paper, the 3,632 page volumes are complete with airbrushed cloth covers and page edges, and bound by Daniel E Kelm at the Wide Awake Garage in Massachusetts.

The RGB Colour Model is an additive three-dimensional colour system typically associated with on-screen colour. Auerbach's atlas of this spatial model allows the eye to track the gradual changes in hue as one flips through the volume.

Auerbach lives and works in New York. Her work encompasses painting, sculpture, photography and publishing.

NINETEENTH CENTURY COLOUR —CHEMISTRY AND THE NEW RAINBOW

SYNTHETIC PIGMENTS

TIMELINE c. 1300–1900

c. 1300 LEAD-TIN YELLOW	c. 1600 MARS RED	1704 PRUSSIAN BLUE	1775 SCHEELE'S GREEN	1782 ZINC WHITE	1802 COBALT BLUE	1809 CHROME ORANGE	1812 CERULEA BLUE

| 1817
CADMIUM
YELLOW | 1828
SYNTHETIC
ULTRAMARINE | 1838
VIRIDIAN | 1850
AUREOLIN | 1850
ZINC
YELLOW | 1856
MAUVE | 1859
COBALT
VIOLET | 1868
SYNTHETIC
ROSE
MADDER |

LEAD-TIN YELLOW

Lead-tin yellow is a fair lemon-coloured pigment. Though historically attributed a number of names, including *giallorino* and massicot amongst others, its current common identity is reflective of its composition; the pigment is created by heating a mixture of lead and tin at extremely high temperatures of up to 800 degrees celsius. Varying the temperature results in similarly varied yellow hues, with a lower heat producing darker, warmer colours.

Lead-tin yellow has been synthesised since the thirteenth century, and the first recorded recipe for the pigment dates to the Bolognese manuscript of the early fifteenth century. Perhaps the most prominent use of the colour is by the seventeenth century Dutch painter Vermeer, who used it extensively and inventively. Alongside ultramarine, lead-tin yellow characterises Vermeer paintings, featuring heavily in a variety of means. He often used it to colour flowing fabrics; in *A Lady Writing* (1670–71), for example, the young woman's fine fur trimmed coat is glowing lead-tin yellow. The piece also displays Vermeer's creative use of the colour to accent cooler tones and add highlights without saturation, another notable example of which is *The Guitar Player*, 1672.

Vermeer often blended lead-tin yellow with other shades, particularly azurite, which, mixed with the shade, produced a new vibrant green. In fact, examples of lead-tin yellow combined with a number of other pigments, including lead white, vermillion, ochre, verdigris and indigo, can be found in pieces from numerous artists and periods, demonstrating the pigment's great versatility. In addition to this broad compatibility, lead-tin yellow is resistant to malefic light and stable in regular atmospheric conditions, positive properties counterbalanced by lead-tin yellow's toxic lead content.

RIGHT
Lead-tin yellow pigment
Courtesy Kremer Pigments

OPPOSITE
Johannes Vermeer
The Guitar Player
c. 1672, oil on
canvas, 53 x 46.3 cm

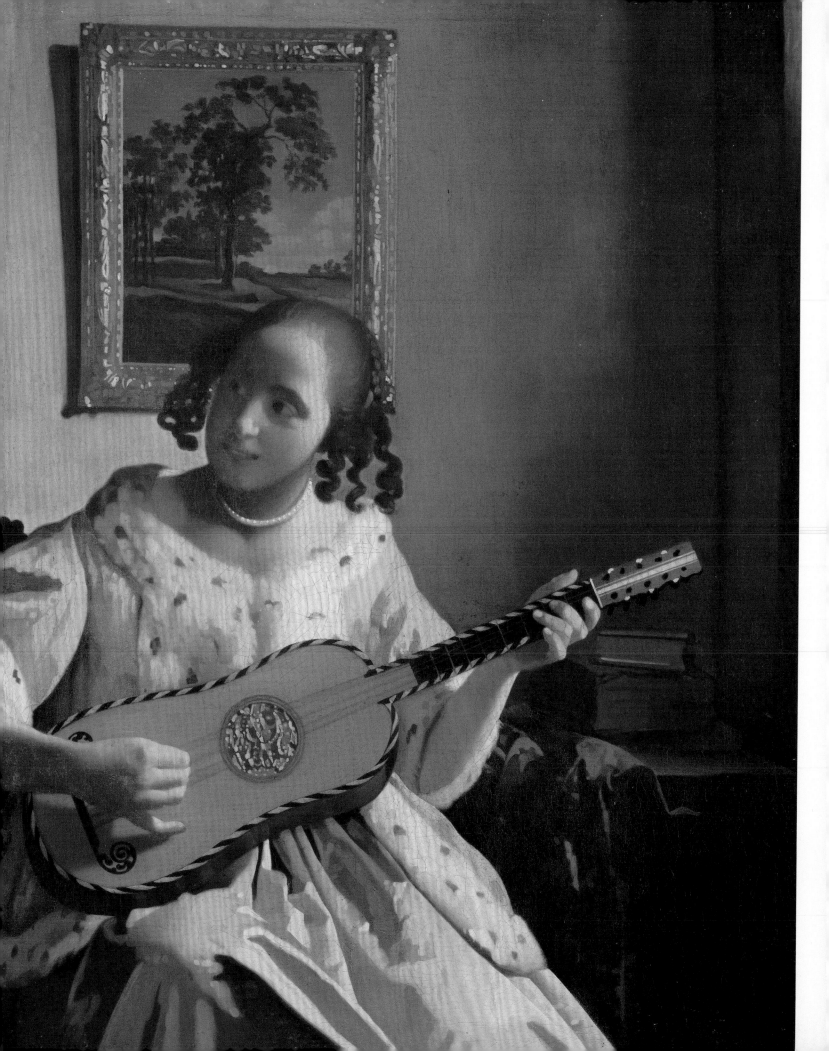

MARS RED

The oxidation of iron in air to create rust is a simple, well-known reaction—the first mention of this process being harnessed for the creation of synthetic artists' pigments dates back to the seventeenth century, when Huguenot refugee Sir Theodore de Mayerne recorded his recipe for red pigment. It wasn't until the eighteenth century however, that synthesised iron oxide became commonplace. This phenomenon has little to do with demand for the pigment; sulphuric acid became an important commercial item and iron oxide was a by-product of the manufacturing process. Thus, large quantities of synthetic iron oxide were produced and sold.

The synthetic pigment came to be known as 'mars red'. Like its naturally occurring counterpart, it exhibits a bevy of desirable traits, including durability, opacity, consistent properties, and tinting strength. The process that creates mars red can be used to synthesise a range of 'earth' colours (including browns, yellows, and black), depending on the levels of moisture and heat used.

Today, the building materials industry is the biggest user of synthetic iron oxide. Mars colours are commonly found in paving blocks, bricks, tiles, and concrete. The Mall, the ceremonial route to Buckingham Palace in London, owes its rusty red colour to synthetic iron oxide. Many have likened the effect to that of a giant red carpet through the city. The Mall was completed in 1911 but did not adopt its striking mars red appearance until the early 1950s.

RIGHT
Iron oxide mars red

OPPOSITE
The Mall, London
Photograph Rob Young

PRUSSIAN BLUE

The limited choice and high cost of blue pigments, meant much effort went into finding an affordable blue pigment. However, despite the market demand for an affordable deep blue, the discovery of Prussian blue, happened by chance.

Around 1704, Berlin colour-maker Diesbach was using iron sulphate and potash to create cochineal red lake but, presumably in an effort to save money, he was using potash that had been contaminated with animal oil, causing his red lake to come out pale and, when he concentrated it to deepen the colour, turn deep blue. Through this happy accident it was discovered that potassium ferrocyanide, when mixed with iron sulphate, creates the chemical compound iron ferrocyanide, otherwise known as Prussian blue.

At just a tenth of the price of ultramarine, Prussian blue quickly grew in popularity. One of its first uses, and the origin of its name, was as a dye for the uniforms of the Prussian Army.

Hydrogen cyanide forms in the making of Prussian blue, which gave name to the entire ferrocyanide and cyanide families of compounds: the word 'cyanide' is derived from the Greek word for 'dark blue', despite the substance's colourless appearance.

Prussian blue has been used extensively in painting, first by European artists such as Thomas Gainsborough and Antoine Watteau, and later in the works of Claude Monet, Vincent van Gogh, and Pablo Picasso, who used the pigment to create sombre moods in his *Blue Period* paintings. Japanese artist Katsushika Hokusai used Prussian blue to magnificent effect from around 1829 onwards. The vivid blue is prominent in his colour woodblock print series *Thirty-six Views of Mount Fuji*.

Most notably, it is the deep blue used in *The Great Wave Off Kanagawa*, perhaps the best-known work by a Japanese artist. These early paintings illustrate Prussian blue's tendency to fade over time: once deep blues now appear greyish and washed-out; however modern manufacturing techniques have since eliminated this issue.

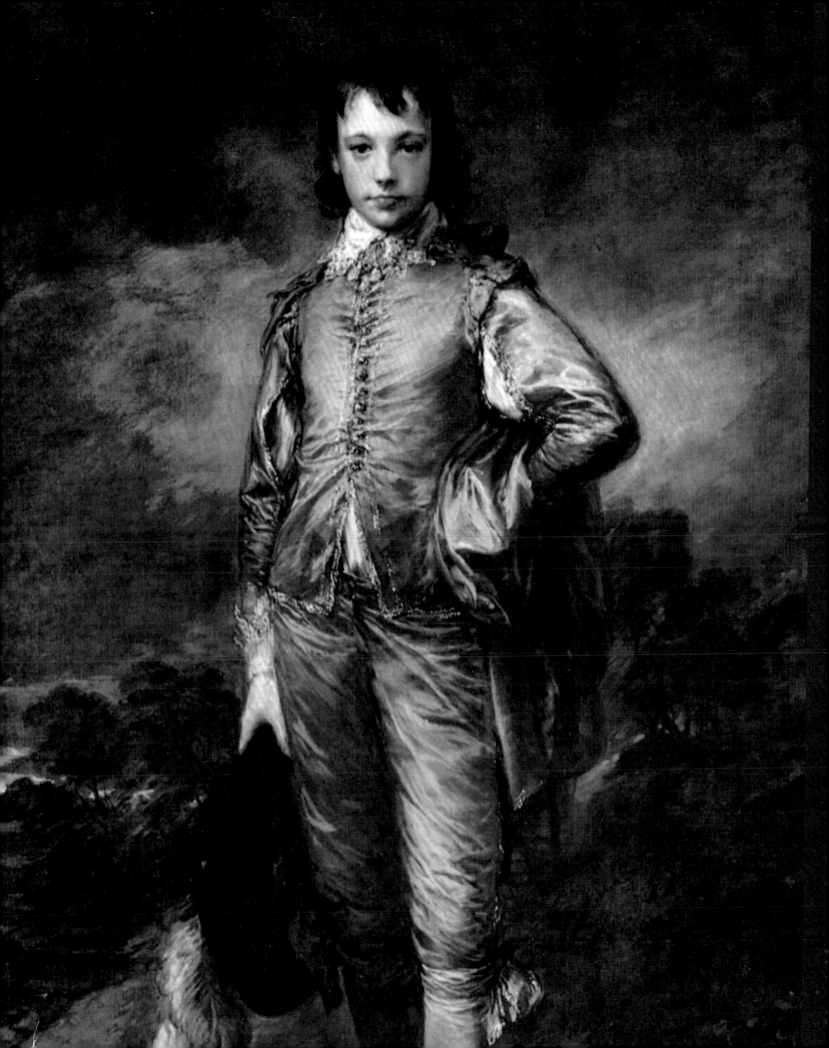

SCHEELE'S GREEN

In the early 1770s German-Swedish chemist Carl Wilhelm Scheele isolated chlorine and oxygen and discovered a new yellow pigment, lead oxychloride. This was sold by a British manufacturer as 'Turner's patent yellow' but it did not meet with much commercial success. In 1775, while investigating the properties of arsenic, Scheele produced a green compound called copper arsenite. A few artists utilised this new pigment, perhaps most notably JMW Turner in his 1805 *Guildford from the Banks of the Wey*, but it was manufacturers who wholeheartedly embraced Scheele's green (particularly after it was improved by German paint manufacturer Wilhelm Sattler and pharmacist Friedrich Russ. Their green was known as 'emerald green').

The widespread use of this arsenic-laced green led to countless health problems and deaths. Throughout Europe, clothing, soaps, lampshades, children's toys and candles were all tinted with Scheele's killer green pigment. Green wallpaper was particularly popular. It is believed that English designer and craftsman William Morris was one of many to utilise Scheele's green in his wallpaper designs. In 2003 biochemist Andrew Meharg found traces of arsenic in the green pigment from an early sample of Morris' patterned wallpaper, produced sometime between 1864 and 1875.

Napoleon Bonaparte died in his bedroom in Longwood House on the island Saint Helena, a room that just happened to be decorated with green wallpaper. The cause of death, as reported by his doctors, was cancer of the stomach. However, doubt was cast upon this claim when 140 years later a lock of Napoleon's hair (bought at auction in 1960) was analysed and substantial quantities of arsenic were found. It is likely that the green and gold *fleurs-de-lis* wallpaper in Longwood would have reacted with the wet climate of St Helena to produce poisonous vapours in Napoleon's bedroom. Despite this evidence, Napoleon's exact cause of death is still unknown and speculation abounds.

RIGHT
Paul Cézanne
Interior of a forest (detail)
1880–1890, oil on canvas,
46.4 x 56.1 cm

OPPOSITE
William Morris wallpaper

ZINC WHITE

Unlike zinc yellow's discovery, the discovery of zinc white was a deliberate one. In the early 1780s the French government approached chemist Guyton de Morveau to search for a new, safer alternative to lead white, the only white pigment in wide use. In 1782 de Morveau reported that the best alternative was zinc oxide, known as zinc white.

Because zinc white dried slowly as an oil pigment it was first used by artists as a watercolour pigment, sold as 'Chinese white' by Winsor & Newton in 1834. Subsequent improvements by French colourmakers and chemists, in particular EC Leclaire, refined the manufacturing process for zinc oxide and made it better able to stand up to oil colours.

A breakthrough discovery in the United States in the 1850s led to the 'American process' of synthesising zinc white directly from zinc ore. This discovery, like so many in the field of colour, was an accident. A worker named Burrows at the Passaic Chemical Company near Newark, New Jersey left some zinc ore over a furnace (as part of a make-shift fix for a leaky fire flue), and mentioned the resulting white fumes of zinc oxide to members of the neighbouring zinc company, Wetherill and Jones. They used this information to develop their direct method for producing zinc white.

Zinc white was commonly used by paint manufacturers, who added it to their products as a lightener. Though lead white remained the white of choice for most artists throughout the nineteenth century—despite its poisonous nature—some artists did turn to zinc white, utilising its cold, flat, 'clean' tone—Cézanne and van Gogh among them.

Much like zinc yellow, zinc white has the long-term disadvantage of degrading over time. The pigment's lack of pliancy can cause severe cracks in oil paintings after just a few years. Of course, there are those paintings made with both zinc yellow and zinc white that remain in remarkably good condition today. The Pre-Raphaelites often utilised these pigments,

particularly zinc white, which they used as a ground for their strong colours in the 1850s. Though some did not age well, many remain in good condition today—using zinc white sparingly helps to avoid later cracking. John Everett Millais' *Ophelia* (1851–1852) is a good example. It was retouched on two occasions— in 1865 and in 1873—primarily to restore some already fading yellows, and today looks largely the same.

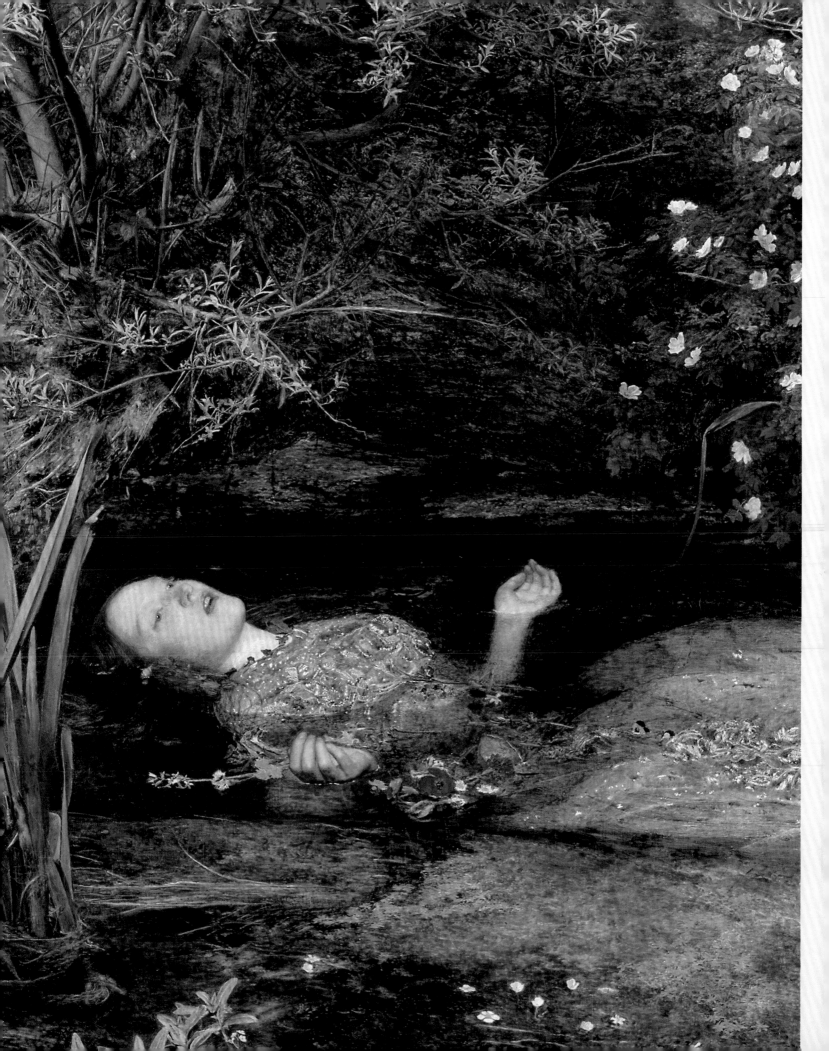

COBALT BLUE

Cobalt-based blue pigments have been used since ancient times—in pottery, painting and ceramics, from Ancient Egypt to China under the Juan and Ming dynasties, and Scandinavia in the nineteenth century.

In the early 1800s the French interior minister, Jean-Antoine Chaptal, commissioned chemist Louis-Jacques Thénard to develop a synthetic substitute for ultramarine, which was still the costly king of blues. Drawing on his knowledge of pottery, in particular French Sèvres porcelain (which used salts containing cobalt to create blue glazes), he used a mix of cobalt salts and alumina to produce the pigment he called 'cobalt aluminate' in 1802. The pigment was marketed as 'cobalt blue' to artists, who immediately embraced it.

The method of synthesising cobalt blue was soon simplified so that natural cobalt ore could serve as the starting material. The synthesised pigment had a purer tint than azurite, Prussian blue, or indigo. It was expensive, but widely popular none-the-less.

Cobalt blue is intrinsically linked to the downfall of one of the most ingenious forgers ever, Dutch painter Han van Meegeren. Critics panned van Meegeren's faux-Renaissance style, calling it unoriginal. To exact a sort of revenge, he devised a plan to paint a perfect Johannes Vermeer. He sourced the requisite pigments (among them ultramarine, purchased from Winsor & Newton) and painted *The Supper at Emmaus* in 1936, signing it with Vermeer's name. His forgery was a massive success, and in the following six years van Meegeren painted a further six 'Vermeers'.

Van Meegeren only fell into trouble when *Christ with the Adulteress* was sold to Reichsmarschall Hermann Göring. When Allied Forces eventually collected artwork looted by the Nazis, the painting was traced back to van Meegeren and he was arrested in 1945 for aiding and abetting the enemy. It was a scientific examination of his paintings, specifically the pigments he used, which eventually outed the forger. In the painting sold to Göring, *Christ with the Adulteress*, the ultramarine used had been adulterated with cobalt. Vermeer could not have used the paint, as cobalt had not been invented then.

Cobalt blue led to the creation of four new colours: cobalt green and cobalt violet, which were expensive and had poor opacity, a yellow known as 'aureolin', which found general use only as a watercolour, and cerulean blue. Cerulean blue, which is made from a mixture of cobalt and tin oxides, became available in the 1860s as a watercolour and then as an oil colour in the 1870s. The blue's reputation for impermanence, firmly in place by the 1890s, means it was not widely used after that date. The blue turns up on Impressionist's canvases, such as in the sky in Monet's *Le Gare Saint-Lazare*, 1877, as well as the works of Neo-Impressionist Paul Signac, who was so enamoured by the colour that he ignored its bad reputation.

CHROME ORANGE

Chrome orange takes its name from its chemical composition, which is mostly made up of lead chromate. The element chromium, naturally found in the reddish lead ore from Siberia, was discovered in 1797 by the French chemist Louis Nicolas Vanquelin. Given the pigment's high lead content, chrome orange, also known as Victoria or Persian red, is no longer made—many alternative coal tar-derived colours produce similar tones with the added benefit of being non-toxic. As such, chrome orange's life as a pigment was short-lived. Its first use dates back to 1809, however by 1900 it was almost completely out of use.

Chromium was so called because of its colour-giving properties, deriving its name from the Greek for colour (*chroma*), due to the array of colours it produced—ranging from an egg-yolk yellow to a deep, russet red. For this reason, chrome orange isn't really one pigment but a range of oranges, going from reds to yellows.

Chrome orange was the first bright orange pigment that artists had ever encountered. Its short but bright existence had a huge impact on Modern art. The colour was used liberally by the Impressionists; it contrasted with bright blue and it produced colour combinations that shocked the viewing public with their 'unnatural' boldness.

Frederic Leighton's *Flaming June* from 1895 is an almost entirely orange painting, composed towards the end of chrome orange's reign. It utilises the pigment in its romantic agenda: an orange glow envelops the sleeping woman, from her gossamer gown to the molten gold sunset behind her, evoking a dreamy atmosphere.

CERULEAN BLUE

Cerulean blue is a crisp blue inorganic pigment, first popularised in England in the late nineteenth century. A cobalt stannate, cerulean blue was a development of cobalt blue, an earlier blue pigment obtained by heating tin oxides with cobalt.

Its positive physical properties—the pigment does not react to light or other chemicals, and its highly refractive particles create a vibrant surface effect—made a high-quality pigment that appealed to artists used to more expensive and delicate blues. It was particularly popular with the Impressionists and can be seen in the sky of Monet's *The Gare Saint-Lazare*.

It wasn't only the Impressionists who recognised the similarity of cerulean blue and the heavens, however; the name 'cerulean' is a derivative of the pigment's earlier moniker 'coeruleum' which comes from the Latin terms *caerleus* (dark blue) and *caelum* (sky).

As a vision of a beautifully clear sky, the colour has some interesting psychological associations. Research suggests that gazing at tranquil skies can have a calming effect on the body and mind, even lowering blood pressure, heartbeat and rate of respiration. With our need for de-stressing influences in high-tech, high-pressure modern life, Pantone, in 1999, voted cerulean blue the colour of the century.

CADMIUM YELLOW

Cadmium is a rare naturally occurring silver-white metal. In 1817 the German chemist Friedrich Stromeyer, while carrying out medicinal tests, discovered that cadmium could also be found in other compounds, primarily zinc-containing ores. Subsequently, the newly more accessible material became available for emerging experiments in chemical colours. It was soon discovered that heating cadmium sulphide with hydrogen sulphide gas resulted in a yellow powdery residue that made an excellent pigment.

Cadmium yellow is bold and sunny, as close to primary yellow as is achievable. Varying the strength of the chemical mixture can create a spectrum of yellow tones from the palest lemon to dark, thick orange hues. In fact, the range of cadmium pigments even extends to include red and maroon.

It took until the latter part of the nineteenth century for cadmium yellow to become commonplace in the artist's palette. Stable and versatile, both in mixing with other pigments and in the number of forms in which it is effective—it works well as oil, acrylic, watercolour or guache, and is available in all of these medias—cadmium yellow has many qualities that made it a successful pigment.

That cadmium yellow stays bright and bold lent the colour to a significant role in the Modern movement. Modernist artists, such as Piet Mondrian, who frequently used the pigment in his minimalist compositions, often paired cadmium yellow with primary reds and blues.

SYNTHETIC ULTRAMARINE

Synthetic ultramarine was, arguably, the most sought-after man-made colour: while most synthetic colours were the result of chemists' independent research, a synthetic version of the expensive pigment ultramarine was so highly coveted that prizes were offered for its discovery. The Royal College of Art in England offered a cash prize to anyone who could synthesise the pigment in 1817, and seven years later the Société d'Encouragement pour l'Industrie Nationale in France did the same, but with a larger incentive of 6,000 francs. By 1828 the world had a synthetic ultramarine, invented by colour-manufacturer Jean-Baptiste Guimet. Guimet began selling his 'French ultramarine' at once, at about a tenth of the price of the naturally occurring pigment.

Synthesising ultramarine turned out to be a relatively simple process. China clay, soda, charcoal, quartz (or sand), and sulphur are thrown together and cooked. The 'green ultramarine' substance that results is ground, washed, and then re-heated, converting it to a blue substance. This is then ground and washed again, producing the final synthetic ultramarine pigment. The precise colour of the pigment varies depending on the amounts of the ingredients used.

French artist Yves Klein worked with a chemist to devise his own particular shade of ultramarine. He registered it as a trademark colour in 1957, calling it International Klein Blue (IKB). For Klein, the colour was his art; he used the intense, vivid blue to create monochromatic works representing immateriality and boundlessness.

In his short life Yves Klein created nearly 200 monochrome paintings using IKB. The early ones tend to have an uneven surface, whereas his later monochrome paintings are more uniform in texture. These later paintings were achieved by stretching his canvas over a wooden backing, which had been treated with casein, a milk protein. This helped the paint to adhere. He then applied industrial paint (similar to guache) mixed with a highly volatile fixative to the canvas with a roller. These techniques succeeded in creating finished works where the pigment appears to hover over the surface of the canvas. They have a strange sense of depth, achieving Klein's goals of representing 'pure space' with ultramarine.

RIGHT
Synthetic ultramarine pigment
Courtesy Kremer Pigments

OPPOSITE
Yves Klein
Venus Bleue
1962, blue pigment in synthetic resin on plaster,
70 x 30 x 20 cm
Courtesy DACS 2013
Copyright ADAGP, Paris and DACS, London 2013

VIRIDIAN

RIGHT
Paul Cézanne
Mountains in Provence
1880, oil on canvas,
54.2 x 74.2 cm

OPPOSITE
Viridian pigment
Courtesy L Cornelissen & Son

Bold blue-green in colour, the pigment viridian is chromium oxide hydrate; it is a hydrated advancement of the duller, olive green chromium oxide green. Infused with more moisture, chromium oxide green becomes the cooler, deeper and more vibrant viridian and, though the pigment is fairly stable in most respects, it reverts back to the dark, dull properties of its predecessor on exposure to high heat.

A method of obtaining viridian was first devised by the French colourman Pannetier, who guarded his secret recipe fiercely and charged high prices for the pigment he produced. By 1858, however, an alternative viridian recipe had been developed by Guignet and, with the influx of 'Guignet's green' on the market, the colour became far more available and vastly popular. It soon supplanted other less desirable green pigments, such as the poisonous Emerald Green.

Viridian was popular with the Impressionists who used the colour in abundance. The reeds and trees of Renoir's *La Yole*, for example, are deep with viridian. Cézanne was a particular fan of the colour, and a number of his pieces feature traces of the pigment. Notably, *Mountains in Provence* depicts viridian trees nestling in the French landscape.

L. CORNELISSEN & SON

VIRIDIAN GREEN

105 GREAT RUSSELL STREET, LONDON WC1B 3RY

AUREOLIN

Aureolin is a water-soluble compound, which, in oil and watercolour, transforms into an exuberant, sunshine yellow pigment.

Sometimes known as cobalt yellow, aureolin is a member of the cobalt family that also encompasses cobalt blue and violet. It is obtained by mixing together cobalt salts, acetic acid and additional concentrated potassium nitrite solution—a process that precedes the slow formation of yellow crystals, ready for preparation as a powdered pigment.

It is commonly believed that German NW Fischer originally discovered the compound whilst conducting a study of nitrite salts, in 1831. It was not available however until the 1850s, when it was introduced by E Saint-Evre, of Paris, who also independently synthesised the pigment and released it under the name still used today.

Aureolin quickly gained popularity, favourable over other yellow pigments of lower quality— aureolin can withstand exposure to light well— but was eventually largely superseded by less expensive cadmium yellow.

RIGHT
Aureolin, cobalt yellow
pigment
Courtesy Kremer Pigments

OPPOSITE
Thomas Eakins
Sailing (detail)
c. 1875, oil on canvas,
81 x 117.5 cm

ZINC YELLOW

French Chemist Nicolas Louis Vauquelin's investigations into the element chromium (which he discovered in 1761) led to a number of different yellows. When he synthesised pure lead chromate he found it to be a rich yellow, and discovered that the exact hue of the lead chromate could be adjusted by co-precipitating it from solution with lead sulphate, and altering the temperature of the synthesis, which affects the size of the grains. Along with chrome orange, Vauquelin's experiments yielded zinc chromate, which was sold to artists as zinc yellow in the 1850s.

Though it starts off as a bright greenish-yellow colour, zinc yellow does, unfortunately, darken with age, as seen in George Seurat's famous large-scale works: *Une Baignade, Asnières* (*The Bathers at Asnières*) from 1884 and *Un Dimanche Après-Midi à L'Ile de la Grande Jatte* (*A Sunday Afternoon on the Island of La Grande Jatte*) from 1884–1885. Seurat went to great lengths to create a vivid effect in these works, through his use of colour theory, their grand scale, and of course his pioneering use of pointillism. Unfortunately, he was not aware of the then new pigment zinc yellow's degeneration over time and what once were bright yellow highlights on the lawn of *Grande Jatte* are now brown spots. *Un Dimanche Après-Midi à L'Ile de la Grande Jatte* was retouched several times over the course of Seurat's life, and *Une Baignade, Asnières* was embellished using a pointillist technique in 1887.

Perhaps surprisingly given what we now know of zinc yellow's propensity to turn brown in paintings, it is used outside of the world of art to prevent rusting. Zinc chromate, sometimes tinted green, was widely used on military vehicles during the Second World War to prevent corrosion.

right
Georges-Pierre Seurat
Un Dimanche Après-Midi à L'Ile de la Grande Jatte
1884, oil on canvas,
207.5 x 308.1 cm

OPPOSITE
B-25 bombers painted using zinc chromate to avoid corrosion at North American Aviation, Kansas City, Kansas, 1942.

MAUVE

As with so many synthetic pigments, mauve was discovered serendipitously. 18 year-old chemist William Henry Perkin was studying at the Royal College of Chemistry under August Wilhelm von Hofmann, an expert in anilines. They were investigating a synthetic alternative to quinine, a difficult to source malaria remedy. Building on his professor's observation that some of the substances left over from gas lighting were similar to quinine, Perkin attempted to add hydrogen and oxygen to coal tar, carrying out this homework from his family home in East London. While washing his glass flasks one evening he noticed a black residue. A true scientist, he decided to investigate, and found that dissolving the substance in alcohol resulted in a striking purple solution.

Perkin patented his discovery, dropped out of the Royal College of Chemistry in October 1856, and went into business with his father and brother selling his purple dye. He originally called his discovery 'Tyrian purple', a reference to the luxurious ancient dye worn exclusively by Roman emperors. He later renamed it 'mauve' or 'mauveine', after the French mallow flower that shares the dye's colour. By 1859 it was being marketed exclusively as 'mauve'.

Mauve—sometimes called 'aniline purple'—was the first aniline dye. Aniline dyes are synthetic organic compounds: carbon-based chemicals that are altered by another substance, or synthesised. The aniline boom changed the way the world thought about colour and soon mauve was all the rage.

Perkin's attempts to attain French patents failed, so European chemists began experimenting with his recipe. By 1858 mauve was being used by French calico printers, which in turn increased British demand for Perkin's product. Consumers were wowed by the purple colour's unprecedented brilliance and intensity when applied to textiles, and it received the royal seal of approval when Queen Victoria wore a mauve dress to the 1858 wedding of her daughter Princess Victoria. In August 1859 the British periodical *Punch* wrote that London was afflicted with "Mauve Measles," and indeed it wasn't alone; ladies across many major cities, including Paris and New York, were vying to wear the colour of the moment.

Perkin's extraction of a brilliant colour from coal tar inspired chemists to find numerous other petrochemical paints and dyes, putting an end to Mauve's reign. Verguin's fuchsine, Manchester brown, and Magdala red became the new 'it' colours of the late 1800s. In 1956 the British Colour Council reported that there were seven fashionable shades in current use that were directly based on Perkin's mauve: wild orchid, daphne pink, pink clover, sweet lavender, purple lilac, homage purple, and, of course, violet.

RIGHT
Dyed mauve yarn samples
Photograph JWBE

OPPOSITE
Gabriel-Amable de Lafoulhouze
La Cocodette
1867, oil on canvas,
73 x 54.5 cm

COBALT VIOLET

RIGHT
Cobalt violet brilliant light
pigment
Courtesy Kremer Pigments

OPPOSITE
Claude Monet
Water Lilies (detail)
1916, oil on canvas,
200 x 201 cm

In the *Water Lilies* series of paintings by celebrated nineteenth century French impressionist Monet, the water of his garden pond vibrantly glimmers with the illusion of the reflected sky. This effect is, at least in part, due to the colours Monet favoured, including the appealing cobalt violet.

Cobalt violet was the first pure synthetic violet, not the product of a complex combination of other pigments. As such it was very attractive to artists of the era, particularly those working with floral subjects—it is also the main colourant of the exuberant flowers in Monet's *Irises*.

A spectrum of purple hues comes under the name 'cobalt violet', though two most commonly used variations stand out; the first, synthesised by Salvetat in 1859, is a cobalt phosphate, rich and somewhat darker than the second, fair violet and highly toxic incarnation, a cobalt arsenate.

Vivid and bright, and excellently long lasting, cobalt violet's immediate quality far outweighed that of the natural dyes and organic pigment alternatives of the time. However, the cost of production of the pigment was high, as was its subsequent purchasing price and general uptake. It was quickly replaced with the next pure violet created: cleaner and stronger, and ultimately cheaper, manganese violet.

SYNTHETIC ROSE MADDER

Rose madder is made from madder lake, a traditional lake pigment extracted from the madder plant. It has been used as a dyestuff since Ancient times and was grown as early as 1500 BC in Egypt, where cloth dyed with madder root was found in the tomb of the Pharaoh Tutankhamun. In more recent history, rose madder was used to dye the British army's red coats.

The dyestuff that provided half the world with red is composed of two organic dyes: alizarin and purpurin. In 1868 the alizarin component of the substance became the first natural dye to be synthetically duplicated. German chemists Carl Graebe and Carl Liebermann, working for BASF, cracked its synthesis by using anthracene, a coal tar product. They filed for a patent in 1869, but soon found they had a likely rival: William Perkin, the inventor of mauve and the first to discover coal tar's potential for colour creation, filed a patent for alizarin just one day before. Both patents were granted and they divided the market

in half—Perkin had a monopoly in Britain while BASF sold to America and mainland Europe. Because of its low cost of production, synthetic alizarin quickly replaced all madder-based colourants then in use. Today, alizarin has in turn been replaced by the more light-resistant pigment quinacridone, originally developed at DuPont in 1958.

The significance of alizarin's discovery should not be underestimated; in many ways, it was much greater than the discovery of Perkin's original coal tar pigment. The creation of a molecule identical to a natural product, but made by artificial means, profoundly changed the way organic chemists thought about colour, and the world.

RIGHT
Alizarin sample

OPPOSITE
William Bouguereau
Moissonneuse,
1868, oil on canvas,
106.5 x 85 cm

RAINBOW WARS —THE NINETEENTH CENTURY LIBERATION OF COLOUR

PHILIP BALL

Vincent van Gogh's letters to his brother Theo belie the legend of the half-mad artist daubing in a delirious frenzy. They contain some of the most eloquent and perceptive comments of any artist on the technique of painting, and in particular on the use of colour. Van Gogh's words have an intensity that almost conjures up the images—what he called "symphonies of colour"—in all their chromatic glory:

Now a seascape, with the most delicate blue-greens and broken blue, and all sorts of pearly tones. Then an autumn landscape with foliage from deep wine red to vivid green, from bright orange to dark havana, with yet more

colours in the sky in greys, lilacs, blue, white, forming another contrast to the yellow leaves. Then again a sunset in black, in violet, in fiery red…. Truly colours that can have quite a lot to say to one another.[1]

In his remark that "colour expresses something in itself", he anticipates the future of Abstract Expressionistic use of pure colour fields. "One can't do without it", he averred, "one must make use of it. What looks beautiful, really beautiful—is also right."

But van Gogh knew all too well that, for the artist, colour is not really an abstract thing. It is a physical substance, a 'paint', by that time bought ready mixed in collapsible tin tubes. As such, it had a price—and for the struggling artist that mattered a great deal. "Paint is expensive", he lamented to Theo in 1882, "and is used up so quickly". Could his brother arrange to get it at net price, not retail? Maybe it would be cheaper to buy in bulk for the colours he used a lot, such as white, ochre, sienna earth? And yet, how could an artist so obsessed with colour resist using these costly materials lavishly? "I am crazy about those two colours, carmine and cobalt" he confessed: "Cobalt is a divine colour, and there is nothing so beautiful for putting atmosphere around things. Carmine is the red of wine, and it is warm and lively like wine. The same with emerald-green. It is bad economy not to use these colours, the same with cadmium."

PREVIOUS PAGE
Winsor & Newton paints
Courtesy Winsor & Newton

ABOVE
Vincent van Gogh
Wheat Field Under Threatening Skies
1890, oil on canvas,
50.5 x 100.5 cm

Paul Gauguin
Parau Api Aka What News
1892, oil on canvas,
91 x 66 cm

"Sometimes", he sighed, "one mustn't worry about a tube more or less." This concern about materials is common among artists. Van Gogh's friend Paul Gauguin sent anguished letters from Tahiti to his dealer Ambrose Vollard, complaining about the materials he had been sent. "I have only one small tube of carmine lake left", he exclaimed. It is an old theme; painters in the Renaissance fretted about the quality and price of their paints, and their palettes were determined as much by the size of the patron's purse and the artist's geographical location as by their aesthetic preferences. (Titian, based in Venice, enjoyed the bright colours imported from the East, which northern Europeans could rarely get.) In this regard, artists in the nineteenth century had it relatively easy, for during that era there was an explosion in the range of colours available, and the commercialisation of colour-making created an industry that catered to their demands.

These developments transformed the visual arts: one need only compare the muted portraits by Joshua Reynolds with the stark intensity of those by Henri Matisse to appreciate what the new colours did to painting. And

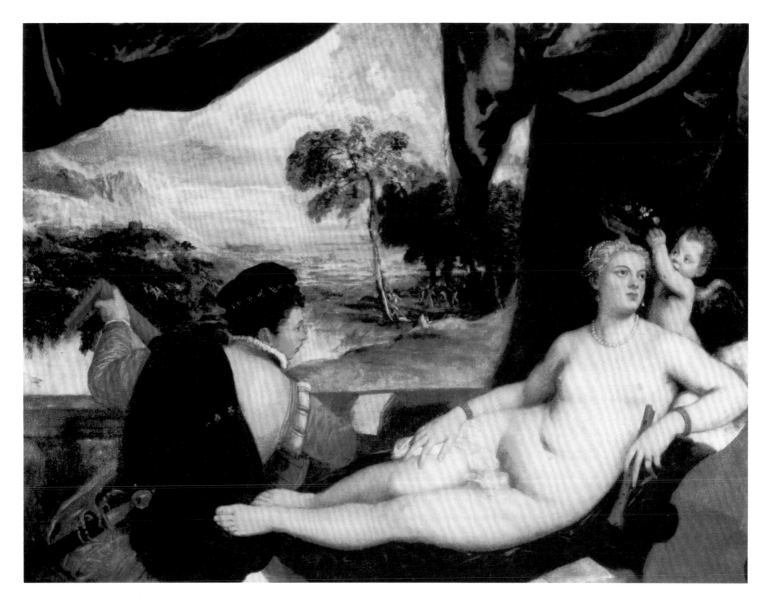

yet this accessibility of off-the-shelf bright colour, which today we take for granted, was not an uncomplicated boon. As van Gogh's remarks indicate, the question of price remained—even today, the expense of cadmium colours will make many artists think twice about using them too freely. And as paint-making was industrialised, artists became ever more estranged from their materials. They no longer knew what they were using, or how well they could trust these alluring hues not to fade or discolour. Colour was liberated, but it was also made remote and forbidding. Now it was the province not of the painter—relegated to a mere consumer—but of the scientist, most of all the chemist.

Titian
Venus and the Lute Player
1560, oil on canvas,
165 x 210 cm

THE RISE OF CHEMISTRY

The transformation of colour-making from a haphazard, trial-and-error folk craft to a systematic, planned industrial science can be located in what Eric Hobsbawm has called the "long nineteenth century", from the French Revolution in 1789 to the beginning of the First World War in 1914.

RIGHT
Joshua Reynolds
James Boswell
1785, oil on canvas,
76.2 x 63.5 cm

OPPOSITE
Henri Matisse
Portrait of Madame Matisse
(The Green Line)
1905, oil on canvas,
40.5 x 32.5 cm
© Succession
H. Matisse / DACS 2013
Image : SMK Photo

These two historical events are not merely convenient markers, but play significant roles in that story. It was in the year of the Storming of the Bastille that the French chemist Antoine Lavoisier published his revolutionary *Traité Élementaire de Chimie*, which established the system of modern chemistry by clarifying what elements are and introducing the central concept of oxygen. Lavoisier's scheme provided chemists with a systematic language for thinking about their discipline, establishing it as the art of understanding how substances are made by the combination of elements. By careful analysis of the quantities in which different elements react, or in which chemical compounds can be decomposed into their constituent elements, Lavoisier showed how chemistry was governed by strict rules of elemental combination: there was a logic to its profusion. It became possible to think in a rational way about what materials are made of, how those found in nature might be created artificially, and how chemists might devise entirely new and potentially useful combinations and permutations. But Lavoisier did not live to see how this system was eventually embraced throughout Europe in the nineteenth century. As a former member of Louis XVI's administration and a tax collector he was an obvious target for the witch-hunt of the Reign of Terror, and in 1794 he was condemned to death by guillotine.

One of the elements on Lavoisier's new list was the metal cobalt, the discovery of which is attributed to the Swedish chemist Georg Brandt around 1735. Cobalt minerals had been long used as blue colourants for glass and pottery glazes, and from the late sixteenth century a blue glassy material made from cobalt ore and finely ground was used by painters as a blue pigment called smalt. But this substance left a lot to be desired—it was no substitute for the painter's finest blue, the inordinately expensive ultramarine.

Ever since the formation of the Académie des Sciences in 1666, the French government had shown more readiness to support scientific endeavours than had the British, where scientific and technological innovation depended much more on private entrepreneurship. Recognising that colour-making was already becoming a lucrative business, around the turn of the century Napoleon's government commissioned the leading chemist Louis-Jacques Thénard to seek an artificial replacement for ultramarine. For Thénard, cobalt chemistry was the obvious place to look. Inspired by the bright blue cobalt glazes of the Sèvres porcelain factory, in 1802 he discovered that by heating cobalt compounds with alumina he could create a strong blue substance that became known simply as cobalt blue.

That was not all cobalt had to offer. Like many of the so-called transition metal elements, cobalt will form brightly coloured compounds of several different hues, depending on which elements it is mixed with. The mid-nineteenth century saw the synthesis of *bleu céleste* or 'cerulean blue', named for its sky-like tint and made from cobalt and tin oxides,

along with cobalt green, a cobalt yellow called aureolin, and most significantly, cobalt violet—the first ever pure and reliable purple pigment painters ever had.

Cobalt blue was rich and dependable, but still it could not match ultramarine. This pigment had, since the Middle Ages, been made from the mineral *lapis lazuli*, for which only one source in the world was then known: the mines of Badakshan in present-day Afghanistan. It was imported across the seas *(ultra marinus)* at great expense, and the blue substance was extracted from the raw ground mineral by a laborious process of flushing from soft wax in water.

Could this material be made by artificial means from its elemental components? It has a complicated composition, containing sodium, silicon, oxygen, aluminium, sulphur, and sometimes calcium and other elements such as chlorine. The relative quantities of these ingredients were determined by two French chemists in 1806, using the principles of chemical analysis that Lavoisier had helped to pioneer. Armed with this information, another chemist, BM Tassaert, proposed to the Société d'Encouragement pour l'Industrie Nationale that artificial ultramarine might be made using a process similar to that for manufacturing soda (sodium carbonate). In 1824 the Société offered a prize of 6,000 francs for a practical industrial process to make artificial ultramarine.

That sum was awarded in 1828 to the Toulouse colour manufacturer Jean-Baptiste Guimet, who had devised a method two years earlier that involved mixing china clay, soda, charcoal, sand and sulphur. Guimet established a workshop in Paris and was soon selling this synthetic ultramarine—French ultramarine, as it was called in England—for a tenth the price of the natural pigment. The cost soon fell much further, and this previously regal blue could now be produced by the ton for industrial use—artists were now just a tiny part of the colour market.

Industrial chemistry and metallurgy have always been common sources of colour innovation: the artist's palette is largely a byproduct of the demand for socially useful materials such as metals, glass, soap, dyes and ceramics. During the Industrial Revolution the sheer volume of chemical processing meant that by-products could become viable commodities in their own right. It was from zinc smelting that, in 1817, the German chemist Friedrich Stromeyer discovered the element cadmium, an impurity in zinc ore and named after the mineral's Latin form *cadmia*. Stromeyer investigated the chemical properties of cadmium and found that in combination with sulphur it formed a bright yellow compound. Chemists were by that time highly attuned to the demand for new pigments, and Stromeyer spotted the potential at once. He found that by altering the conditions under which he reacted the two elements he could also make an orange form of cadmium sulphide. These two pigments—cadmium yellow and orange—became popular once cadmium was available in significant

amounts as zinc smelting expanded in the middle of the nineteenth century. Around the end of the century it was found that adding a dash of selenium to the mixture produces a deep red substance. The chemicals company Bayer began marketing this cadmium red, perhaps the richest red artists have ever known, from 1919.

It is from its propensity to form strongly coloured compounds that the metal chromium (French: chrome, colour) gets its name. It was discovered by the French chemist Nicolas-Louis Vauquelin in 1797 when he analysed the chemical composition of a bright red mineral from Siberia, called crocoite. The mineral is a compound of chromium, oxygen and lead—but when Vauquelin made this same substance artificially, it turned out to have a bright yellow colour that could be tuned between pale lemon and rich golden by adding some lead sulphate. A slightly different procedure results in a deep orange form. These chromium colours were used from the early part of the nineteenth century, later supplemented by a rich green form of chromium oxide that became known as viridian.

The secondary colours green, orange and purple/violet had always been a problem for painters, who had made them mostly by mixing primaries. That wasn't ideal, partly because mixed colours generally tended to be a little dull and also because one or other ingredient might be liable to fade over time: some seventeenth-century Dutch flower paintings sport blue leaves due to the fading of the yellow. Now all of these secondaries were available in bright hues, along with a range of affordable and mostly stable reds, yellows and blues. Infatuated with these materials and inspired by scientific ideas about the formation of colour from light and the dazzling effects of strong colour contrasts, the Impressionists took to using the new pigments unmixed in works of unprecedented brilliance. The shock of seeing their work was not merely due to their new style of painting, without the clear edges and smooth finish favoured by the French Academy of Fine Arts, but also about encountering colours never before seen on canvas. In Renoir's *Boating on the Seine*, 1879–1880, there are just seven pigments apart from the traditional lead white, and all but the reds are 'modern' synthetic colours: cobalt blue, viridian, chrome yellow, 'lemon yellow' (a compound of chromium and strontium) and chrome orange. They are applied raw, in dazzling complementary contrasts: Impressionism straight from the tube.

This colouristic boldness informed the early work of some of the most important artists of the modern age: Cézanne, Gauguin, van Gogh, Kandinsky. As the leader of the Fauves, Matisse followed van Gogh in liberating colour from its natural referents. The saturated red of his *Red Studio*, 1911, relinquishes *chiaroscuro* for a flat, two-dimensional colour field: pure hue, with its own spatial rules. Art critic John Russell regards this picture as "a crucial moment in the history of painting"—"colour is on top", he says, "and making the most of it".

Cornelia van der Mijn
Flower still life
1762, oil on canvas,
76 x 64 cm

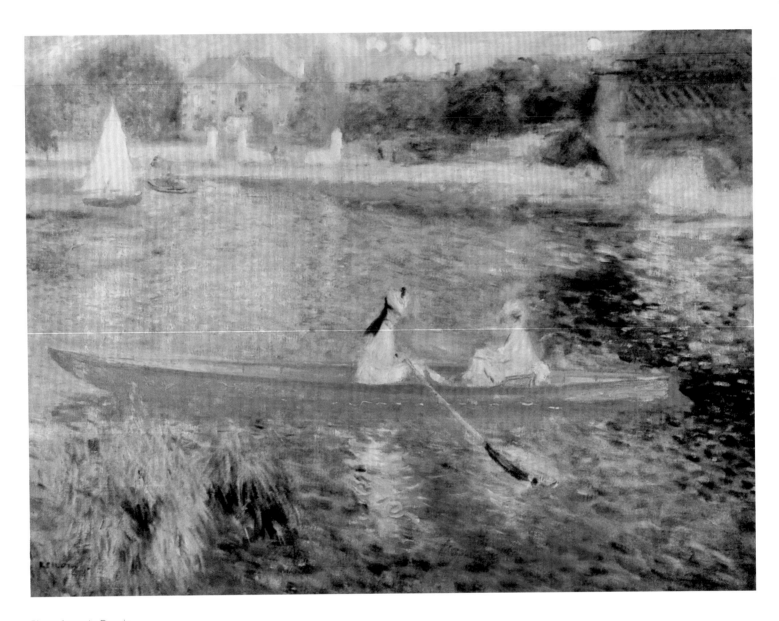

Pierre Auguste Renoir
The Skiff (La Yole)
1875, oil on canvas,
71 x 92 cm

ORGANIC COLOUR

Industrial colour innovation could never have been sustained merely by impoverished van Goghs buying a handful of tubes. There have always been bigger markets at stake. Textile manufacture was the most significant sector of the Industrial Revolution, and motivated advances in dyeing technology. In the late-eighteenth century the traditional materials and methods—dyestuffs extracted mostly from plants and applied using mordants such as metal salts that bind the dyes to the fibres—were largely the products of folk craft, poorly understood from a scientific perspective. But dye and textile manufacturers were becoming

Henri Matisse
The Red Studio
1911, oil on canvas,
181 x 219.1 cm
© Succession
H. Matisse / DACS 2013
Image : SCALAArchives 2013

increasingly aware that they might benefit from the advice of professional chemists, and they began to hire such people as consultants and in-house technical experts. One of the first colourants produced by this union, marketed from the 1840s, was a yellow dye called picric acid, made by treating phenol with nitric acid. Phenol (later employed as the disinfectant carbolic acid) could be extracted from coal tar, an unpromising thick black residue left over from the extraction of gas from coal to fuel the spread of gas lighting.

Many chemists were interested in coal tar because they discovered that it was replete with hitherto unknown hydrocarbon compounds, such as benzene, toluene and naphthalene. The chemistry of compounds of carbon—so-called organic chemistry—was a mysterious but enticing subject. There seemed no end to the substances that carbon (united primarily with hydrogen, oxygen and nitrogen) could form, and it was hard to find any order to them all. This subject was most advanced in Germany, and the extracts of coal tar—called 'aromatic' compounds because of their pungency—seemed to be an important part of it. Picric acid confirmed the belief that these substances might yield gold from grime.

Another popular dye of the mid-nineteenth century was a purple synthesised from a compound extracted from guano and known as murexide. It contributed to the garish fashions of the 1850s, which

became known as the 'Purple Decade'. But murexide was eclipsed in 1856, by the discovery of another purple dye which could be made from aniline, itself derived from a coal-tar extract. William Perkin, an 18 year-old student at the Royal College of Chemistry in London, accidentally made this dye while trying to synthesise the anti-malarial drug quinine. Finding that silk would take up the rich purple colour, he abandoned his studies and set up in business with his father and brother at a factory in Harrow—a gamble by any standards, and surely inconceivable without the lucrative prospect that dye manufacture offered. Perkin's dye became known as mauve, after the French word for mallow, and it was extremely successful, making Perkin rich and famous.

But because he was unable to secure patent rights abroad, the powerful dye manufacturers of France and Germany soon found ways of making this and other coal-tar or aniline dyes. At first these colourants were found by haphazard, trial-and-error experimentation. 'Aniline red', later called magenta, was discovered by the manager of a French picric-acid factory around late 1858, and was soon followed by aniline violet and aniline blue.

Yet as chemists came to understand more about the way these coal-tar hydrocarbon molecules were constituted—in particular, the realisation by German chemist Friedrich August Kekulé in 1865 that their central motif is a ring of six carbon atoms—it became increasingly possible to make

compounds with particular shapes and properties by rational chemical synthesis. That facility developed hand in hand with chemical methods for analysing natural compounds—such as the dyes traditionally extracted from plants—in order to deduce the architecture of their molecules. As a result, it became possible to think of making these 'natural' organic materials from scratch, just as chemists had deduced how to synthesise a 'natural' inorganic mineral like ultramarine.

In 1868 German chemists made alizarin, the molecule that gives the madder red dye its colour, from the coal-tar extract anthracene. They were well aware of the commercial implications, selling the rights to the dye company Badische Anilin und Soda Fabrik (BASF)—just one of the many industrial enterprises becoming rich on the back of aniline dyes. Friedrich Bayer established his firm in 1862 by selling magenta and aniline blues; several dye makers merged in 1863 to form what became the Hoechst chemicals company; and aniline dyes were the core business of Agfa in Berlin.

Chemists at Hoechst and BASF, as well as William Perkin in England, found ways to make the manufacture of alizarin commercially viable. It was soon not only cheaper but also brighter than the natural variety, and the hitherto thriving cultivation of the madder plant collapsed. By 1880, 12,000 tonnes of synthetic alizarin were being produced annually. The next widely used natural dye to yield to chemical synthesis was indigo—first made in the chemical laboratory in 1877, although a way of producing it on an industrial scale did not arrive until 1890. By the turn of the century, synthetic indigo was undercutting imports of the natural dye from European colonies in India, and by the time war broke out in 1914, 90% of the European market for Indian indigo had vanished.

In the 1850s the German chemist Peter Griess discovered a new class of synthetic dyes, also made from aniline, called azo dyes, which were commercialised in the following decades and proved more resistant than aniline dyes to fading. By studying the relationship between the molecular structures of the colourants and their hue, the German chemist Otto Witt was able in 1876 to successfully predict the colour of a new orange azo dye. That was significant. No longer need colour-making be a matter of mix-and-see: it began to be a rational process in which colours could be tailored to order.

Towards the end of the century, the major dye companies began to diversify into new areas, particularly pharmaceuticals. In 1909 the German chemist Paul Ehrlich discovered the first synthetic drug—Salvarsan, a cure for syphilis—while using synthetic dyes to stain cells. Some coal-tar dyes proved to have medicinal benefits, and chemists made variants of natural medicines using coal-tar extracts. Bayer began to manufacture the analgesic Aspirin in 1897.

Frank Stella
Harran II
1967, polymer and
fluorescent polymer paint
on canvas, 300 x 600 cm
Courtesy DACS, 2013
Copyright ARS, NY and
DACS, London 2013

The First World War demonstrated the importance of a nation's chemical prowess: it is often said that it would have lasted barely a year had the German chemist Fritz Haber not discovered a method of converting nitrogen from the atmosphere into ammonia, a crucial ingredient of explosives. But Haber's process only became industrially useful when modified by Carl Bosch, who worked at BASF. More notoriously, Haber was responsible for the production of chlorine gas for chemical warfare. In the midst of the war, Hoechst, Bayer, BASF and Agfa formed the consortium that became IG Farben, an industrial syndicate of such awesome power that it was able to dictate terms to Hitler's government during the subsequent global conflict. Building on Haber's research, IG Farben manufactured the Zyklon B gas used in the extermination camps.

THE REMYSTIFICATION OF BLUE

Colour innovation did not cease at the end of the 'long nineteenth century'. Indeed, many of the pigments in modern paints are inventions of the twentieth century, such as pthalocyanines and quinacridones, which can mimic the hues of more costly mineral-based colours. But artists' use of colour often became dictated by issues other than cost and appearance. Some, such as Frank Stella, took to using industrial paints precisely because of their impersonal, mass-produced association: "I just took what the regular paint stores had to offer", he claimed. Pop artists such as Roy Lichtenstein and Andy Warhol embraced the fluorescent Day-Glo colours because of their explicit artificiality and, some might say, vulgarity. In some ways these choices can be seen as a retreat from an engagement with materials: now that colour-making had become a highly technological affair, painters were like the rest of us, consumers of products they did not understand.

But not always. One of the most fruitful collaborations between an artist and a technologist of colour came about in the mid-1950s, when the French artist Yves Klein approached the Parisian chemical manufacturer Édouard Adam to find a way of preserving the rich lustre of raw ultramarine powder when it was mixed with a binder to make a paint. Their solution was a fixative resin made by the Rhône-Poulenc chemicals company, which Klein thinned with organic solvents. The result was a blue of unprecedented chromatic intensity, which no photograph can ever capture. With it, Klein painted a number of blue monochromes, which he exhibited in 1957, vindicating his conviction three years earlier that "in future, people will start painting pictures in one single colour, and nothing else but colour". To preserve what he called the "authenticity of the pure idea", Klein patented this formulation in 1960 as International Klein Blue.

It seems appropriate that Klein used ultramarine—even if this was mass-produced artificial ultramarine, not the precious pigment extracted

Yves Klein
La Vague (IKB 160 a)
1957, dry pigment and
synthetic resin on plaster,
78 x 50 cm
Courtesy the Yves
Klein Archives
Copyright ADAGP, Paris
and DACS, London 2013

painstakingly by mediaeval artisans. It was a reminder of the vanished mystique of materials, a characteristic even more apparent in Klein's votive offering to the shrine of Saint Rita at the Cascia Convent in Italy, where the pure pigment powders—including gold and ultramarine, the traditional colour of the Virgin's robes—are encased in clear plastic. Klein's work asserts that materials still matter, and that the artist retains an ability to transform the coloured products of chemical technology into forms imbued with spirituality.

1. Vincent van Gogh to Theo van Gogh, Wednesday, 28 October 1885.

PAINTING AIR

SPENCER FINCH

American artist Spencer Finch used Claude Monet's paintings of the water garden in Giverny as inspiration for his sculptural installation *Painting Air* at the Museum of Art, Rhode Island School of Design in 2012. Having visited the garden himself Finch became enamoured with how the changes in light, colour and atmosphere altered perception of the landscape.

For the installation Finch suspended 112 glass panels from the ceiling of the gallery in colours reminiscent of Monet's oeuvre. Monet was renowned for using a select palette, of which the newly synthetic pigments of cadmium yellow, cobalt blue and viridian were commonplace. These colour ranges became the basis for Finch's installation, through which light could permeate the glass, in turn affecting the hue and saturation of the colours of the glass panels at different times of day. Monet famously proclaimed "I want to paint the air", an ambition, which Finch adopted in his making of *Painting Air*, evoking a similar sense of fleeting time within his installation that Monet succeeds in capturing in his paintings.

Spencer Finch is an American artist who lives and works in New York. Having studied at the Rhode Island School of Art and Design, Finch returned for the solo exhibition Painting Air in 2012. Finch attempts to continue investigations of science, art and perception that have concerned the work of artists across the history of art, often making connections between his own contemporary practice and those of prominent artists before him.

COLOUR REPRODUCTIONS —COLOUR PHOTOGRAPHY AND FILM

COLOUR IN FILM

AN INTRODUCTION

PREVIOUS PAGE
Rafael Hefti
Lycopodium
2012
Courtesy the artist and
Ancient & Modern, London

ABOVE
James Clerk Maxwell
Tartan Ribbon
1861, colour photograph

OPPOSITE
Auguste and Louis Lumière
Giving alms in front of the
Monastery of Brou, Bourg en
Bresse
1905, autochrome glass plate,
15 x 12 cm
Courtesy Odile Donis

There are competing opinions about when and how colour made its way into photography, with a number of methods attempted as early as 1840. Numerous patents and processes existed based on the ways in which black and white photography captured and recorded images, but the system most generally agreed upon to have produced the first colour photograph was devised by James Clerk Maxwell, a physicist working in the field of human vision. In a groundbreaking 1855 paper, he established a three-colour method to mimic the way our eyes detect colour: the first step was to take three black and white photographs of the same scene through a red, green, and blue filter, respectively. Once printed on transparent plates, the images would be superimposed on a screen with the help of three projectors, each implemented with a filter of the colours previously used. The result would be a scene showing the entire colour spectrum of the natural world. Despite the success of Maxwell's paper, it was only around 1937 that a print could be made from the original projected positive plates with Dr DA Spencer's Vivex carbro process.

Not only did Maxwell succeed in recreating the process by which we perceive colour, but incidentally, he also devised a method so successful that it is still the basis upon which colour photography functions today, even in our most hi-tech digital cameras. The experiment, first demonstrated in 1861 with the photograph of a tartan ribbon—considered the first permanent colour photograph—was to establish the additive colour model known as RGB (which stands for red, green and blue), a milestone of colour theory. This model is known as 'additive' in that it requires the superimposing of the three primary light beams to create a beam of white light. The human eye interprets the three different wavelengths as the colours red, green, and blue. Where two primary light beams overlap, the emission of the wavelength changes and is perceived as one of the secondary colours—magenta, cyan, and yellow. Based as it is on coloured light, it is the most extended technology amongst screen and video devices. In fact, watching TV at a very short distance might not be very advisable but it certainly is a good way to observe the RGB model at work, as the colours can be clearly seen with the naked eye.

Auguste and Louis Lumière
Marie Weibel-Koehler
portrait
1905, autochrome glass
plate, 15 x 12 cm
Courtesy Odile Donis

Fish and game merchant
1913
Courtesy Bassetlaw Museum

Kathleen Burton
1918
Courtesy Bassetlaw Museum

CAPTURING THE RAINBOW

At the time of Maxwell's experiments, the photographic plates used (predecessors of negative film) were thin glass plates to which a photographic emulsion was applied. The emulsion was sensitive to light and reacted when exposed to it, creating an inverted version of the scene. Those parts of the emulsion most exposed to light would darken the most, such as the sky, for instance, while the darkest areas, say, a group of trees, would be less affected and remain brighter on the plate—hence the term 'negative', as the image's light and darks would be inverted. When printed, usually on paper, the 'negative' would be reversed and the light and darks would revert back to the correct image. Yet, the inadequacy of the photographic material of the time prevented colour photographs from representing the whole spectrum of reality for years to come. Red was particularly difficult to capture. It was not until 1873, when the German chemist Hermann Wilhelm Vogel experimented with aniline dyes, that things changed. Vogel discovered that the emulsion on the photographic plates could be enhanced by dyes, which, when added to the emulsion, increased sensitivity to colour by absorbing it. This also meant that the exposure time (the time in which the plate is exposed to light) could be drastically reduced. All was set for the arrival of the colour camera.

By the turn of the century, the RGB model processes were manifold, while their level of success mainly depended on the complexity of their technical image projection requisites. In 1907, the French brothers Auguste and Louis Lumière presented their Autochrome, the first commercially successful colour photography method, which consisted of a screen plate filter covered in a microscopic mosaic of potato starch particles dyed with our famous colour trio. The results were crisp and vivid, especially as their technology required them to be seen through a specially prepared light-projecting device. While this process did not require printing, taking shots was time-consuming and producing the image was complicated, and the arrival of commercial colour film in the 1930s rendered Autochrome increasingly obsolete. This was virtually the end of the additive model in colour photography—that is, until the invention of the digital camera.

METEORITE NEGATIVES: CAREY YOUNG AND THE REDSHIFT SERIES

Carey Young has given a twist to the basics of photographic printing in her 2010 *Redshift* series. In the darkroom, Young turned light into images without the help of a camera. She made light pass through thin slices of pallasite, a rare kind of meteorite that consists of olivine crystals embedded in a translucent iron-nickel matrix. Coloured photographic paper was used to catch the light as it passed through the translucent material. Considered by Young as having a certain 'forensic' quality,

OVERLEAF
Carey Young
C-type print from the Redshift series (exposed from a slice of pallasite meteorite, formed approximately 4.6 billion years ago, at the birth of the Solar System. The artist hereby declares that with effect from 1 January 2110 copyright protection in this work shall be abandoned on a country by country basis. This global abandonment of copyright is to begin with the Prime Meridian and will proceed westerly across the globe at the rate of 1000 miles per year, as measured from the Equator)
2010, C-type print mounted on aluminium, 84.1 x 106.7 cm
Courtesy Paula Cooper Gallery, New York
Copyright Carey Young

as it reveals the structure of crystals formed billions of years ago, this technique is certainly not that distant from the photographic plates of the nineteenth century.

Young acknowledges the freedom that printers and photographers have concerning the choice of colour when developing film. She chose red and blue for her prints—and the title of the series—alluding directly to the terms 'redshift' and 'blueshift'. These are used in astrophysics to refer to the light transmitted by space bodies moving towards or drifting away from the viewer, respectively. The trajectory of an object emitting light modifies the travel of light on the electromagnetic field. Depending on which direction the emitting body is moving, the wavelength will tend towards the red or the blue end of the spectrum.

PRINTING AND THE SUBTRACTIVE COLOUR MODEL

While the RGB model belongs to the world of light projection, the process of printing colour photographs requires a different, in fact opposite process. This is the subtractive method, also known as CMYK. Anyone who has dealt with ink-jet printers will find the term familiar. Whilst CMYK stands for cyan, magenta and yellow, K refers to black, which is used in mechanical printing processes to control the quality of the print. While, in the RGB model, light beams add up to create the other colours, the CMYK model is called 'subtractive' because dyes and pigments are used to subtract certain wavelengths from the light reflected by a white surface. Hence, cyan absorbs red, magenta absorbs green and yellow absorbs blue: a certain combination of the three primary absorbing colours will allow the remaining light wavelengths to be reflected from the white surface of photographic paper.

It was the pioneering method by the Frenchman Louis Arthur Ducos du Hauron, patented in 1869, which first succeeded in using the subtractive method to print in full colour. The process, known as carbon printing, consisted of three negatives captured through red, green, and blue filters, which were then printed on three sheets containing cyan, magenta and yellow pigmented gelatin. Those sheets would next be developed in warm water and, finally, applied one by one to a sheet of photographic paper. The process was, unsurprisingly, complicated and long, albeit producing beautiful results. Yet, it was the beginning of a long list of inventions and patents that kept Europe busy for decades, when devices with such enticing names as the Miethe-Bermpohl camera were put on sale with relative success. [Perhaps one of the most celebrated early examples of colour photography brought by the subtractive method is the series of scenes recorded by Sergey Prokudin-Gorsky all around the Russian Empire.]

PHOTOGRAPHIC PAPER: JAMES WELLING'S PHOTOGRAMS

Development of the subtractive printing process into more practical methods was made possible by the use of photographic paper, already popular in black and white photography. Ever since the negative to positive printing process had dominated black and white photography (and, increasingly, colour photography), photographic paper had been the common counterpart of negative plates and films. Like the latter, this special paper was coated with a light-sensitive emulsion, which, in the case of colour paper, consisted of three layers made sensitive to each of the subtractive colours. The light-sensitivity of this paper offers a range of experimental and artistic possibilities, some of which do not require a camera. This is the case of photograms, which du Hauron himself tried out. A photogram is achieved by placing objects on photographic paper and then exposing it to light: the reaction of the chemicals on the layers will create the photograph of the objects which, by obstructing light, create an outline of themselves.

American artist James Welling manipulates the materials and techniques of photography, creating objects that are as much an analysis as a celebration of the photographic process. Many of his projects are abstract in appearance, yet they perform as documentations of the often obscure processes that lie behind the photographs. Cameraless exposures have been frequent in Welling's practice since the 1980s. In his *Degradés* series, Welling placed a photographic paper of a certain colour under an enlarger, which acted as the light source. He then moved a piece of cardboard across the surface of the exposure, creating different tones of shadow and brightness on the paper, which reacted accordingly. The results were varied and individual, going from colour gradients that remind the viewer of digital colour samples in photo-editing software, to blocks of colour that resemble Mark Rothko's iconic Modernist paintings.

COLOUR FILM IN MOVEMENT

The public availability of more practical, mobile cameras increased steadily after Kodak introduced plastic roll film in 1889. The nitrocellulose used in making this transparent new base proved to be a milestone of commercial photography—with an explosive twist. This nitrate film was tough and cheap, but also extremely hazardous as it burned easily. Yet, it was this tempestuous material that gave birth to one of the pillars of twentieth century culture: the motion picture. While glass plates were still widely used for photography long after the introduction of plastic film, the very nature of the moving image required something flexible and fluid to exist.

Louis Arthur Ducos
du Hauron
View of Agen, France,
showing the St Caprais
cathedral
1877, heliochrome,
16.5 x 22.6 cm

In 2012, some everyday life scenes shot around 1902 by a British inventor called Edward Raymond Turner rewrote the history of colour film. While Turner's complicated three-colour system was already known, it had been considered a failure until digital technology revealed the historical value of his film. Coloured film had already made an appearance by the time of Turner's experiments: Thomas Edison had started showcasing the hand-dyed *Annabelle's Serpentine Dances* in 1895, and early special effects innovator George Méliès sold coloured versions of his black and white films. What is extraordinary about Turner's footage is that it is the first surviving example of colour achieved by natural means—that is, through photography. Patented in 1899 by Turner and his financial associate F Marshall Lee, the new additive colour system was adapted from Maxwell's model and applied with a camera built by a Brighton engineer called Alfred Darling. The camera contained three frames of exposed film that recorded the scenes simultaneously in red, green, and blue. Three coloured filters were then used to project the frames, achieving a final scene with the whole spectrum of colour. The computers at Bradford's National Media Museum managed to merge the three films and combine their primary colours into one whole, astonishing full-spectrum film.

Also British was Charles Urban's Kinemacolor, direct descendant of Turner's model, although this one only used additive red and green filters, through which a prepared black and white film was projected. After years of exclusivity and wonder at Urban's films of coronations and other national ceremonies, Kinemacolor gave way to many new additive projecting models. However, all of them shared the ailment

LEFT
James Welling
ISLB
2004, unique C-type print
mounted on plexi, framed:
109.5 x 87.6 x 3.2 cm
Courtesy Maureen
Paley, London
Copyright the artist

ABOVE
James Welling
IPGI
2004, unique C-type print
mounted on plexi, framed:
109.5 x 87.6 x 3.2 cm
Courtesy Maureen
Paley, London
Copyright the artist

of requiring too much energy: the presence of filters dimmed the final amount of light that made it to the screen, which had to be smaller than usual. Subtractive colour and Kodak would bring this problem to an end.

TECHNICOLOR AND THE CONQUEST OF COLOUR MOVIES

In 1918, William van Doren Kelley left his experiments with additive colour and started releasing short motion films developed with a bi-colour subtractive printing process called Prizma. Prizma recorded red and cyan light on a special kind of film that had one emulsion on each side. This film negative was then washed out to black and white and next dyed with the complementary colours. Prizma would become the origin of all the main colour systems for motion picture that followed, including Technicolor, which started as a two-colour system researched by Dr Herbert Kalmus. Decades of expectation and funding finally bore fruit when, in 1932, Dr Kalmus and his lab revealed their latest invention: the three-strip camera that would bring the whole of the spectrum of the rainbow to cinema. This iconic machine—and its extremely complicated printing system, which included attaching the soundtrack to the film itself—would become the most important and profitable device available in filmmaking for the following 20 years. Indeed, the importance of Technicolor in the success of film studios such as Disney is almost incalculable.

It didn't all end with Technicolor, though. In 1932, Hungarian chemist Dr Bela Gaspar devised a one-film tricolour system called Gasparcolor, which produced beautiful results and was favoured by many early artists and filmmakers, such as the German Oskar Fischinger and the New Zealander Len Lye. The production and distribution of Gasparcolor was greatly disrupted by the hostile attitude of the international community towards Nazi Germany, where Dr Gaspar lived and worked. As a result of the political atmosphere—and following a conflict with the Nazi government, which stole some of his patents to develop Agfacolor film—Dr Gaspar would eventually flee the country, moving to Hollywood and trying his luck there. Gasparcolor didn't catch on in America, where Technicolor had an unbeatable monopoly in the distribution of colour film and cameras among the big studios. Iconic triumphs of colour cinema such as The Adventures of Robin Hood, 1938, and The Wizard of Oz, 1939, fed the audiences with a taste for the rainbow that would never fade away again.

TOWARDS MODERN COLOUR PHOTOGRAPHY

Similar to Dr Gaspar's tricolour film, Kodak's 1930s home movie 16 mm rolls had three layers of emulsion on one film, each for one of the additive colours. Leica marketed the 35 mm camera in 1925, and Kodak followed in 1936 when a 35 mm film for still photography was made available. The 1930s marked the division between the science and the consumption of photographic material: as processes became more and more complex, 'snapshot' cameras and film were also increasingly affordable. Autochrome and other screen processes on glass became

obsolete, what with the appearance of reliable negative processing services and colour film that adapted the flexibility of the ones used in monochrome hand-held cameras. With the first 'integral tripack' film, popularly known as Kodachrome, you no longer needed to know much about photography to take a photograph.

Kodachrome was quick, light, easy and cheap: once consumed, the roll could be sent, still inside the camera, to the Kodak laboratories, where it was developed, made prints of, and sent back to the customer together with the camera ready to use again. In 1946, Kodak Ektachrome could be processed by the photographers themselves. This was just the beginning of a fast-growing industry, with Agfa providing even simpler and quicker processes shortly after, and with Polaroid producing its iconic instant colour film in 1963.

The world of modern colour photography has brought many variations ever since, each with its own fascinating process. Yet, all share the same physics and chemistry principles, demonstrated and perfected by the pioneers of nineteenth century photography. Myriad contemporary projects use the instruments and science of photography to produce colour, revealing the inherent wonder of a process that has a particular materiality to it.

HISTORY OF PHOTOGRAPHY AND RAPHAEL HEFTI'S LYCOPODIUM SERIES

Artist Raphael Hefti's practice is deeply ingrained in material and industrial processes, looking in them for the unusual or the accidental and re-enacting elements of chance in order to achieve objects of great beauty and significance. Hefti's *Lycopodium* series looks at photography from its most basic foundation on light, revealing the primary chemical reactions that we eventually come to identify as images. Hefti made great scale photograms using lycopodium powder, a yellow substance composed of the dried spores of several clubmoss plants. The spores, extremely flammable, were spread on coloured photographic paper and then made to react within a pitch-dark room. Exposed exclusively to the light generated by the burning spores, the colour paper creates shapes and textures that the uninformed viewer finds abstract and enigmatic.

Hefti did an almost archaeological study of these lycopodium spores, not only looking at their immediate chemical powers but also at their historical meaning. The natural origin and easily controllable nature of the spores have made them a widely used, mild explosive that, among other things, worked in early photography as flash powder. By transporting the spores' luminous properties from their originally external use to the core of the appearance of the image on the paper, Hefti renders them more visible than ever.

Rafael Hefti
Lycopodium
2012
Courtesy the artist and
Ancient & Modern, London

Nowadays, as photography is constantly developed to fulfil ever more complex technical functions, the artist projects here discussed offer something different to contemporary professional and media hi-tech products. In contrast to the certainty provided by incredibly complex apparatus, these artists operate in an area of uncertainty where colour is often a product of chance, bending to the idiosyncrasies of matter. The obscure properties of much of today's machinery, only manageable after a careful read of complicated instruction manuals, separate us from the process of creation of many of the materials and objects without which our lives would not be possible. Carinna Parraman's essay will unveil the making of digital colour, which, for all its involvement in the current fabric of culture, can be considered one of the big mysteries of contemporary life.

COLOUR CARBON PRINTING
ART & SOUL

Seattle-based Art & Soul work with photographic artists to develop unique prints using the nineteenth century process of colour carbon printing (sometimes referred to as pigment transfer), originally developed in 1855 by Frenchman Alphonse Louis Poitevin. The nineteenth century process of colour carbon printing worked by mixing carbon black pigment with gelatin and dichromate, which was then exposed to light through a negative and washed—the unexposed areas of the print washing away to reveal an image.

Art & Soul's modern day technique utilises digital technology to reach a similar outcome. Pigmented gelatin emulsions are exposed to ultraviolet light through high-resolution negatives created from digitally captured images. The exposed films are then laminated onto polyester sheets and washed in hot water to reveal images, the exposed features forming the picture and revealing a permanent colour carbon print. Four layers of these prints are then combined (cyan, magenta, yellow and black) to create the intensity in colours unique to the process.

Art & Soul work with a range of artists, printing their work using the colour carbon technique—including Burk Uzzle and Tod Gangler. The quality of the prints and the vivid colours this method of printing produces can be viewed in both *Oaxaca at Night* and *Arctic Ocean* by Tod Gangler and *Jesus & Bat Under Glass* by Burk Uzzle.

CHRIST CRUCIFIED
HAVE MERCY ON US

VIVEX TRI-COLOUR PHOTOGRAPHY

MADAME YEVONDE

Madame Yevonde was one of the first British photographers to utilise the craft of colour photography. Working between 1914 and 1975, Madame Yevonde became known for her society portrait photography and work for fashion magazines. Mounting the first colour photography exhibition in the UK in 1932, Yevonde became known for her prowess with the camera and her adoption of this technologically sophisticated mode of working, creating contemporary images far beyond those of her peers. Today, more than 3,000 sets of colour negatives by Madame Yevonde remain in the Yevonde Portrait Archive.

Madame Yevonde's technique became synonymous with the Vivex tri-colour separation process—a subtractive photographic technique that used three negative plates in cyan, magenta and yellow, which allowed for colour manipulation at exposure. Yevonde worked with the Vivex technicians to develop its technology and master all aspects of its process, continuing its legacy after the company's closure during the war.

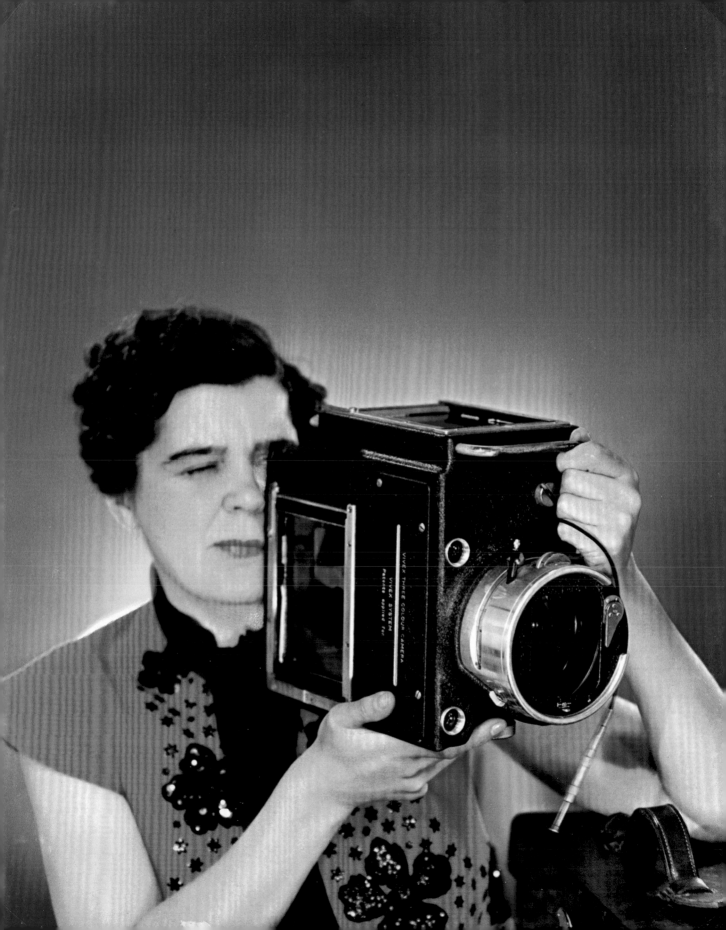

3PART HARMONY: COMPOSITION IN RGB #1

AMANDA DAWN CHRISTIE

3part Harmony: Composition in RGB #1 is an experimental dance film by Canadian artist Amanda Dawn Christie. Choreographed, performed and directed by Christie herself, the performance explores "the psychological fracturing and reunification in representations of the female body" through a unique filmmaking process, reminiscent of the 1930s three-strip Technicolor process.

Three separate dances were choreographed corresponding to each primary colour. These were then separately filmed onto black and white film through the corresponding red, green, and blue colour separation filters. The three black and white films were then recombined onto colour film, one frame at a time, using an optical printer.

Christie lives and works in Moncton, Canada, where she is Director of the Galerie Sans Nom. Her interdisciplinary practice encompasses several mediums, including film and video, installation, performance, photography and sound art. The technology behind film and photographic images is central to Christie's practice, in which she explores different methods of production, often in relation to themes on the human body and identity, as seen in *3part Harmony: Composition in RGB #1.*

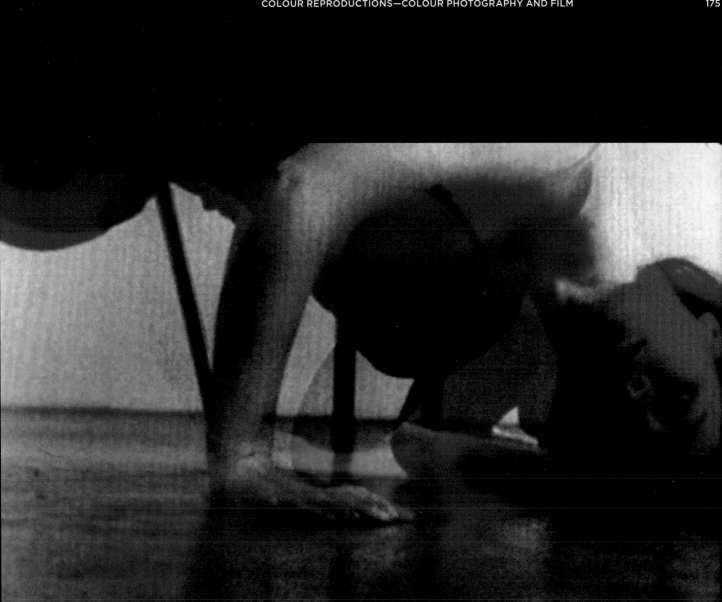

TWENTY-
FIRST
CENTURY
COLOUR
—PRINTED
COLOUR

COLOUR MIXING IN THE TWENTY-FIRST CENTURY

THE CRAFT OF THE DIGITAL

CARINNA PARRAMAN

Over the last 150 years colour has evolved. From heat enduring pigments used in the automotive industry, fade resistant colours and colour changing chemicals used for textiles and printing, to a wide gamut of colours used for film and television and graphics, these new kinds of colour are ubiquitous to almost every aspect of our waking life. This evolution is the result of new synthetic pigments and dyes, methods for mixing and measuring colour as wavelength (red, green, blue), the development and application of printers' process-colours (cyan, magenta, yellow, black), and the ability to create three-dimensional models and to specify colour within a colour-space so that colour can be accurately reproduced.

Now in the twenty-first century, computers, image manipulation and publishing software have significantly advanced colour mixing. Electrostatic and inkjet technologies now enable colour, text and image to be printed in one pass. From its roots in nineteenth century photomechanical reproduction, the science and technology of the twenty-first century print has become staggeringly sophisticated. Print machines, operating systems, colour calibration methods, software, cameras, and scanners provide the artist with a seamless workflow system; from image capture to print. Inkjet printers are capable of rendering accurate colour onto highly glossy papers at an extraordinary speed and scale. Furthermore as the primary benchmark for inkjet printing is based on photographic reproduction, papers (smoothness, roughness, gloss, matt) and colour gamut (tonal range, dynamic range) are used to mimic photographic qualities.

As one may have noticed when browsing magazines, books, or postcard reproductions from an art exhibition, colour reproductions—even of the

PREVIOUS PAGE
Carnovsky
RGB
2010, wallpaper installation
J&V Showroom, Milano
Photography Luca Volpe
Courtesy the artist

ABOVE
Verity Lewis
Skulls
Demonstrating the range of colours and complexity of shape that is achievable using additive layer manufacturing (ALM) or 3D printing.
Courtesy the artist

same image—can appear quite different. The quality of the colour print is dependent on a range of mechanical factors: the quality of the capture devices, the gamut of the inks, the tonal curves for colour separating the image, the halftoning algorithms and the quality of the paper and finishing. Adding to this the varying aesthetic and technical knowledge of the designer in achieving a pleasing colour-balance and tonal range of an image, the permutations are limitless. Technological developments in image capture, colour and reproduction have therefore centred on reducing error, towards the creation of a universal colour language that can measure and reproduce colour with nano-metre accuracy. For example, in branding and advertising when a specific colour is needed to represent a brand, a Pantone® colour reference number might be used, which combines colour swatches and their correlating CMYK colour percentages. Whilst this is not a wholly precise mixing system—process colours can vary and the surface quality of the paper can impact the reflectance of the printed colour—it does provide the printer and the customer with a benchmark for colour specification and reproduction.

But what are the technological and aesthetic implications and limitations for the artist? Technology has become so advanced, an ongoing criticism is that some artists no longer have an understanding or a hands-on engagement with the application of colour to surfaces and objects in a physical world, or of manipulating materials or working with a range of different processes. Being reliant only on computer software, it can be argued that some artists are unlikely to know how to make the things they use, or know how they are made. Has the artist become deskilled?

Considering the evolution of pigments, colour mixing and the application of colour, this essay will address how in the last two decades we have experienced a digital shift in the way artists make images and artefacts. In the light of the current generation of artists it has been necessary for artists to re-evaluate ways of colour mixing and adapt to methods in the application of colour. This essay will consider the different artists' skills that have evolved in colour mixing, through different materials engagements, processes, software and hardware.

A BRIEF HISTORY TO PHOTOMECHANICAL METHODS OF PRINTING

From the perspective of examining digital colour and current print processes there were three discoveries in the mid-nineteenth century that had a significant impact on contemporary colour. Four-colour printing, and subsequently inkjet technology, has evolved from nineteenth century photomechanical processes, methods and new pigments. As developed by William Henry Fox Talbot (1800–1877), the first milestone of the nineteenth century (in the context of this essay) was the development

William Tillyer
The Large Bird House
1971, etching aquatint on
paper, 56 x 76 cm
Courtesy the artist
Copyright William Tillyer

William Henry Fox Talbot
*Latticed Window at Laycock
Abbey*
1835, taken with a
Camera Obscura

and the production of photographic images using a printing press.[1]
The second, that had a significant commercial impact for the textile
industry, was made by William Henry Perkins (1838–1907) in 1856 when
he successfully synthesised aniline purple or mauve. Also in 1856, James
Clerk Maxwell (1831–1979) demonstrated his theory of trichromacy (red,
green, blue) using photography, and calculated how colour, relative to
one another, could be plotted in a three-dimensional space.[2] This spatial
understanding of colour relationships has had an enormous impact on the
accurate specification and measurement of colour. Although seemingly
disparate, these three extraordinary scientists working across different
disciplines have had a remarkable impact on the way we use, make,
perceive and specify colour.

From the three primary print processes (relief, intaglio and planographic), there have evolved a wide range of autographic and photomechanical print processes, each demonstrating a range of printerly marks. An artist knowledgeable of these processes is able to use these qualities to convey expression through many different techniques. However, on a more commercial level, these processes evolved primarily to reduce costs and increase production while increasing accuracy of reproduction and colour.[3]

Contemporary four-colour printing has evolved through the many developments in nineteenth century photomechanical processes and, particularly, methods of halftoning, which is a process for breaking an image into a series of dots. These dots vary—either by size, shape and spacing—according to the intensity of the tone, that when printed or viewed at a distance, conveys the impression of a full tone image. The basic procedure of any photomechanical process relies on the presence of a light hardening emulsion to create an image of photographic quality. Working from his negative-positive photographic image, William Henry Fox Talbot patented his photomechanical print in 1852.[4] Working as an artist and scientist, by developing the idea of breaking up tones by means of a screen, Talbot produced a range of beautiful images by capturing and reproducing nature in detail. From his original method, there quickly evolved many photomechanical variations, which, within 25 years, the print industry was able to commercially adapt for high-speed print production.

By way of an interesting twentieth century comparison, the etching by William Tillyer in the 1970s resembles the early work by Talbot. According to Tillyer, for his print *The Large Birdhouse*, 1971, the idea was in fact conceived not far from Talbot's house when Tillyer was teaching at Bath Academy of Art in the late 1960s. Tillyer called these works "lattice etchings", calling to mind both the halftone structure of the print and also the first picture that Fox Talbot successfully captured of his *Lattice Window at Laycock Abbey*. The subtle changes of the crossed lines in Tillyer's etching demonstrates the use of a combination of commercial Letratone grid patterns with his more intuitive hand-drawn approach to 'developing' the image using acid instead of photo chemicals.

It was not until 1881 when the halftone had practical and economic implications. FE Ives of Philadelphia devised a halftone system that was made up of a series of small squares and dots. In 1882, Georg Meisenbach patented his cross-line screen or halftone screen, whereby during exposure, a single lined screen was turned to create the cross-lined halftone. This process offered a greater depth of tone and enabled three or four-colour printing to become more practical. However, viable four-colour process printing was not really available until the 1920s when accurate photographic filters and pure process colours were available to make and print the separations.[5]

Although printmakers have often suffered criticism for being overly dependent on process, the fine art print has evolved symbiotically with other technological and commercial processes and can therefore be considered the link with many areas of applied arts, science and technology. In more recent times, through the combination of digital and traditional print practice, print has developed into a new and sophisticated field and has assisted in the crossovers between traditional and innovative practice, particularly where colour is concerned.

COLOUR MIXING USING HALFTONES

At the turn of the twentieth century, making a colour print involved creating a mechanical colour separation — three separate photographs of the image would be taken using red, green and blue colour filters. These photographs were then inverted to create three negative images and their process-colour counterpart, i.e., a red component produces a cyan separation, the green a magenta and blue produces a yellow. When printed using cyan, magenta and yellow inks, a positive print is the result. This is still the basis of colour separation today but through developments in digital prepress these systems are now highly sophisticated, allowing for imaging software to add colour channels, spot colours and to determine the dot size, shape and resolution. Understanding the basics of how these processes function will enable more control over the production and reproduction of images today.

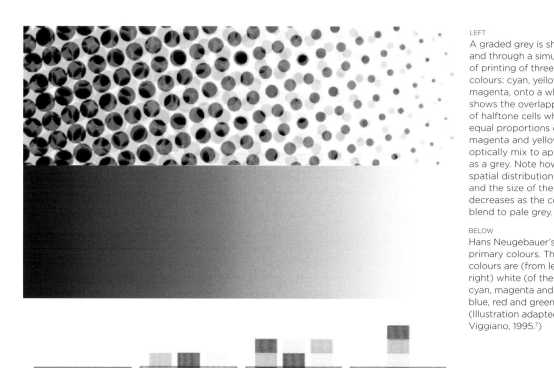

LEFT
A graded grey is shown and through a simulation of printing of three process colours: cyan, yellow and magenta, onto a white paper shows the overlapping of halftone cells where equal proportions of cyan, magenta and yellow will optically mix to appear as a grey. Note how the spatial distribution increases and the size of the dots decreases as the colours blend to pale grey.

BELOW
Hans Neugebauer's eight primary colours. The primary colours are (from left to right) white (of the paper); cyan, magenta and yellow; blue, red and green; black. (Illustration adapted from Viggiano, 1995.[7])

Screenprinting in the first half of the twentieth century, particularly during the war, was a convenient method for printing large stencil areas onto flags and signs. However, the process was quite crude, and poor quality inks and inaccurate stencils resulted in uneven edges and prints that did not dry.[6] In the 1960s, with the introduction of sharp edged stencil films that could be ironed onto a screen, pre-sensitised screen films that enabled halftone and a greater degree of accuracy, and combined with high-quality pigmented inks, thus facilitated a new method of expression and enabled artists to engage with photographic images to produce a new form of visual expression. The possibility of combining text, collage, colour, onto a variety of surfaces as many times in as many variations was limited only by the artist's imagination. In the early 1950s Richard Hamilton made collaged paintings by incorporating cuttings from magazines. It was not until the 1960s, when photographic emulsion could be employed, that he was able to produce photomechanical screenprints. Hamilton's work combines his creative drive with technical innovation and demonstrates why screenprinting became so popular.

Unlike artists' pigments, commercial CMYK colour mixing is based on percentages of colour, as exampled in the commercial Pantone® colour matching system, and now emulated in inkjet printing. Moreover, the success of the printed halftones lies in the principle of additive and subtractive colour mixing. In 1937 Hans Neugebauer published his method

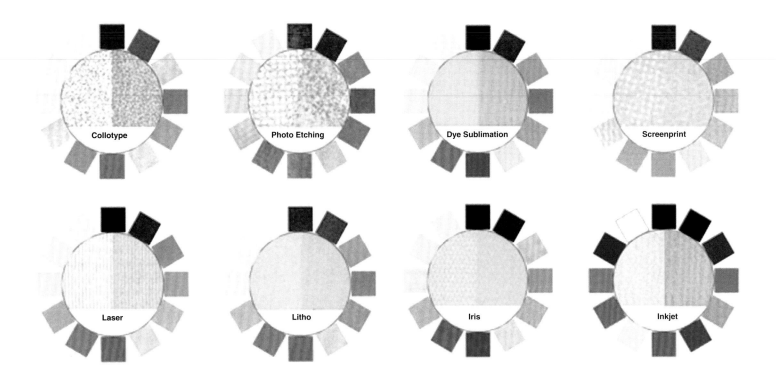

Examples of primary process colours printed at different percentages using a range of print processes. The inkjet sample shows full primary colours printed at 100 per cent and reflects the extended process primary colours now used in digital printing. The white patch relates to a gloss, which is used as an enhancer to increase the surface gloss on photographic papers.

for mathematically predicting and modelling the printed appearance of process colours.[7] Neugebauer's eight primary colours are achieved by placing one primary process halftone on top of another. Through the placement of coloured cells of cyan, magenta and yellow onto a white paper, and when viewed at a distance, our visual system will assimilate a blended range of ink colours with the white of the paper.

As described in the introduction of this essay, there is a vast range of pigments required for a range of colour applications. A CMYK oil based ink set that is printed from an etching plate onto a heavy weight uncoated paper will present a very different appearance if compared to an aqueous CMYK inkset that is inkjet printed onto glossy paper.[8] By way of example, the following CMYK colour circles show different process colour patches printed at 100 per cent, 80 per cent and 40 per cent. The centre of each colour circle shows a microphotograph (approximately 40 times magnification) of the cyan samples printed at 80 per cent and 100 per cent. In some examples it is difficult to identify the dot structure at 100 per cent. It is interesting to compare the different halftone patterns, for example, the regular dots of the photoetching or screenprint, compared to a random reticulation of collotype, or the near continuous tone of the inkjet print. The inkjet example includes an extended colour-set including red, green, violet, and a range of greys. In order to fulfil the many requirements of digital printing, some inkjet printers may contain

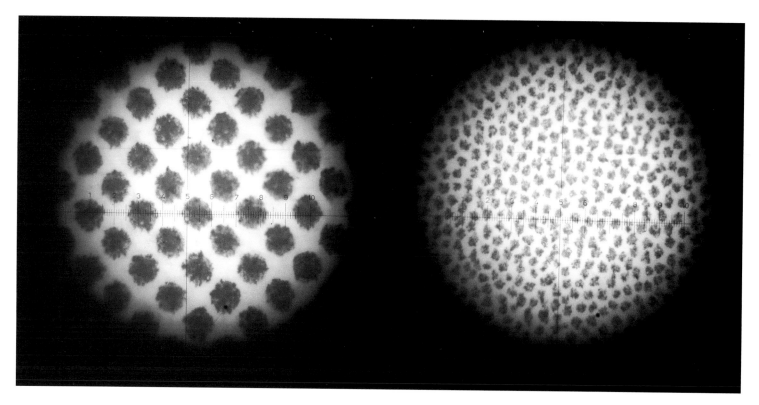

12 different colour channels. It is also interesting to compare the primary process colours, their brightness and density. When comparing inkjet process colours to litho process colours, one can begin to understand the gamut limitations when making reproductions of artworks or colour matching between on-screen colour (monitors, cameras) and printed colour.

Showing the difference between a regular halftone (left) and a stochastic halftone (right).

With the advent of inkjet, recognised CMYK colour systems and language were appropriated and transferred from the commercial offset litho and screenprint industry. Designers and printers working in the graphic design industry—using all the prepress software, and commercial colour systems—could easily make the transition to inkjet printing. Therefore, for these designers and printers who were used to working in a CMYK language, inkjet machines quickly became commercially expedient as a replacement for short run printing projects.

A significant and important element of the printed inkjet halftone was to sidestep the traditional Ives' regular halftone ruling, replacing it with alternative stochastic algorithms—or a more random dot, also known as FM frequency-modulated screening.[9] Through new stochastic developments in half-toning, methods by which thermal or piezo print heads apply dots to the paper surface the resulting dots are more pleasing, where more opportunity for overlayering of other colours and a greater amount of colours can be printed at the same time with no obvious interference patterns.

Contemporary artists have exploited halftone patterns or alternative patterns as a way of artmaking. Well known for their signature art-style, Roy Litchtenstein used Benday dots and stripes to create the quality of a large-scale comic-strip. Sigmar Polke incorporated Benday dots using a painterly halftone approach for his grand scale canvases. Taking the idea of patterning further, Eduardo Paolozzi used commercially printed dry-transfer Letratone™ patterns, which he used as stencils for screenprint, that when overprinted created novel colour results. The combination of the pattern and colour are so effectively used, that when standing at a particular distance, they begin to optically mix.

My own creative practice has investigated theories and methods as explored by scientists and artists who had an interest in the perceptual properties of colour. These prints demonstrate an ongoing fascination for the illusory properties of colour by using different patterns to create different tones. These prints also change according to viewing distance: isoluminant colours appear to vibrate and dazzle close up, but far away the image appears grey and desaturated (a similar phenomenon experienced in the works by Seurat).

NEW PIGMENTS, DYES AND INKS

In the previous sections in this book, Mark Clarke and Philip Ball have described how making paints and inks have evolved over time. This section will consider the users' requirements in the twenty-first century. Paints and inks have changed considerably in order to meet the demands of colour mixing, matching, reproduction and application. More importantly, coloured materials must be resistant to light, moisture, air, alkalis, acids and also be resilient to thermodynamic requirements of an inkjet printer head system. These highly specialised materials are required for high performance applications that are very different to the traditional watercolours and paints as used by artists.

As explained by Philip Ball, during the mid-nineteenth century when Fox Talbot was developing a method to photomechanically print images, William Henry Perkins was experimenting with synthetic dyes. These synthetic dyes had almost completely replaced their natural counterparts, and at a fraction of the cost radically changed the dying industry; markets for the organic pigments collapsed almost overnight.

At the beginning of the twentieth century, synthetic pigments also began to be developed. These new synthetic organic pigments tend to be more lightfast than their natural organic counterparts, they are highly saturated and can be used as an extender to replace larger proportions of inorganic pigments; thus reducing manufacturing costs. The rather unimaginatively named C1 pigment Red 57:1, is one of the most significant pigments

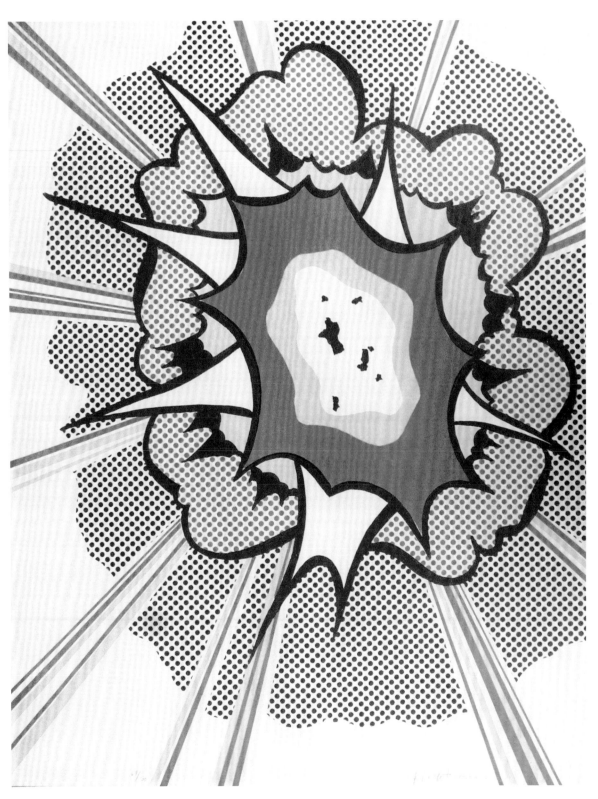

Roy Lichtenstein
Explosion
1965–1966, lithograph on
paper, 56.2 x 43.5 cm
Copyright Estate of Roy
Lichtenstein/DACS 2013

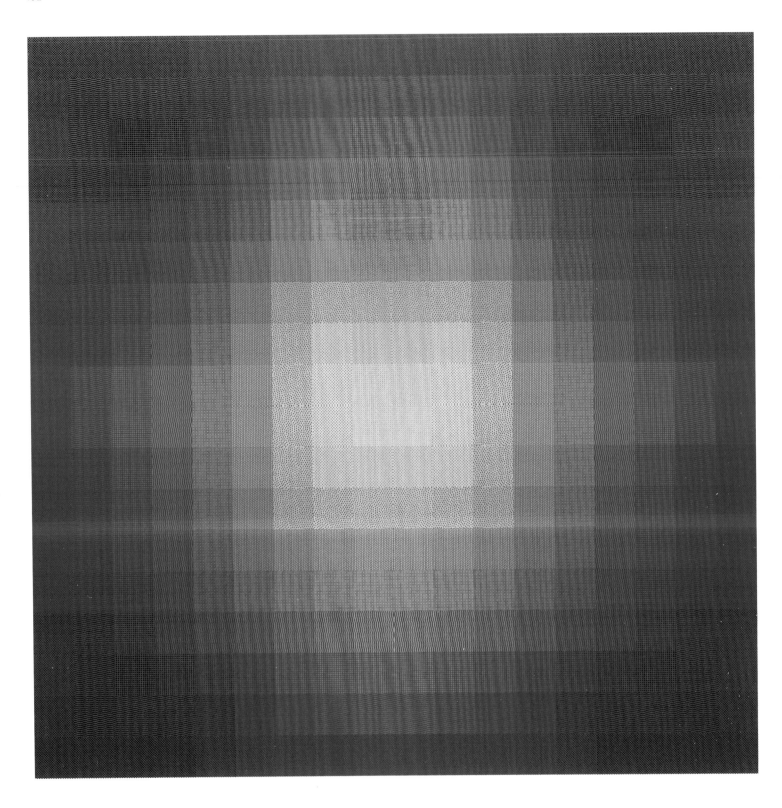

ABOVE
Carinna Parraman
Assimilation and Contrast II
2007, digital inkjet on paper,
50 x 50 cm
Printed at The Centre
for Fine Print Research,
University of the West
of England, Bristol
Courtesy the artist

today and is used as magenta in CMYK colour printing. Other pigments, due to their hue purity, such as diarylide yellow and the greenish-blue phthalocyanine, among others, are also important colours for process colour printing. The carbon based black ink is the most resistant to fading and is capable of withstanding visible, ultraviolet light, moisture and air.[10]

Based on my experience of early inkjet dyes in the 1990s, inkjet colours were dye-based inks and faded in a relatively short space of time, in some cases overnight. Since 2000, inkjet inks have developed with a higher degree of permanence. The cheaper and less permanent inks still fulfil a necessary role for major sectors of the industrial and office market, whereas the high-end fine art market inks have significantly shifted their use of dye based to pigment based inks. Pigment inks have brought the longevity of printed output in line with standards established in the high-end museum quality print market. This shift has developed in response to user demand for archiving and colour longevity, especially for the production of large print works, including exhibition, display and the fine art and poster market, where it is essential for colours not to fade.[11] As wide format printers are becoming wider and computers are able to process large image files, there is more of the opportunity to make very big prints that move beyond the boundaries of the frame to free hanging works and installation works. Particular examples were the room sized pieces in Wolfgang Tillman's Exhibition, If One Thing Matters, Everything Matters, 6 June–14 September 2003, Tate Britain.

Although pigment inks are less intense than dyes, they are more resistant to light and gas fading. The pigment molecules are more complex and break down at a slower rate than the simpler, small molecule dyes. Whilst early pigment inks lacked intensity, advances have been made to improve the quality of these inks. Some manufacturers combine dye and pigment as a balance or trade-off between brightness and permanence. Furthermore, with greater demands and technological developments in high performance dyes and pigments, these definitions are beginning to be blurred. In very broad terms, many materials exist with a range of solubility and permanence; pigments at the low-end and dyes at the higher-end.

Over the last few years, manufacturers of solvent inks are now incorporating decorative inks such as white, gloss and metallic. Although white has always been a necessary component of any artists' palette, inkjet manufacturers have been slow to incorporate it into the inkset. This is mainly because particulate sizes need to be larger in order to obtain the right degree of opacity when printed. These novel inks can be printed onto coated vinyl, fabrics and boards that can be used outside and subjected to more challenging temperatures and weather conditions. These inks, solvent or so-called eco solvent (lower-solvent, slower drying) or ultraviolet (UV) curable inks, are increasingly available.

Wolfgang Tillmans
Peaches VI
2001
Courtesy Maureen
Paley, London
Copyright the artist

Showing different UV printed samples onto a range of materials including foil and decorative plastics, heavy weight paper printed on the back and front, printing gold onto decals, gloss and white onto translucent paper, multilayer printing onto a clear polypropylene. Artists (clockwise from top left): Gemma Wright, Carinna Parraman, Sarah Barnes, Katie Wallis

These examples were generated as part of a wallpaper project at University of the West of England (2011) and tested the capabilities of UV curable inks onto a variety of surfaces.[12]
Courtesy the artists, printed at Centre for Fine Print Research, University of the West of England, Bristol.

The main difference between conventional aqueous or solvent inks and UV curable inks is the addition of photoinitiators. In UV inks, the photoinitiator is combined with liquid monomers (light-weight molecules that bind together to form polymers), and when exposed to ultraviolet light, release free radicals (reactive molecules that can start rapid chain reactions). These produce polymers (high molecules), which results in a resinous printed material. A UV printed surface tends to be more robust, scratch resistant and can be applied to a wider range of materials, like cardboard, plastic, metal and canvas, because, unlike conventional inks, they are not reliant on the coating of the paper to hold ink on the surface.

THE CRAFT OF THE DIGITAL FROM RASTER TO VECTOR

The majority of our contemporary physical artefacts have some digital element to their manufacture, from image capture to prototyping. Digitally made objects can be fabricated in two and three dimensions and will either involve pixels or vectors to create an image. Each method carries with it different ways of making and thinking, and in some cases has implications in the way the image or artefact is manufactured. Zooming into a raster or bitmapped image will show it is composed of thousands or millions of coloured square pixels, where each pixel is the combination of RGB values. The size, quality and resolution of the printed image that is captured by a digital camera, or colour image that is generated in Photoshop, for example, is determined by the number of pixels: too little and the edges of objects in the print will appear jagged and look more like a patchwork blanket of odd colours, too many and the computer might grind to a halt.

Zooming into a vector-based image will show that lines, Bézier curves, layers and filters, shapes or text remain smooth with no degradation. Artists are increasingly using vector-based software as it means they can work in two and three dimensions, scale their work without degradation to the quality of the lines or text, and embed postscript colour information that is necessary for gloss or white spot colours. Richard Falle has chosen to create his surreal images in Adobe Illustrator, a vector based software, which for him is more akin to building or constructing an image from thousands of discreet components. He makes the analogy of the difference between Lego and clay. The building blocks of Lego, he explains, resemble the way Illustrator software can be used to work on individual objects and layers, which can be modified and adapted without affecting the rest of the image. The composite image is constructed from blends of colour and fills, layers can be added or removed, which create the illusion of translucency and texture. He finds that Photoshop, resembling clay, is too malleable, a modification to one section of clay can affect the rest of the artefact. For example, if the brightness or saturation of a colour channel is adjusted in Photoshop, then the image is changed

Richard Falle
*Exercise 10: Phalaenopsis
Memento Mori*
2012, pigmented inkjet print
on Somerset Photo Satin,
60 x 46 cm
Printed at The Centre
for Fine Print Research,
University of the West
of England, Bristol
Courtesy the artist

globally. It is interesting to note that although Falle is working in two dimensions he is thinking in three (Lego versus clay). The subtle nuances of colour are dependent on the composite of layers and filters. Using layers he is able to generate subtle nuances and blends. The visual effect of his work relies on a smooth surface and the inkjet printer is a perfect machine for rendering colour for that perfectly uniform, precision edged finish. Specially coated fine art inkjet papers are designed to hold the minute particle of ink to convey a continuous tone image.

Falle's files are printed in one pass on an inkjet printer, and this uniformity of surface was something that he desired in his print. However, surface and texture can now be added to inkjet prints that, through gloss, white and printed 'embossing', can change the surface dynamic and reflectance of the image. These new UV curing decorative inks can be used in a variety of ways, determined in design software such as Adobe Illustrator

Special printing features are accomplished by specific spot colours that are exported and embedded in the EPS or PDF files

or InDesign as a series of special printing features by using specific spot colours embedded in the file and then processed through a RIP (Raster Image Processor). For example, white ink can be used as an undercoat to print vibrant images onto clear, coloured or metallic surfaces much like a painter might use a white underpainting to make certain colours more vibrant. It can also be used as a single spot colour to provide highlights, for example on a dark material. In the same way, clear inks can be used as a single gloss, as a varnish to enhance areas, or to create a raised surface by overprinting layers of clear ink to create an embossed effect. Metallic inks are also being added to the inkjet set, where a silver base layer is printed with CMYK spot colours to create a wide range of metallic colours.

These spot colours have specific swatch colour names that when exported as an EPS (encapsulated postscript) or PDF (portable document format) from the Adobe design software are recognised by the RIP printer software driver. A job can be saved into several files, each having

Verity Lewis
Text'ured
2011, UV-curing inks printed
on paper using a UV Versa
LEC inkjet printer,
53 x 45 cm
Printed at The Centre
for Fine Print Research,
University of the West of
England, Bristol
Courtesy the artist

different components of artwork enabled. The first file may contain the
white and colour data, and the second file may contain the clear and the
cut-path data. In fact, the processes of printing a book such as this will
also use this process.

Playing with the idea of text, and specifically well-known lyrics to classic
movies, Verity Lewis used the theme tune to *The Spy Who Loved Me*
as the inspiration for wallpaper. Working in layers in Illustrator, and with
the layering capabilities of the printer, Lewis printed layers of both white
ink and clear matt varnish to create lettering in high relief. The text is
created as a spot-colour in Illustrator and then assigned to the various

combinations of passes. After trialling different layering combinations, the resulting 25 pass image comprised layers of: white (two passes), matt (ten passes), gloss (ten passes) and white (three passes).

Moving from two-dimensional vector based software, three-dimensional printing technologies are increasingly being exploited by a wider range of practitioners in the creative arts and design. 3D software is used to create complex wireframe objects, which can then be used to fabricate sculptural objects using 3D printing or additive layer manufacturing (ALM). The types of materials used for ALM include thermoplastics, metal, flexible and non-flexible photopolymers and powder. These are body coloured, in other words their colour is determined by the colour of their material make-up—metallic, neutral resin, white powder—but in some manufacturing processes colour is applied to the outside of the object as part of the additive layer process, for example, ZCorp printers employ heads that can inkjet a coloured layer to the surface.[13]

As exampled in Peter Walters' work, the 3D NURBS (Non Uniform Rational B-Spline) surface model is created in Rhinoceros (Robert McNeel and Associates). This model is then converted into a polygon mesh file for 3D printing. Colour information is assigned to the triangulated polygon mesh model. The objects are fabricated by powder-binder 3D printing (Z-Corp) which uses a plaster-based composite powder and inkjettable CMY and clear liquid binders.

COLOUR HACKERY

Current digital colour printing methods, as described in the most basic terms, involve the translation of a full coloured image as viewed on an RGB (red, blue green) monitor, from an RGB, or CMYK working space, via a digital printing pipeline, to a printer that combines highly intermixable process colours and halftoning to reproduce an image as closely as possible to the image on the monitor. The technical goal and commercial focus of manufacturers is to replicate a colour-balanced, continuous-tone image and the look and feel of a smooth surface of a traditional photograph. This goal has largely been achieved through high-quality inkjet printers and inks, even at the desktop level. As a result of the current advances in colour management and printing, the significant impact of inkjet printing has meant that users can now take for granted high-quality colour and resolution in their printed images.

However, there is a downside for the user, the printing process is increasingly becoming a closed loop system with very little intervention for tinkering and modification. Moreover, these digital methods for transferring a photographic coloured image from screen to paper are constrained by pixel count, file size, colourimetric conversion between colour spaces and the gamut limits of input and output devices. In other

As shown in the figures to the right, the green shape in the Rhino software can be assigned and printed in any colour. The two shapes are merged in the software and printed at the same time. These sculptural forms show how impossible objects can now be fabricated (right).

Peter Walters
Trumpet Spheres
2009, 3D printed using a
Z-Corp 3D printing system
Printed at The Centre
for Fine Print Research,
University of the West of
England, Bristol
Courtesy the artist

words, the constraints for artists are getting tighter, unless they know and understand the system, or can learn to circumvent it. It could therefore be argued that many artists no longer have an understanding of or a hands on engagement with mixing colour, manipulating materials or using a range of processes. For an artist reliant only on computer software the process of making is removed and the artist, deskilled. Yet, as described by Charney in *The Power of Making*, the catalogue to support the exhibition of the same name at the V&A (2011), craft skills are very much alive, despite the on-going negative and conflicting counter-arguments, "since the industrial revolution there has been a mourning for the loss of manual labour".[14]

An important question to ask at this point might be whether there is need for modification. Given the so-called deskilling of the modes of making and using colour in the digital realm, artists have proven how they are highly adaptive and active in readdressing the craft of colour for the twenty-first century. In the light of recent developments of post-digital printmaking processes, artists' adoption of CNC technologies have increased the range and diversity of image making, artefact construction and a re-evaluation of old analogue processes by hybridising old and new processes, and hacking earlier twentieth century technologies.[15] The following examples demonstrate that the printing machine, such as inkjet, has been re-employed as an innovative and creative colour mixing and plotting device. A deeper understanding of the relationship between artists' methods for colour mixing and their choices of colour pigments suggests new methods to developing alternative approaches for digital printing systems. The work of Ben Grosser, Kai Franz, and research at the CFPR, demonstrates different methods of modification, adapting and hacking of digital technologies, and illustrates how knowledge of and interest in the relationship of CAD based programmes to the fluid dynamics of materials are challenging this notion of the deskilled brought about by the digital.

This machine comprises an x and y axis flat bed, a z axis to raise and lower the brush, and uses a four paint colour system. The interesting aspect of this machine is the use of a brush that is attached to a circular rotating mechanism for dipping and swirling the brush in the paint pot. Once the brush is charged with paint, it applies a line according to its stimulus.

Grosser has chosen similar hues that will intermix to create a pleasing blend of colours. As the brush is not cleaned during the whole painting process, he has to carefully choose colours that will inter-mix on the canvas in a pleasing way and not result in a desaturated mess. In this instance on the machine bed he has chosen a light bluish grey, a grey, a turquoise, and blue. In the inset picture, the variables of ultramarine, light bluish grey, blue and red have resulted in some interesting colour

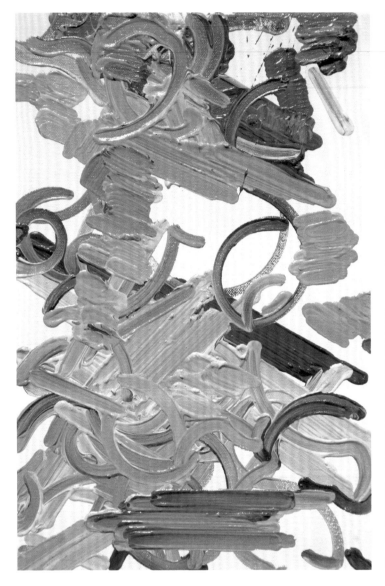

LEFT
Benjamin Grosser
*Interactive robotic
painting machine*
2011, oil on canvas,
38 x 25.4 cm
Courtesy the artist
Copyright Benjamin
Grosser (bengrosser.com)

RIGHT
Benjamin Grosser
*Interactive robotic
painting machine*
2011, installation
computers, robotics, camera,
microphone, mixer, speakers,
projector, oil paint, canvas,
and custom software
Courtesy the artist
Copyright Benjamin
Grosser (bengrosser.com)

mixtures. He uses oil-based paints and a medium to ensure colours do not dry and are able to mix on the canvas.

Kai Franz has been working in a similar area. Adapting a wideformat printer by raising the print head height by 30 cm, and incorporating a flat bed that moves perpendicular to the head, so that the print head can reach every point on a 2D plane, he has created a Dual-Axis Precision Deposition System, or 'Plopper' for short. The low relief latticed, web-like pieces are the result of Franz's investigation into highly complex and accurate computer aided drawings and the material and fluid properties of powders—sand, pigments, sugar and plaster—and liquids—paint and polyurethane resin.

Franz generates drawings using a vector based drawing software, then a program, written by Franz, interprets the drawings and converts them into a machine CNC-code to drive the Plopper. The head begins by depositing the various materials. The sand is mainly used to establish form, but also works as a binder for the resin and paint. The sand is also important in the creation of texture. The dual axis machine and head operates as a mediator between the precision lines of the CAD drawing and the more organic, fluid and viscous behaviour of the sand and liquid. Colour has taken on more importance in Franz's more recent works. He began by using colour to study the path of the machine across the plane, but it has now evolved as a method to investigate the physical qualities of the process: fluidity, overlayering, mixing of the dry and wet materials, their granularity, absorption and saturation. The colour appearance changes slightly through the chemical reaction of the resin. Sometimes, the pigments are added partially unmixed so that, as he explains, "the pigments will find manifestation and determination on the canvas".

As exampled in *Double Grid With Six Colors,* two of the Plopper's resulting objects are shown side-by-side, which are created from the same CAD drawing. Comparing these two structures they appear to be similar, but like fraternal twins are not the same, recalling the nuances and unpredictability of the machine and the materials and colours.

In both coloured examples there is a pooling of paint as the CNC-code is directed by the drawing for the Plopper to stop and deposit material. Here one can see that depending on the speed of the deposition there is a variation of fine lines as the Plopper moves quickly across the bed, or a build-up of paint and sand as it is standing or more concentrated in its movements. As demonstrated so well by Franz, the layering and textural qualities are crucial to the finished work. However, the inkjet process, modelled on photographic reproduction, is an example where there is a distinct absence of surface. As demonstrated in the work by Richard Falle, artists also desire this effect. However, when looking to the future of colour printing, it is important to consider whether texture could be incorporated into the inkjetted printed surface. Can artworks

The figures on the opposite page show the completed sculpture (above) and the layout drawing used to drive the Plopper (below). In the CAD drawing there are two layers, the black lines show the individual paths, the green path shows the deposition of the sand, where the circles indicate locations at which the Plopper stops and deposits sand for a certain amount of time. Here, the annotations translate as follows: SD = sand deposition . # order/ sequence (time stopped at this location in milliseconds). The black lines shows the deposition of the polyurethane. Annotation here: path# (this drawing only has one path). sequence #/order

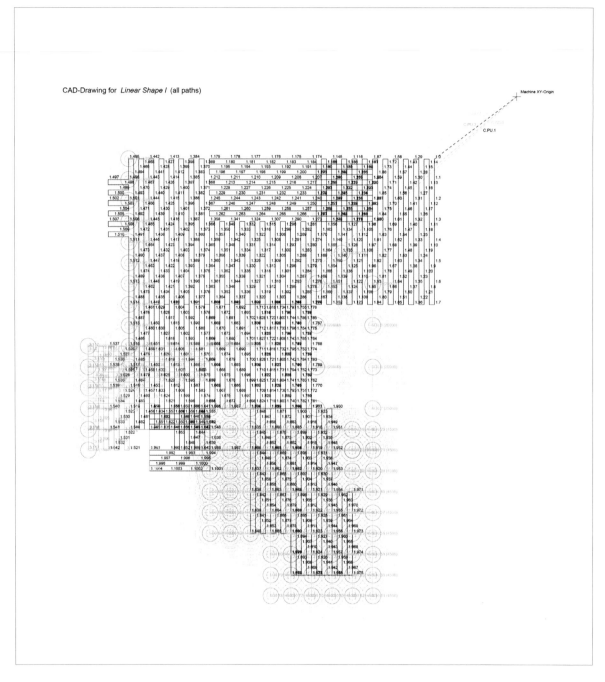

CAD-Drawing for *Linear Shape I* (all paths)

Kai Franz
Linear Shape I
2012, CAD-drawing,
custom CNC-code, custom
CAM-software, plopper,
polyurethane, sand,
pigments, 41 x 61 x 6.5 cm
Courtesy the artist
Copyright Kai Franz
(www.kaifranz.de)

Kai Franz,
Double Grid With Six Colors
2012, pair of two sculptures,
CAD-drawing, custom CNC-
code, custom CAM-software,
plopper, polyurethane, sand,
pigments
34 x 57 x 3.5 cm (each
sculpture)
Courtesy the artist
Copyright Kai Franz
(www.kaifranz.de)

be reproduced with the benefit of texture that incorporates, for example, paint instead of ink, or vector instead of dot?

WHAT MIGHT WE EXPECT FROM COLOUR PRINTING IN THE FUTURE?

During Hockney's 2012 exhibition at the Royal Academy, London, the viewer had the opportunity to experience the way in which digital technologies have impacted his fine art painting practice.[16] Although striking, the flatness of the digital works caused me to question the relationship of Hockney's method of applying paint onto canvas versus his new iPad sketches and inkjet prints. His paintings and drawings on canvas and paper have a multi-dimensional quality, the varying translucency and opacity of the brush strokes can be perceived, as can the gloss and matte differential between oil on canvas and watercolour on paper. The inkjet prints generated from the iPad work well at a distance, where colour and pattern convey the illusion of texture, but close-up the print reveals a flat ubiquitous surface.

There have evolved a wide range of hardware devices for aiding the artist. An interesting example, recently developed at the Rochester Institute of Technology (USA), is a touch-screen paint mixing application.[17] Tangipaint creates the appearance of gloss and the texture of paint and its development highlights interesting opportunities for manipulating virtual

paint, but this program, and others like it, does not indicate how images will appear when printed.

With the digitisation of public collections, many works of art are now only viewed on a screen. The evolving question is whether images can be created with the benefit of printed texture. Could this texture be incorporated, for example, as a method for enhancing tactile interaction for the visually impaired, or to reproduce fine detail such as cracks, brush strokes or impasto on the surface of paintings to provide meaningful information to the conservator or to create new avenues for artists to make images. Current inkjet manufacturers are developing UV printing methods that build up a surface texture layer by layer to create a surface contour or a Braille dot. However, this is more of a reproductive approach that is achieved by creating a texture map from a scan, or where an image is applied to a pre-textured surface. The objective here is to integrate texture and colour as one mark, that like peaks and troughs of a brush stroke, delineate the contours in the image.

In 2001 Jim Lambie asked the question, "How can I make a painting without having to lift a paintbrush?" In his floor-based artworks Lambie uses everyday and easily accessible coloured materials, multi-coloured vinyl tapes are used to create dynamic geometric patterns. The tape extends to all corners of a space, the tape traces around columns, alcoves and entrance-ways to create concentric rings of colour.

From these examples, contemporary artists have shown how they are engaged with colour mixing and application in new and more challenging, playful and interactive ways that incorporate both the traditional and the novel. Katsutoshi Yuasa, for example, working with the traditional medium of Japanese woodblock printing, has incorporated digital methods for creating large-scale hand-cut woodblock prints, and Savage, who works with colour through LEDs, engages audiences in a spectrum of coloured light.

For artists, digital technologies—software, hardware, materials—have simply offered new means for making artworks and new ways of engaging with colour. It has enabled users to capture, create and print with colour additively and subtractively in both two and three dimensions. Artists are now so used to mixing millions of tiny pixels of light and pigment and are working across analogue and digital technologies that take them beyond the traditional realm of image manufacture. It is by knowing and understanding the methods for making and creating colour in this 'post' digital age that artists have re-engaged with materials, sometimes reinventing traditional methods, that will have a new resonance in the future.

1. Weaver, Mike, ed., *Henry Fox Talbot: Selected Texts and Bibliography*, Oxford: Clio Press, 1992.

2. Mahon, Basil, *The Man Who Changed Everything: The Life of James Clerk Maxwell*, Chichester: John Wiley, 2003.

3. Gascoigne, Bamber, *Milestones in Colour Printing, 1457–1859: With a Bibliography of Nelson Prints*, Cambridge: Cambridge University Press, 1997, p. 42.

4. British Patent 565 (29 October 1852).

5. Crawford, William, *The Keepers of Light: A History and Working Guide to Early Photographic Processes*, New York: Morgan & Morgan, 1979.

6. Williams, Reba and Dave, "The Early History of the Screenprint", *Print Collectors Quarterly*, vol. 3, issue 4, 1986, pp. 287-321.

7. Viggiano, Stephen J A, "The Legacy of Hans Neugebauer in Color Imaging: A Centennial Remembrance", *Proc. 13th Color Imaging Conference: Color Science and Engineering Systems, Technologies, and Applications*, 2005, pp.153–158; Hans E J Neugebauer, "The theoretical basis of multicolor letterpress printing", *Color Research & Application*, vol. 30, no. 5, 2005, pp. 322–331; Translation from Hans E J Neugebauer, "Die theoretischen Grundlagen des Mehrfarbenbuchdrucks", *Zeitschrift für wissenschaftliche Photographie Photophysik und Photochemie*, vol. 36, issue 4, 1937, pp. 73-89.

8. Parraman, Carinna and Stephen Hoskins, "The Impact of Paper on Ink: From the Photomechanical Printer's perspective", *Proc. 9th Color Imaging Conference: Color Science and Engineering Systems, Technologies, and Applications*, 2001, pp. 214-218.

9. Tritton, Kelvin, *Stochastic Screening*, Leatherhead: PIRA International UK, 1996.

10. For more information on the main families of pigments go to: http://www.specialchem4coatings.com/tc/color-handbook/index.aspx?id=families also for a detailed description of artists pigments go to Bruce MacEvoy's Handprint website. Copyright 2005 http://handprint.com/HP/WCL/ [accessed 2012].

11. Wilhelm, Henry, *The Permanence and Care of Color Photographs: Traditional and Digital Color Prints, Color Negatives, Slides, and Motion Pictures*, 1993.

12. Parraman, Carinna and Sophie Adams Foster, "Traditional approaches using new technologies: Case studies of printed wallpaper using UV inkjet printing", *Proc. Desire'11*, Eindhoven: The Netherlands, 19–21 October 2011, pp. 297-307.

13. Hoskins, Stephen, *3D Printing for Visual Artists*, London: Bloomsbury, 2013.

14. Miller, D, "The Power of Making" in Charney, D, ed., *Power of Making, The Importance of Being Skilled*, London: V&A and The Crafts Council, 2011.

15. Catanese, P and Geary, A, *Post Digital Printmaking, CNC Traditional and Hybrid Techniques*, London: A&C Black, 2012.

16. Gayford, Martin, "David Hockney: A Bigger Picture The Infinity of Nature", *Royal Academy of Arts Magazine*, no. 113, 2011, pp. 52-64.

17. Ferwerda, James A, "Tangible display systems: bringing virtual objects into the real world", *IS&T/SPIE Electronic Imaging Science & Technology, Human Vision and Electronic Imaging XVII*, 2012.

PHOTOSHOP GRADIENT DEMONSTRATIONS
CORY ARCANGEL

Brooklyn-based artist Cory Arcangel, works across a multiplicity of formats, including video, installation and printed media. Primarily concerned with the exploration, resurrection and re-appropriation of outmoded technologies, he is best known for work that intervenes with existing materials, such as video clips or computer technologies.

In 2011 Arcangel became the youngest artist to present a solo exhibition at the Whitney Museum of American Art. Amongst many computer-based works on display were also a number of prints from the ongoing series, *Photoshop Gradient Demonstrations*, which address the contemporary question of colour and technology.

These bold colour planes, which sweep through the colour spectrum in a variety of compositions, are reminiscent of artwork of the Abstract Expressionist era. Just as an Abstract Expressionist painting conveys some sentiment of the artist in the mediums of colour and application, Arcangel's Photoshop prints could be read as energetic demonstrations of sensation or emotion. As the series' name implies, the pieces are made with the gradient tool of Adobe Creative Suite's popular software Photoshop—a device usually employed by designers and amateur digital design enthusiasts to create seamlessly merged backgrounds.

Arcangel reveals the images' origins openly by declaring the precise program settings used to achieve each in their respective titles. For example, *Photoshop CS: 84 by 66 inches, 300 DPI, RGB, square pixels, default gradient 'Blue, Red, Yellow', mousedown y=25150 x=0, mouseup y=50 x=19750* is the title of a large rectangular print which smoothly transitions through rich yellow, bold red and deep blue from the top right hand corner to the bottom left, as well as the directions to recreate the effect perfectly.

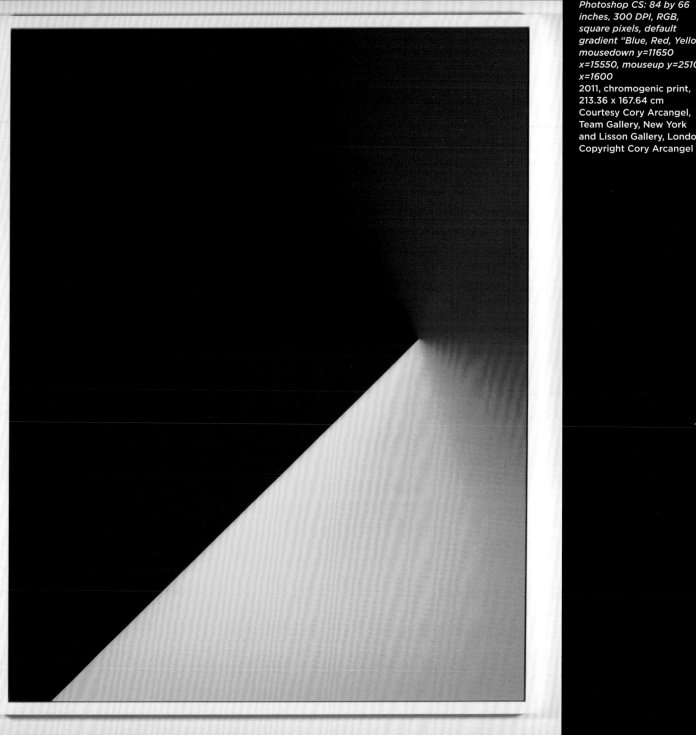

*Photoshop CS: 84 by 66
inches, 300 DPI, RGB,
square pixels, default
gradient "Blue, Red, Yellow"
mousedown y=11650
x=15550, mouseup y=25100
x=1600*
2011, chromogenic print,
213.36 x 167.64 cm
Courtesy Cory Arcangel,
Team Gallery, New York
and Lisson Gallery, London
Copyright Cory Arcangel

Photoshop CS: 84 by 66 inches, 300 DPI, RGB, square pixels, default gradient "Yellow, Blue, Red, Green", mousedown y=3000 x=16700, mouseup y=0 x=12600

2011, chromogenic print, 213.36 x 167.64 cm
Courtesy Cory Arcangel, Team Gallery, New York and Lisson Gallery, London
Copyright Cory Arcangel

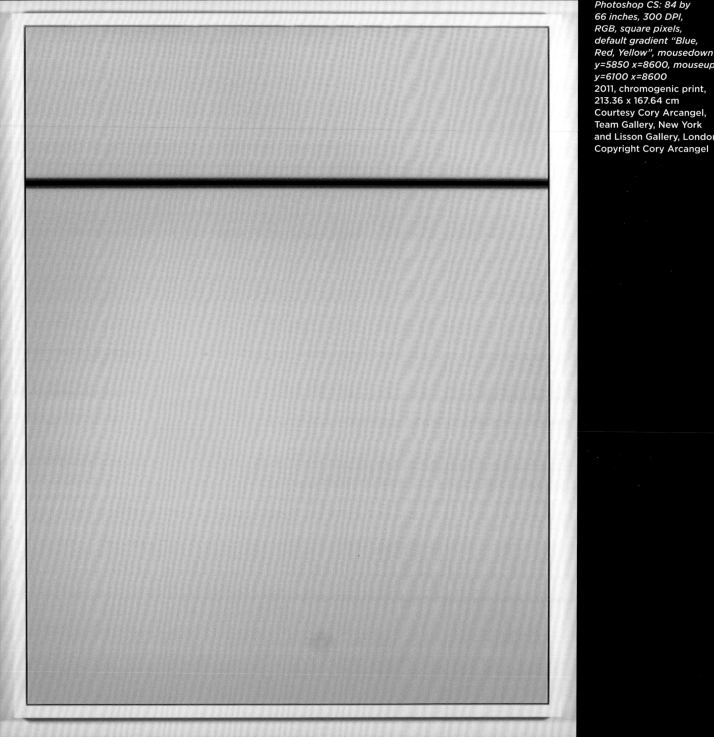

Photoshop CS: 84 by 66 inches, 300 DPI, RGB, square pixels, default gradient "Blue, Red, Yellow", mousedown y=5850 x=8600, mouseup y=6100 x=8600
2011, chromogenic print, 213.36 x 167.64 cm
Courtesy Cory Arcangel, Team Gallery, New York and Lisson Gallery, London
Copyright Cory Arcangel

COLOR JAM
JESSICA STOCKHOLDER

Color Jam by Jessica Stockholder was Chicago's largest-ever public art installation. Using 76,000 square feet of vibrantly coloured adhesive vinyl, with which to camouflage one of the city's busiest intersections, Stockholder encompassed everything from the street to the buildings in a patchwork of green, orange and blue for the summer of 2009.

Commissioned by the Chicago Loop Alliance—an organisation founded in 1929 to initially help to promote the businesses of the 'Loop' area of the city during the Great Depression, the Alliance continues to this day to develop the culture of the city through a multi-disciplinary programme of events. The Art Loop series, through which *Color Jam* was commissioned, celebrates contemporary art in Chicago, and with Stockholder's relocation to the city in 2011 as Chair of the University of Chicago Department of Visual Arts she became the ideal candidate.

Central to Stockholder's practice is the role of colour in human perception: "I began, and still do begin, with a love for colour". Working in a range of mediums, primarily sculpture and installation, Stockholder investigates human perception and physical experience, incorporating different materials and textures, visual effects and cacophonous colours into her practice to investigate aspects of sensory experience. Her work is included in collections internationally, including the Vancouver Art Gallery, Canada, and the Stedelijk Museum, The Netherlands.

Jessica Stockholder
Color Jam
2009, vinyl, variable
dimensions
Courtesy the artist and
Mitchell-Innes & Nash

PANTONE®
PAINTING
THE PARTNERS

London design agency The Partners utilised the Pantone® colour matching system to create this pixelated reproduction of Edouard Manet's *A Bar at the Folies-Bergère*, 1882—a detailed oil painting of a woman stood at the bar of the Folies Bergère nightclub in Paris, France. Using 5,000 colour samples from recycled Pantone® colour charts, The Partners painstakingly colour matched the original painting, taking them four days to complete in total. From a distance the original painting's details are highly recognisable, however on closer inspection, each Pantone® colour sample can be viewed, along with colour matching code and branding. The finished artwork is displayed in The Partners London offices.

The Partners is a brand strategy, design and innovation agency based in London, New York and Singapore. Emphasising creativity within their working process, The Partners have teamed up with some of the world's biggest brands to work on their campaigns.

Pantone are the leading provider of colour systems internationally. Designers and manufacturers rely on the Pantone® colour system as the standard colour language so that they can ensure consistency in the reproduction of different colours.

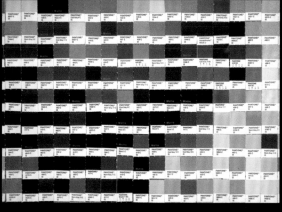

The Partners
Pantone® Painting
2012, Pantone® samples
Courtesy The Partners

PUBLIC PERCEPTION OF COLOUR/ LUMINOGRAMS

ROB & NICK CARTER

Rob and Nick Carter are a husband and wife artist duo who live and work in London. Concerned with the possibilities of colour, light and form, Rob and Nick Carter's practice incorporates a range of mediums, including painting, camera-less photography and sculpture.

Public Perception of Colour by Rob and Nick Carter in association with Pantone® is a public project exploring the idea of the colour chart. Created at London's 100% Design in 2009, Rob and Nick Carter used the entire Pantone® range of colours (2,700 in total), asking 1,000 members of the public to select the shades that best represented the seven spectral colours of pink, red, orange, yellow, green, blue and purple. These swatches were then compiled on seven sheets of aluminium to create 'monochromes' to represent these seven colours—or rather the public's perception of them.

The Carter's *Luminograms* series, 2007, explores the photogram: a camera-less mode of photography that uses light and photographic paper to produce an image. The series consists of 12 canvases of intense colour that range from one end of the spectrum to the other, for which the artists were inspired by Goethe's colour circle (see pp. 73–75) in their choice of complimentary colours. Coining the word 'luminogram' to convey the process in which the works were made—the light having been filtered through coloured gels in varying intensities to create graduated colour—each work is a journey through the different hues of one colour.

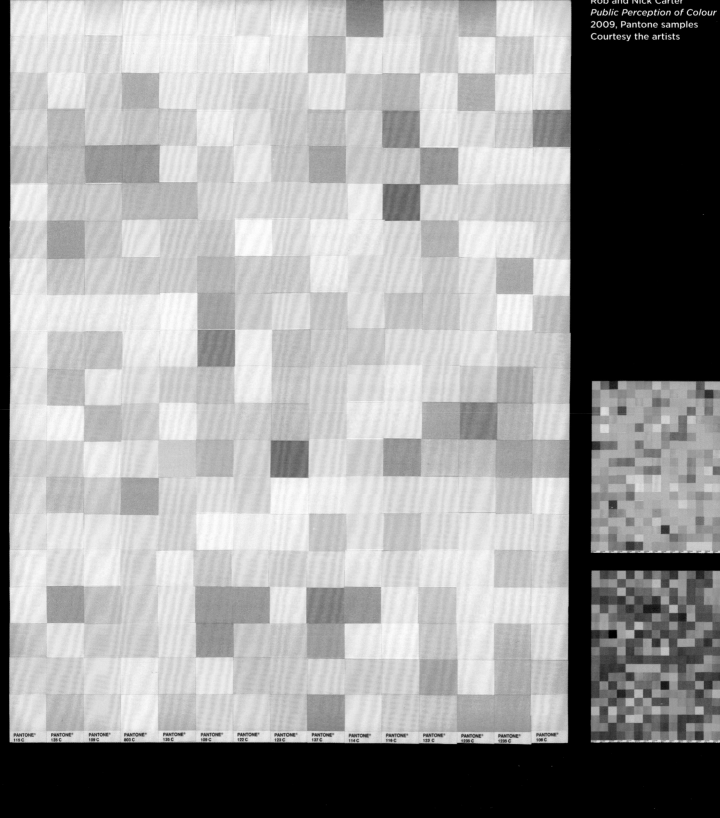

Rob and Nick Carter
Public Perception of Colour
2009, Pantone samples
Courtesy the artists

PANTONE® 115 C PANTONE® 135 C PANTONE® 109 C PANTONE® 803 C PANTONE® 135 C PANTONE® 109 C PANTONE® 122 C PANTONE® 123 C PANTONE® 137 C PANTONE® 114 C PANTONE® 116 C PANTONE® 123 C PANTONE® 1235 C PANTONE® 1235 C PANTONE® 108 C

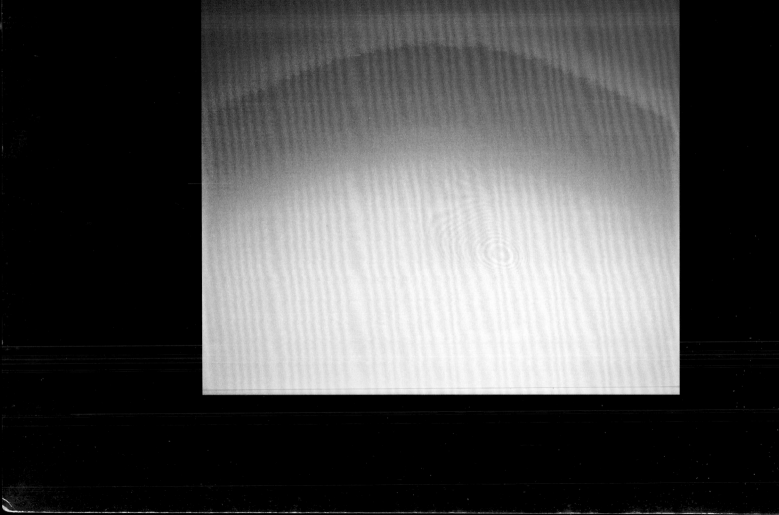

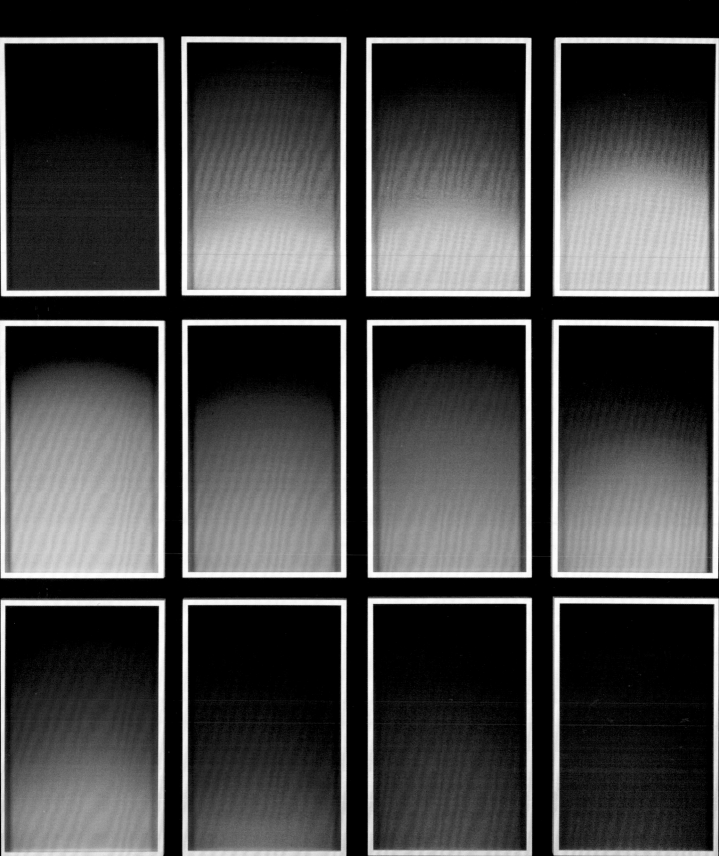

RESOURCES

PAINT & PIGMENT MANUFACTURERS

Kama Pigments
7442 Rue Saint-hubert
Montreal, Quebec
Canada, H2R 2W8
+1 514 272 2173
info@kamapigment.com
www.kamapigment.com

Kremer Pigments
Kremer Pigmente GmbH
& Co. KG
Hauptstr. 41-47
DE 88317 Aichstetten
Germany
+ 49 7565 91120
info@kremer-pigmente.de
www.kremer-pigmente.
de/en

Winsor & Newton
The Studio Building
21 Evesham Street
London, W11 4AJ
United Kingdom
020 8424 3200
www.winsornewton.com

L Cornelissen & Son
105 Great Russell Street
London, WC1B 3RY
United Kingdom
020 7636 1045
info@cornelissen.co.uk
www.cornelissen.com

Golden Artist Colors, Inc.
188 Bell Road
New Berlin, NY
13411-9527 USA
+1 607-847-6154
+1 800-959-6543
Fax: 607-847-6767
goldenart@
goldenpaints.com
www.goldenpaints.com

Guerra Paint and Pigment
510 East 13th Street
New York
10009 USA
+1 212 529 0628
www.guerrapaint.com

Master Pigments
+1 949 636-4300
info@masterpigments.com
www.masterpigments.com

Natural Pigments
291 Shell Lane
Willits, California
95490 USA
+1 888 361 5900
www.naturalpigments.com

R&F Handmade Paints
84 Ten Broeck Ave
Kingston, New York
12401 USA
+1 800 206 8088
www.rfpaints.com

Sinopia Pigments
& Materials
1340 Bryant Street
San Francisco, California
USA 94103
+1 415 824 3180
pigments@sinopia.com
www.sinopia.com/

The Woad Centre
Woad Barn, Rawhall Lane
Beetley, Dereham
Norfolk NR20 4HH
United Kingdom
01362 860 218
info@woad-inc.co.uk
www.thewoadcentre.co.uk

Zecchi
Via della Studio, 19r
50122 Florence
Italy
+39 055 211 470
zecchifi@tin.it
www.zecchi.it

COLLECTIONS / ARCHIVES

Bassetlaw Museum
Amcott House
40 Grove Street
Retford, Nottinghamshire
DN22 6LD
United Kingdom
01777 713 749
Bassetlaw.museum@
bassetlaw.gov.uk
www.bassetlawmuseum.
org.uk

The Courtauld Gallery
Impressionism and Post-
Impressionism Collection
Somerset House
Strand, London, WC2R 0RN
United Kingdom
020 7848 2526
galleryinfo@courtauld.ac.uk
www.courtauld.ac.uk

The Geological Museum
The Natural
History Museum
Cromwell Road
London, SW7 5BD
United Kingdom
020 7942 5000
www.nhm.ac.uk/visit-us/
history-architecture/
geological-museum

Glasgow Colour
Studies Group
University of Glasgow
and Glasgow School of Art
colourstudies@
jiscmail.ac.uk
www.gla.ac.uk/schools/
critical/research/
seminarsandevents/
glasgowcolour
studiesgroup/

Harvard Mineralogical
& Geological Museum
Harvard Museum of
Natural History
26 Oxford Street
Cambridge, Massachusetts
02138, USA
+1 617 495 3045
hmnh@hmnh.harvard.edu
www.geomus.fas.harvard.
edu/icb/icb.do

National Media Museum
Bradford, West Yorkshire,
BD1 1NQ, United Kingdom
0844 856 3797
talk@
nationalmediamuseum.
org.uk
www.nationalmedia
museum.org.uk/

Old Holland Classic
Colours Museum
Nijendal 36
3972 KC Driebergen
The Netherlands
+31 343 518 224
info@oldholland.com
www.oldholland.com

Royal College of Art Colour
Reference Library
Royal College of Art
Kensington Gore
London, SW7 2EU
United Kingdom
020 7590 4234
special-collections@rca.
ac.uk
www.rca.ac.uk

Society of Dyers
and Colourists
Perkin House, 82 Grattan
Road, Bradford
West Yorkshire, BD1 2LU
United Kingdom
01274 725138
info@sdc.org.uk
www.sdc.org.uk

The Slade School of Fine
Art Materials Museum
(This small, travelling exhibit
is usually located on the
ground floor of the Slade
School of Fine Art)
University College London
Gower Street
London, WC1E 6BT
United Kingdom
www.ucl.ac.uk/slade/
research/staff/current-
research/project-
6#materials-museum

ONLINE RESOURCES

All About Wood
Online woad resource
www.woad.org.uk

Color Chart Interactive Gallery
MOMA
www.moma.org/interactives/
exhibitions/2008/colorchart

Color Matters
www.colormatters.com

Colour Theory: Understanding and
Modelling Colour
JISC Digital Media
www.jiscdigitalmedia.ac.uk/guide/colour-
theory-understanding-and-modelling-
colour/

Isaac Newton's Theory of Light and Colours
The Newton Project, Sussex University
www.newtonproject.sussex.ac.uk/view/
texts/normalized/NATP00006

Library of Congress
Historical colour photograph archive
www.flickr.com/photos/library_of_congress

Making Artists' Paints, An Easy to
Follow Guide
www.paintmaking.com/index.html

Minerals: Uses, Properties and Descriptions
www.geology.com/minerals

The Mudcube Colour Sphere
www.mudcu.be/sphere

Munsell
www.munsell.com

Natural Colour System
www.ncscolour.com/en

Pantone
www.pantone.co.uk

Precise Color Communication Guide
Konica Minolta
www2.konicaminolta.eu/eu/Measuring/
pcc/en

The Art is Creation
Color of Art Pigment Database
www.artiscreation.com

The National Portrait Gallery
A history of British artist's suppliers,
1650—1950
www.npg.org.uk/research/programmes/
directory-of-suppliers

The Madame Yevonde Portrait Archive
www.madameyevonde.com

Timeline of Historical Film Colors
Barbara Flueckiger and the University
of Zurich and Swiss National Science
Foundation.
www.zauberklang.ch/filmcolors

Winsor & Newton Online Resource Centre
www.winsornewton.com/resource-centre

SELECT BIBLIOGRAPHY

MATERIALS

BALL, PHILLIP, *Bright Earth: The Invention of Colour*, London: Vintage, 2008

BIRREN, FABER, *History of Colour in Printing*, New York: Reinhold, 1965

BERSCH, JOSEPH, *The Manufacture of Earth Colours*, London: Scott, Greenwood and Son, 1921

BRIDGEMAN, JANE, "Purple Dye in Late Antiquity and Byzantium" in *The Royal Purple and the Biblical Blue: Argaman and Tekhelet*, Jerusalem: Keter Publishing House, 1987, pp. 159–65

CHENCINER, ROBERT, *Madder Red: A History of Luxury and Trade, Plant Dyes and Pigments in World Commerce and Art*, Richmond: Curzon, 2000

CLARKE, MARK, *The Art of All Colours: Mediaeval Recipe Books for Painters and Illuminators*, London: Archetype Publications, 2001

CLARKE, MARK, *Mediaeval Painters' Materials and Techniques: The Montpellier 'Liber diversarium arcium'*, London: Archetype Publications, 2011

EASTLAKE, CHARLES, *Materials for the History of Oil Painting*, London: Longman, Brown, Green and Longmans, 1847

EDMONDS, JOHN, *The History of Woad and the Mediaeval Woad Vat*, Little Chalfont: John Edmonds, 1998

FELLER, ROBERT, ed., *Artists Pigments: A Handbook of Their History and Characteristics, Vol i'*, Washington DC: National Gallery of Art, 1986

FITZHUGH, ELIZABETH WEST, ed., *Artists Pigments: A Handbook of Their History and Characteristics, Vol iii'*, Washington DC: National Gallery of Art, 1997

KIRBY, JO; SAUNDERS, DAVID; SPRING, MARIKA, "Proscribed Pigments in Northern European Renaissance Paintings and the Case for Paris Red", in *Studies in Conservation*, August 2006, pp. 236–243(8)

NEWMAN R, WESTON C, FARRELL E, "Analysis of Watercolour Pigments in a Box Owned by Winslow Homer", *Journal of the American Institute for Conservation 1980*, vol. 19, no. 2

ROY, ASHOK, ed., *Artists Pigments: A Handbook of Their History and Characteristics, Vol ii'*, Washington DC: National Gallery of Art, 1993

WALL THOMAS, ANNE, *Colours from the Earth: The Artists Guide to Collecting, Preparing, and Using Them*, London: Van Nostrand Reinhold, 1980

POST NEWTONIAN COLOUR —COLOUR PERCEPTION

BURWICK, FREDERICK, *The Damnation Of Newton: Goethe's Colour Theory and Romantic Perception*, Berlin: de Gruyter, 1986

CANTOR, GN, *Optics After Newton: Theories of Light in Britain and Ireland, 1704–1840*, Manchester: Manchester University Press, 1983

CHEVREUL, ME, *The Principles of Harmony and Contrast of Colours and their Applications to the Arts*, New York: Van Nostrand Reinhold, 1981

GOETHE, JOHANN WOLFGANG VON, *Theory of Colours*, Cambridge (MA.): MIT Press, 1970

KEMP, MARTIN, *The Science of Art: Optical Themes in Western Art From Brunelleschi to Seurat*, Yale: Yale University Press, 1990

PARRAMAN, CARINNA, "Colour in Flux: Describing and Printing Colour in Art" in *Color Imaging XIII: Processing, Hardcopy, and Applications*, January 2008

SEPPER, DENNIS L, *Goethe Contra Newton: Polemics and the Project for a New Science of Color*, Cambridge: Cambridge University Press, 1988

STABELL, ULF; STABELL, BJØRN, eds, *Duplicity Theory of Vision: From Newton to the Present*, Cambridge: Cambridge University Press, 2009

STEINLE, F; MJ PETRY, "Newton's Colour-Theory and Perception" in *International Archives of the History of Ideas*, Boston: Kluver Academic Publishers, 1993

CHEMISTRY AND THE NEW RAINBOW

BARNETT, JR; MILLER, SARAH, PIERCE, EMMA, "Colour and Art: a Brief History of Pigments" in *Optics & Laser Technology*, vol. 38: Issues 4-6, June–September 2006, pp. 445–453

CRONE, RA, "A History of Colour: The Evolution of Theories of Light and Color" in *History and Philosophy of the Life Sciences*, vol. 23, Part 2, 2002, pp. 327–328

FEESER, A; MD GOGGIN; BF TOBER, eds, *The Materiality of Color: the Production, Circulation, and Application of Dyes and Pigments, 1400–1800*, Farnham: Ashgate, 2012

GARFIELD, SIMON, *Mauve: How One Man Invented a Colour That Changed the World,* London: Faber & Faber, 2000

HARLEY, RD, *Artists' Pigments c.1600–1835: A study in English Documentary Sources*, London: Butterworth Scientific, 1982

SKELTON, HELEN, "A Colour Chemist's History of Western Art" in *Review of Progress in Coloration*, Millennium Issue, vol. 29, 1999

CONTEMPORARY COLOURISTS

ALISON, JANE, ed., *After Klein: Rethinking Colour in Modern and Contemporary Art,* London: Black Dog Publishing, 2005

BATCHELOR, DAVID, ed., *Colour*, London: Whitechapel, 2008

BRACEWELL, MICHAEL; JIM LAMBIE, *Jim Lambie: Male Stripper*, Oxford: Modern Art Oxford, 2004

DAVIS, KATE; GORDON NESBITT, REBECCA, *Grayscale/CMYK*, Helsinki: Nordic Institute for Contemporary Art, 2002

LAMBIE, JIM, ed., *Painting Not Painting*, St Ives: Tate St Ives, 2003

LYOTARD, JEAN-FRANÇOIS, *Karel Appel, un Geste de Couleur/Karel Appel, a Gesture of Colour*, Leuven: Leuven University Press, 2009

NEALE, MARGO, *Utopia: The Genius of Emily Kame Kngwarreye*, Canberra: National Museum of Australia Press, 2008

NEMITZ, BARBARA, ed., *Pink: the Exposed Color in Contemporary Art and Culture'*, London: Art Books International, 2006

TEMKIN, ANNE, *Color Chart: reinventing Color, 1950 to Today*, London: Thames & Hudson, 2008

YARD, SALLY, *Stephen Antonakos, Neons and Works on Paper*, La Jolla Museum of Contemporary Art, 1984

COLOUR AND ART

FINLAY, VICTORIA, *Colour,* London: The Folio Society, 2009

GAGE, JOHN, *Colour and Meaning: Art, Science and Symbolism,* London: Thames and Hudson, 2011

GLASNER, BARBARA; SCHMIDT, PETRA, *Chroma: Design, Architecture and Art in Colour*, Boston: Birkhauser Verlag, 2010

HORNUNG, DAVID, *Colour: A Workshop for Artists and Designers,* London: Lawrence King Publishing, 2005

ROSENBUM, ROBERT; JANSON, HW, *19th-Century Art*, New York: Harry N Abrams Inc, 1984

VEROUGSTRAETE, HÉLÈNE, ROGER VAN SCHOUTE AND TILL-HOLGER BORCHERT, *Fake or not fake: het verhaal van de restauratie van de Vlaamse primitieven*, Ghent and Amsterdam: Ludion, 2004

ZELANSKI, PAUL; FISHER, MARY PAT, *Colour For Designers and Artists*, London: Herbert Press, 1993

ZELANSKI, PAUL; FISHER, MARY PAT, *Colour*, London: Herbert Press, 1999

AUTHOR BIOGRAPHIES

PHILIP BALL

Philip Ball is a freelance writer. He has authored many books on the interactions of the sciences, the arts, and wider culture, including *The Self-Made Tapestry: Pattern Formation in Nature, Bright Earth: The Invention of Colour, Critical Mass*, and *The Music Instinct.* Ball previously worked for over 20 years as an editor of the science journal *Nature*.

MARK CLARKE

Mark Clarke is an interdisciplinary researcher in 'Technical Art History'—the interdisciplinary study of works of art as physical objects and the history of artist's technology. His particular specialisms are mediaeval artist's paint and artists' recipe books. He has been a researcher at the universities of Cambridge, Amsterdam and Lisbon, the cultural heritage agencies of the Netherlands and Spain, and institutions including the Dutch Institute for Atomic and Molecular Physics, the Fitzwilliam Museum, the Max Planck Institute for the History of Science and the Royal Flemish Academy in Berlin. Clarke lives in Belgium.

CARINNA PARRAMAN

Dr Carinna Parraman is Senior Research Fellow and Deputy Director at the Centre for Fine Print Research, University of the West of England, Bristol. Her research background in subtractive colour mixing and photomechanical colour printing, has developed into an in-depth study of the application of colour for wideformat printing. In 2006–2010 she coordinated a European colour group (www.create.uwe.ac.uk) that comprised experts from a diverse range of backgrounds in colour in the arts, humanities, computer science, physics and conservation sectors that has spread knowledge beyond Parraman's own creative arts sector. Parraman's fine art practice explores the perceptual relationship of halftone patterns, colour assimilation and contrast.

ACKNOWLEDGEMENTS

Thank you to all those involved in the production of *Colour in the Making: from old wisdom to new brilliance*. The authors: Mark Clarke, Philip Ball and Carinna Parraman, not only for their insightful essays but also for their expert advice in the early research stages of the book; the Winsor & Newton Archive; Master Pigments; Kremer Pigmente; Art & Soul; the Yevonde Portrait Archive and all the artists and galleries for the donation of their work.

At Black Dog a special thank you to Phoebe Stubbs for her conception of the title and editorial expertise; Arrate Hidalgo for adopting the title and making it her own; Dana Seay, Leanne Hayman, John Hewish and Richard Duffy for their valuable editorial assistance throughout; Alex Wright for initial design ideas and Amy Cooper-Wright for her vibrant and stylish design, without which the book would not be the same.

INDEX

Black Dog Publishing Limited
10A Acton Street
London
WC1X 9NG
UK

t. +44 (0)207 713 5097
f. +44 (0)207 713 8682
e. info@blackdogonline.com
www.blackdogonline.com

Edited at Black Dog Publishing by Phoebe Stubbs, Arrate Hidalgo, Phoebe Adler
and Leanne Hayman.

Designed at Black Dog Publishing by Amy Cooper-Wright.

ISBN 978 1 907317 95 8

art design fashion
history photography
theory and things

**black dog
publishing**

www.blackdogonline.com london uk